JAPAN FASHION NOW

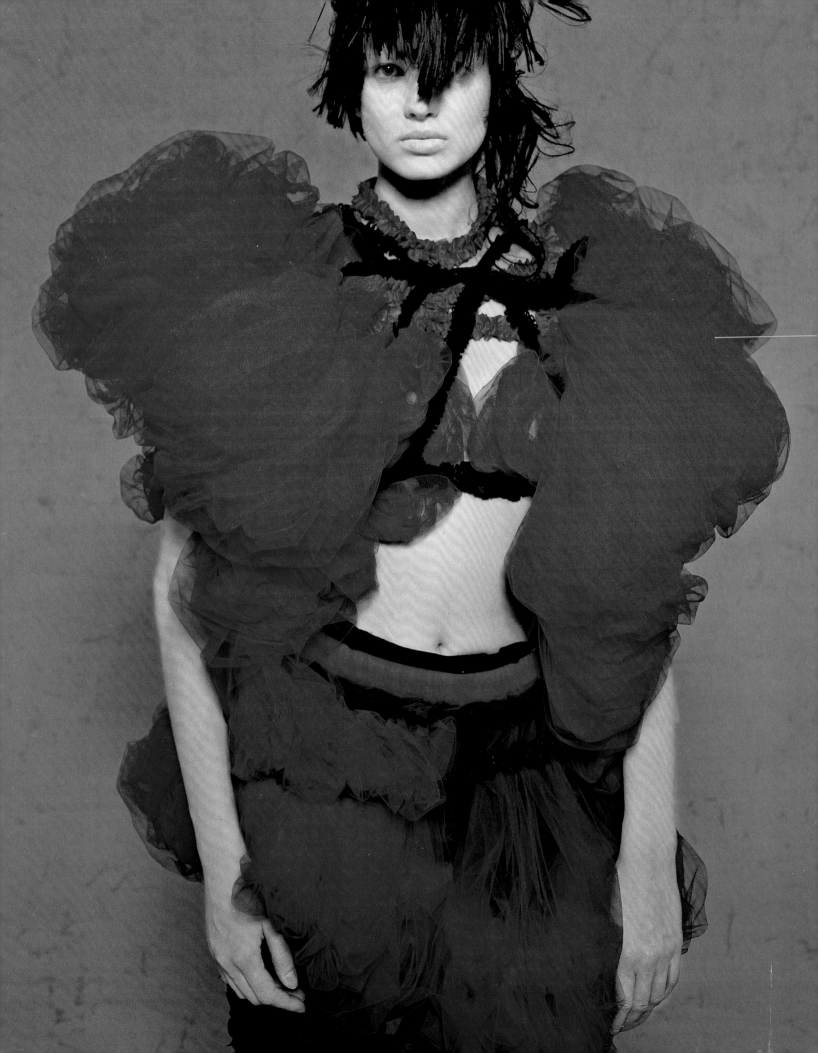

valerie steele

patricia mears

yuniya kawamura

hiroshi narumi

JAPAN FASHION NOW

Yale University Press, New Haven and London, in association with
The Fashion Institute of Technology, New York

This book is dedicated to the staff of The Museum
at FIT, and especially to Varounny Chanthasiri,
Harumi Hotta, and Melissa Marra.

Designed by Paul Sloman

Printed in Italy by Conti Tipocolor

Library of Congress Cataloging-in-Publication Data

Steele, Valerie.
Japan fashion now / Valerie Steele.
p. cm.
Includes bibliographical references and index.
ISBN 978-0-300-16727-6 (pb : alk. paper)
1. Fashion design–Japan. 1. Title.
TT504.6.J3–74 2010
746.9–2–dc22

2010034192

A catalogue record for this book is available from The British Library

frontispiece:

Comme des Garçons, from *High Fashion*, August, 2008 (no. 322).
Photo: Yoshiko Seino. Make-up and hair: Katsuya Kamo (Mod's Hair).
Model: Natalia Siodmiak.

contents

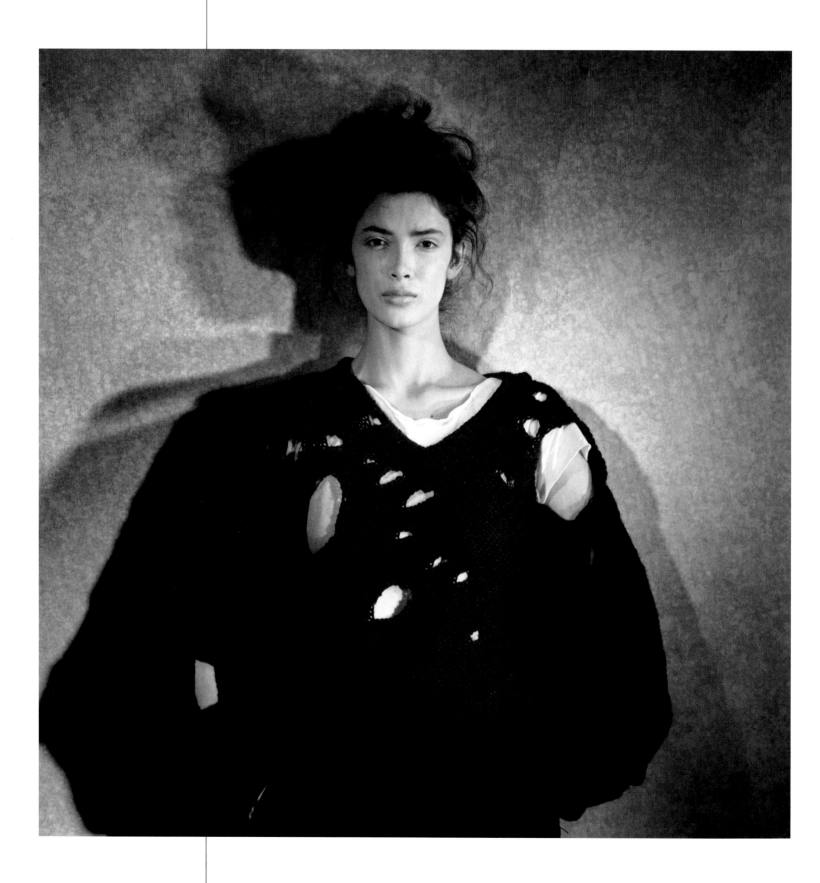

valerie steele

IS JAPAN STILL THE FUTURE?

The Japanese "fashion revolution" of the 1980s dramatically transformed the world of fashion. Avant-garde Japanese designers such as Issey Miyake, Yohji Yamamoto, and Rei Kawakubo of Comme des Garçons introduced a radically new concept of fashion to the catwalks of Paris. Utilizing innovative textile technologies, together with aspects of traditional Japanese clothing culture, these designers were instrumental in creating a new relationship between body and clothes, a new attitude toward the beauty of imperfection, and a new appreciation of avant-garde fashion as "art."

I vividly remember how strange and wonderful the new Japanese fashions looked and how they polarized opinion. Many people, even fashion professionals, were horrified by the sight of clothes that seemed to have been deliberately damaged or destroyed. Equally shocking was the perception that these clothes were apparently not intended to make women look more "beautiful." At a time when most western fashion was aggressively sexual and body-conscious, avant-garde Japanese fashion was body-concealing, asymmetrical, and overwhelmingly black.

In retrospect, the Japanese fashions of the 1980s marked a very important turning point in fashion history. It was not simply that black rapidly became the default fashion color, nor that "deconstruction"

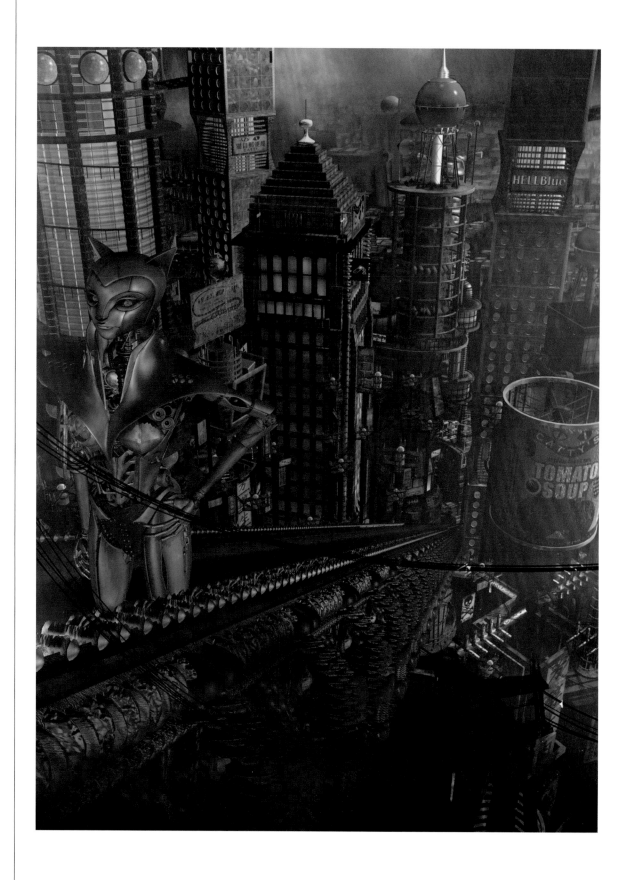

Tamala's doppelganger Tatla riding
on the escalator,
frame from anime *TAMALA 2010:
A Punk Cat in Space*, created by
artists t.o.L (trees of Life),
copyright TAMALA 2010 Project

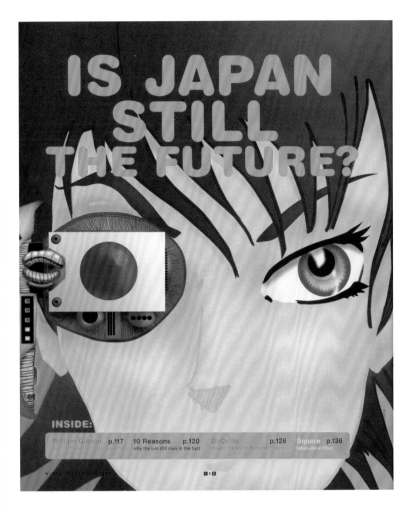

soon influenced everything from haute couture to fast fashion. For the first time, a non-western culture had significantly affected the global fashion system, and had done so by projecting an image of hyper-modernism. In her influential book *Fashion Zeitgeist*, Barbara Vinken argues that the appearance of Japanese fashion in Paris in the 1980s "spectacularly marked the end of one era and the beginning of another." What she calls the "fashion of a hundred years . . . stretching from Worth to Saint Laurent" was replaced by a new phenomenon that she dubbed "postfashion."[1]

But it was not merely that Japanese fashion was revolutionary during the 1980s. Japan itself seemed to embody the future. The image of Japan as the "the post-modern society *par excellence*" took root in the

1980s as a result of the country's "spectacular economic development, together with the techno-digital revolution and pervasive consumerism."[2] In the world of business models, money, and technology, Japan was widely proclaimed "Number One." As the global cultural environment became increasingly saturated by electronics, the genre or movement of "cyberpunk" emerged – and from the beginning, cyberpunk was closely associated with a futuristic image of Japan, evident, for example, in the proto-cyberpunk film *Bladerunner* (1982), and in the novels of William Gibson, especially *Neuromancer* (1984).

The 1980s are now history. How has Japanese fashion evolved in the thrity years since then? Who are the new Japanese designers? What is the role of Japanese youth fashion? Where does Tokyo fit in the hierarchy of fashion's world cities? Is Japan still the future?

A BRIEF HISTORY OF FASHION IN JAPAN

Fashion is usually regarded as a modern, western phenomenon. While it is true that the development of fashion as a regular pattern of style change is associated with the rise of capitalism in Western Europe, it is also clear that fashion-oriented behavior has existed in at least some pre-modern cultures, such as Tang and Ming Dynasty China.[3] Certainly, by the late Heian period in Japan (794–1192 CE), one of the highest terms of praise was to call something *imamekashi*, "up-to-date." A type of fashion existed at the court of Heian-kyo, where aristocratic ladies such as the novelist Murasaki Shikibu and the diarist Sei Shonagon ruthlessly mocked contemporaries who failed to live up to the sophisticated aesthetic code that made even a minor lapse of taste – such as wearing one of several layered kimono in "a shade too pale" – the subject of cruel mockery.[4] A much more extensive fashion culture developed by the seventeenth century in the city of Edo. In contrast to western fashion, however, "being modish in kimono" seldom involved significant changes in silhouette, focusing instead on color combinations and/or textile patterns.[5]

Japan's fascination with fashion and novelty appears to derive, in part, from its historic "cult of beauty." Traditional Japanese aesthet-

ics extol the beauty of the ephemeral. Cherry blossoms, for example, are perceived as beautiful, because they evoke the transience of life, an idea that is central to Buddhism. A key Heian aesthetic concept is *mono no aware*, "the transience of things." However, it is all too easy to "explain" Japanese fashion in terms of Orientalist stereotypes about the Japanese. The fact that there are also many Japanese scholars who are obsessed with a myth of Japanese uniqueness does not make the idea of an essential and unchanging Japanese aesthetic any more believable. The cult of beauty that emerged a millennium ago at the court of Heian-kyo evolved considerably in the centuries that followed, as the luxurious Heian court culture gave way to a society dominated by a new warrior class, the samurai.

One of the most influential aesthetic concepts to develop during this era was *wabi-sabi*, which focused on "simplicity and elegance as Japanese ideals of beauty." A compound word, *wabi-sabi* embraces both the medieval term *wabi*, implying a "simple, austere type of beauty," and *sabi*, a kind of "lonely beauty," such as "the beauty of silence and old age." The aesthetics of wabi-sabi are associated with Zen Buddhism, and particularly with the Zen concept of emptiness.[6] As the wabi aesthetic developed over the centuries, in connection with art forms such as the tea ceremony and the No drama, certain aspects were emphasized, including "simple, unpretentious beauty," "imperfect, irregular beauty," "austere, stark beauty," "a beauty of reticence and non-being," and a "stark, cold beauty."[7]

The costume curator Harold Koda famously used the concept of wabi-sabi to describe the austere and imperfect look of late twentieth-century fashions by Comme des Garçons.[8] Although it is an interpretation that Rei Kawakubo herself rejected, many influential Japanese fashion scholars, such as Akiko Fukai, believe that wabi-sabi is an important component of the Japanese aesthetic worldview. It is not, however, the last word in Japanese aesthetics.

In the late seventeenth century, Japanese fashion culture heated up once again. The samurai and the great regional lords, the *daimyo*, were brought under the central political control of the *shogun*, and political stability ushered in an era of economic growth. The city

of Edo became one of the largest cities in the world and evolved an urban culture of its own. Despite a rigid social hierarchy and harsh sumptuary laws, samurai, merchants, artisans, and entertainers all competed fiercely to wear the latest styles, and a variety of commercial establishments catered to consumer demand. Over-sized patterns and brilliant color combinations came into fashion. Sleeves and sashes grew ever larger.

By the 1720s, however, this "lavish and radiant" style "began to be replaced by the darker, sophisticated aesthetic called *iki*," which is usually translated as "elegant chic." One reason for the change was political. Merchants and even actors often had more money than samurai, and the authorities responded by repeatedly enacting sumptuary laws with heavy penalties for wealthy commoners who dared to dress above their station. But it is also likely that the stylistic pendulum had simply swung to the opposite extreme, "from the obvious to the subtle, from bright colors to dark, and from jumbo freeform patterns to petite repeats."[9]

According to Liza Dalby, author of *Kimono* and *Geisha*:

"Iki implies, above all, high connoisseurship. . . . The edicts drove luxury underground – not burying it, but making it subtler and, in the process, slightly twisted . . . Iki was just as expensive as opulence, but it was not overt. How better to sidestep the stiff samurai who forbids you to wear gold-embroidered figured silk than to wear a dark-blue striped kosode of homely wild silk – but line it in gorgeous yellow patterned crepe? . . . Anyone with taste would turn to the subtle details marking a person as iki. . . . Growing out of the necessity to be discreet, iki made discretion its virtue. Yet it was a cool discretion, shunning the propriety of the established order. The energy of iki lay in its streak of perversity. In fashion, geisha were the most iki of women . . . A shy maiden was too innocent to be iki, a proper wife too correct . . ."[10]

The most famous Japanese theorist of iki was Count Shuzo Kuki (1888–1941), a student of Martin Heidegger and a right-wing nation-

alist who argued that iki was unique to the Japanese race.[11] Yet iki bears an unmistakable resemblance to Baudelairean dandyism.[12] Significantly, iki is still relevant to modern Japanese aesthetics – and social conventions. Subtlety, connoisseurship, and a seductive yet elegant sobriety remain highly valued in Japan, as will become apparent.

The appearance of western fashion in Meiji Japan (1868–1912) was a direct result of the political and economic "opening" of the country in 1854 when the American *kurofune* (black ships) appeared. As Kon Wajirō puts it, "The kurofune frightened the Japanese into thinking that Japan might be occupied unless she completely renewed her military defense and shocked them into thinking that they had to change their clothes too."[13] Forced to respond to western imperialism, a segment of the samurai elite radically reorganized the country's political structure, overthrowing the Tokugawa Shogunate and launching the Meiji Restoration.

The country's rapid transition from feudalism to modernity occurred because the Japanese state initiated a revolution from the top down. This involved an intensive effort to research and duplicate the sources of western power. A modern military was obviously crucial, so the Japanese investigated the various western military systems, and ultimately decided that the Prussian military was the most advanced. Prussian officers were duly imported to modernize the Japanese armed forces. Industrialization was the engine of modernization, so the Japanese resolved to learn from the west's greatest industrial

power, which at that time was Great Britain. Other aspects of western society were more mysterious. It may or may not have been beneficial for the Japanese to eat beef, for example, or wear tailored clothing. Western clothing had one definite advantage, the Japanese leaders realized: it made westerners more likely to see the Japanese as "civilized" and, therefore, potentially, as equals.

The adoption of western fashion was a global phenomenon, but it occurred in Japan under highly unusual circumstances – without the experience of colonization, before extensive industrialization, and as a direct result of state power and ideology. It was no accident that military uniforms were the first western clothes to be adopted in Japan. There were experiments with the adoption of foreign military uniforms even in the late Tokugawa period, despite the regime's xenophobia. With the Meiji Restoration, British naval uniforms were copied, and after the Franco-Prussian War, decorative French army uniforms gave way to Prussian uniforms (there was no point in copying losers). The English-style tailored suit was rapidly adopted by members of the state bureaucracy, and in 1872, the Meiji emperor mandated that all men in attendance at the imperial court had to wear western clothing (either a frock coat and top hat or a military uniform). In 1886, women at court were also told to adopt western fashions, including corsets and bustles. By 1900, many urban men, although still only a minority of women, wore some form of western dress – at least in public.

In his book *Japanese Fashion: A Cultural History*, Toby Slade argues that by the late Meiji period, the Japanese elite had achieved a "near-perfect imitation" of western dress. This is not a criticism and does not mean to imply that the Japanese are capable of imitation only. Rather, Slade suggests that during the Meiji period, the Japanese developed "a new aesthetic" surrounding western dress, one involving formality, elegance, and abstraction, as well as "a preference for the new."[14] Simultaneously, as sartorial modernity was associated with the west, Japanese dress underwent a kind of "invention of tradition," involving the samuraization of taste and the spread of an austere, Zen-like aesthetic that came to be seen as timelessly Japanese.[15]

The meanings associated with modern fashion in Europe and America – such as the class connotations of fashion or the changes between past and present styles – were almost entirely absent in Japan, subsumed as they were by the more important concept of western versus Japanese. Because modernity arrived so suddenly in Japan and represented such a radical break with the past, the appropriation of modern western fashions "represented a general experimentation with form. They had nothing to do with identity – they were in fact totally alien." As a result, "modernity was not just incorporated into an identity but performed, and thus had an element that was . . . aesthetic."[16]

Western clothing (*yofuku*) was very much an official work uniform, since traditional Japanese clothing (*wafuku*) continued to be worn in private. It was not usually the case that an individual made a conscious choice to wear foreign clothes; rather, groups of people (soldiers, bureaucrats, students, nurses, and so on) were told to adopt particular foreign clothing ensembles. Japanese schoolboys, for example, were put into a uniform modeled after Prussian military uniforms: a black high-collared jacket with brass buttons, trousers, and a cap with a brass badge. After the Russo-Japanese War, a long black cape was (temporarily) added.[17] This school uniform has remained essentially unchanged up to the present day, although recently many schools have begun replacing the Nehru-style jacket with a blazer. Sartorial deviance was (and continues to be) criticized. "To be a student is to be plain in habit and taste . . . Dandyism is a heinous offence," thundered Meiji headmaster Nitobe Inazō.[18]

Japan remains "a uniformed society" where almost everyone from students and construction workers to "salarymen" (white-collar workers) and "office ladies" (secretaries) wears some kind of uniform or quasi-uniform. "Even the gangsters have a type of regulated dress comprised of flashy suits, loud neckties, expensive jewelry, sunglasses and closely cropped hair," observes Brian J. McVeigh.[19] The author of *Wearing Ideology: State, Schooling and Self-Presentation in Japan*, McVeigh writes: "As tangible symbols of the ability of the enormous and extensive politico-economic structures to shape bodily practices,

and by implication, subjectivity and behavior," uniforms play an extremely important role in contemporary Japanese fashion culture, being "utilized on a massive scale on a daily basis."[20]

Uniformity has its critics, of course. Within what he calls the "straightjacket society" of the Japanese bureaucracy, the psychologist Dr. Masao Miyamoto found that "Bullying even extends to matters of taste in dress." His colleagues resented his interest in fashion (expressed, for example, in elegant Italian suits) and pressured him to "dress like everybody else."[21] While Americans tend to regard "following fashion" as a conformist, group-oriented activity, fashion also implies individuality, distinction, and competition. The very uniformity of Japanese society can provoke creative outbursts of individual style, as well as another kind of creativity that manipulates the perimeters of uniformity itself.

During the Taisho period (1912–1926) and for the first ten years of the Showa period (1926–1936), modern western clothing was increasingly associated with women, consumer culture, and leisure. Individuals, especially young people and urban working women (bus conductors, elevator girls, and typists), increasingly adopted western dress, not only as an officially mandated uniform for work, but also as a sign of modernity and sophistication. Although the majority of women still wore kimono, some chose fabrics with "Art Deco" patterns, such as stylized skyscrapers, while other women adopted western sportswear, showing their legs in short frocks or bathing suits.[22]

The "modern boy" and "modern girl" – *modaan boi* and *modaan gaaru*, or *mobo moga* for short – were performing modernity largely on their own initiative. In contrast to the Meiji period, it was not a case of modernity in the service of authority, with western fashion trickling down from the ruling class. Instead, individuals were adopting modern fashion by choice, selecting from among the objects and images provided by popular and consumer culture. Department stores, cosmetics companies, entertainment venues, and lifestyle peri-

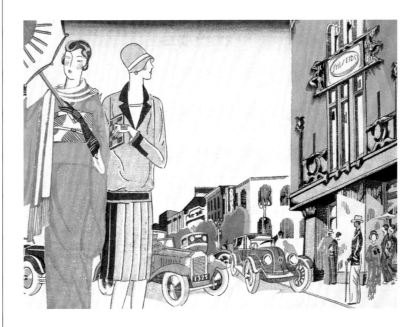

odicals flourished during this era of parliamentary democracy, before Japan moved toward militarism and ultra-nationalism. A number of artists and intellectuals embraced the western notion of individualism, while also warning against blindly following the west.[23]

Junichiro Tanizaki's novel *A Fool's Love* (translated into English as *Naomi*) depicts a "modern girl" (*moga*) of the 1920s, a former café waitress (*jokyu*), who adopted western dress both to assert her individual identity and to charm her boyfriend, Tanizaki's narrator, who is sexually stimulated by seeing Naomi in western dress with fashionably cropped hair. He even began to imagine that her face and body resembled those of Hollywood movie stars.[24] As the taste for western movies, ballroom dancing, and cabaret shows became increasingly widespread, social conservatives denounced a popular culture of "erotic grotesque nonsense."[25]

The great Kanto earthquake of 1923 destroyed much of Tokyo, shattering social optimism. The metropolis that rose from the ashes was even more self-consciously modern than it had been before, and in

the wake of the world depression of 1929, more proletarianized, too. Japanese politics became increasingly nationalistic and militaristic after the Manchurian incident of 1931 (although Korea had already been annexed in 1910). As in Germany and Italy in the 1930s, the Japanese state increasingly emphasized so-called "national attire" (*kokuminfuku*). Western fashion did not disappear. However, men who were not in the military tended to adopt a khaki outfit resembling a military uniform, while women were encouraged to look like "good wives [and] wise mothers" in conservative kimono. Many women wore *monpe* (loose trousers) for work.

After the Second World War, Japan was occupied for six-and-a-half years by American troops. In Tokyo, American military residences congregated in Harajuku. This was the origin of Harajuku's long-standing reputation as a trendsetting neighborhood, since Japanese who lived nearby had greater access to American styles.

Subculture in a modern sense began in the postwar years, when American vernacular styles – from Levis to Brooks Brothers – began to be adopted by young Japanese. Hiroshi Narumi, author of *Street Fashion, 1945–1995*, discusses the history of subcultural styles in Japan in another essay in this book, but a brief survey here will be useful to put later developments in perspective.

By the 1950s, the media in Japan had already articulated the concept of "tribes" (*zoku*) to describe youth subcultures, most of which were associated with supposedly "deviant" lifestyles. The Taiyozoku (Sun Tribe) was the first to be named, in homage to a popular Japanese novel, *Taiyo no Kisetsu* (*Season of the Sun*), published in 1956, which dealt with hedonistic youth that liked to spend its leisure time soaking up the sun at the beach. According to the stereotype in the newspapers, members of the Sun Tribe wore brightly colored Aloha shirts with shorts and sunglasses.

The Kaminarizoku (Thunder Tribe) was the term applied to late 1950s Japanese motorcycle gangs. (The term "thunder" referred to the noise that motorcycles made, especially when the mufflers had

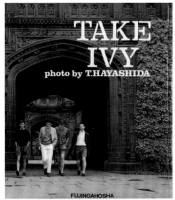

been removed.) Although hardly the Japanese equivalent of Hell's Angels, the Thunder Tribe caused intense social unease. Inspired by James Dean and Marlon Brando movies, young gang members wore blue jeans, black leather motorcycle jackets, and heavy boots, just like their counterparts elsewhere in the world, such as the *blousons noirs* of France. In the 1970s, Japanese bikers would reapppear as the Bosozoku (Speed Tribe) with an entirely different look, but an equally bad reputation.

Meanwhile, "Ivy style" clothing became extremely popular for young men, especially after Kensuke Ishizu – known as the Ralph Lauren of Japan – formed the Van Company. While working as a translator for the American troops, Ishizu became friendly with two lieutenants who had gone to Harvard and Yale. Impressed by their traditional Ivy League style and recognizing that few Japanese could afford imported American brands such as Brooks Brothers, he founded his own company, with slogans such as "Be trad forever!"[26] In 1965, Kensuke Ishizu commissioned photographer Teruyoshi Hayashida to travel to America and document the sartorial scene at Ivy League colleges. The result was *Take Ivy*, a book that has now achieved cult status among connoisseurs of traditional American menswear.

Dress by Christian Dior,
from *Hanatsubaki* magazine, 1955,
courtesy Shiseido Corporate Museum

Cover of *Take Ivy*, 1965,
photo: T. Hayashida,
image courtesy Nathan Liu

Clean-cut college students wearing Madras shirts, windbreakers, and penny loafers, sometimes carrying guitar cases with a Van sticker pasted on the side, became known as the Miyukizoku (Miyuki Tribe), after Miyuki Street in Ginza, then Tokyo's most exclusive shopping district, where they congregated. "Ivy style" seems incredibly benign today, but it was different enough from mainstream menswear that the older Japanese community became concerned, and the Tokyo police began a crackdown in September 1964. Although the Ivy look continued, the Miyukizoku disappeared.[27]

For many years, fashion trends, like street styles, were derivative of those in the west. French designers such as Christian Dior held fashion shows in Tokyo, and films such as *Roman Holiday* and *Sabrina* made Audrey Hepburn a lasting style icon for young women. During the 1950s and early 1960s, young Japanese women wore pencil skirts, New Look-inspired dresses with full skirts over petticoats, and Capri pants, while young men wore blue jeans, rockabilly styles (modeled after the clothes shown on record covers), and Ivy League styles. Indeed, photographs from the period show young Japanese dressed much like American teenagers of the 1950s, and engaged in the same pursuits, such as dance parties.

As soon as Mod fashions became popular in London, they began to appear in Tokyo. Twiggy even went to Tokyo to do a fashion show. The Japanese press predictably denounced the Erekizoku (Electric Guitar Tribe) as "un-Japanese."[28] The appearance of hippies in America in 1967 was quickly followed by the Hippiezoku (Hippie Tribe) in Japan. (When he lived in Japan, my husband once saw a young man wearing a T-shirt that announced: "I am Japanese hippy.") Blue jeans, tie-dyed T-shirts, bell-bottoms, love beads, granny glasses, and, of course, long hair were all part of a remarkably complete look. The Seibu Department Store opened a hippie boutique, called Be-in.

Tokyo tribes were – and still are – often identified by neighborhood, with Roppongi, Ginza, Harajuku, and Shinjuku being trendy during the 1950s and 1960s, followed later by Shibuya and again Harajuku. Occasionally, an indigenous style developed. The Takenokozoku (Bamboo Shoot Tribe) appeared in Tokyo's Harajuku neighborhood

in the late 1970s. They took their name from the Takenoko clothing boutique, which sold cute, brightly colored, loose-fitting clothes vaguely inspired by traditional Japanese dress, and took part in group dancing resembling that performed at traditional religious festivals. Another group of trendy dressers was dubbed the Annonzoku (An-non Tribe), after two young women's fashion magazines, *An-An* and *Non-No*.

As the Japanese economy grew stronger in the 1970s, Japanese consumers were increasingly able to travel to Paris to indulge their voracious taste for prestigious western brands, such as Chanel and Louis Vuitton. At the same time, the indigenous fashion industry developed its own *burando* (brands), often with foreign names, such as Nicole by Hiromitsu Matsuda. The vast majority of these brands were sold only within Japan, but a handful of Japanese designers also began to show their work abroad – especially in Paris. Hanae Mori, who began designing in Tokyo in the 1950s, opened a couture house in Paris in 1977. Her elegant clothes often featured Orientalist motifs such as butterflies and cherry blossoms.[29]

Kansai Yamamoto was yet another Japanese designer to show in Paris, where his decorative exoticism attracted attention. Drawing on both Kabuki and Pop Art, his clothes were decorated with Japanesque im-

ages, such as the figure of a samurai. He visited London and New York, met various trendsetters, such as the model Tina Chow, and designed the costumes that David Bowie wore on his Ziggy Stardust tour.

Kenzo Takada – known as Kenzo – was the first Japanese fashion designer to make a big impact in the west. After studying fashion in Tokyo, he moved to Paris in 1965, where he freelanced for various companies. In 1970, he launched his own collection and opened a boutique, both called Jungle Jap. "I knew it had a pejorative meaning," Kenzo said later. "But I thought if I did something good, I would change the meaning."[30] Kenzo's designs were youthful and fun, usually brightly colored separates, often incorporating ethnic elements, such as a combination of African and Japanese textile patterns. Although Kenzo drew on aspects of Japanese culture, they were not central to his work. An inveterate world traveler and self-proclaimed "exotic," he was just as likely to feature Mexican ponchos or Indian-inspired styles as anything Japanese.

Meanwhile, young Japanese who liked music were increasingly traveling to London, where punk rock flourished and the Sex Pistols' 1977 hit "God Save the Queen" reached number one in the British pop charts, although the record was banned from being aired on the radio. Vivienne Westwood opened her store Seditionaries the same year, providing the visual identity for punk. It was not long before the first wave of Japanese punk music appeared in the early 1980s. By the mid-1980s, if not earlier, Westwood's fashions had begun to exert a powerful – and recurring – influence on both Japanese youth style and Japanese avant-garde fashion.

AVANT-GARDE JAPANESE FASHION

At the beginning of the 1980s, three designers transformed the world of fashion. Rei Kawakubo of Comme des Garçons and Yohji Yamamoto began to show their radically deconstructed clothes in Paris, where they joined Issey Miyake, who was already famous for having created a pioneering east–west synthesis in fashion.

Although Miyake was not the first Japanese fashion designer to attract an international audience, he was the first to create an aesthetic that was simultaneously modern and also deeply rooted in Japanese clothing culture. Born in Hiroshima in 1938, Miyake studied at Tama Art University in Japan and then at the school of the Chambre syndicale de la couture Parisienne. While living in Paris, he experienced the events of May 1968. The following year he lived in New York City, where he worked for Geoffrey Beene and experienced American youth culture. In 1970, he returned to Tokyo, where he founded the Miyake Design Studio and immersed himself in the study of traditional Japanese textile techniques (such as cotton quilting and tie-dye), Japanese clothing construction (which differed radically from western methods of pattern-making), and even samurai armor and Japanese tattoos.

Miyake held his first fashion show in Paris in 1973. He also developed a design concept that came to be known as "A piece of cloth." This focused on two-dimensionality and anticipated his launch of the A-POC line of clothing twenty years later. For the next quarter of a century, people were repeatedly amazed by his radical innovations, which were artistic and philosophical as much as they were fashionable. Miyake was constantly engaged in exploring how to make things, such as clothes made from rectangular pieces of cloth, wrapped and tied, or a bustier made of lacquered and woven bamboo inspired by samurai practice armor. He also explored the relationship between body and clothes. Another bustier, for example, was made of molded plastic in the shape of a naked female torso.

Miyake repeatedly returned to questions about what clothes were for, and what the relationship was between traditional Japanese clothes and modern western fashion. Significantly, he looked beyond the history of kimono to investigate workers' and peasants' clothing, which formed part of his wider interest in *mingei*, traditional Japanese folk art. The first, and still one of his most influential books, *Issey Miyake: East Meets West*, was published in 1978.

When Miyake's woven rattan bustier was featured on the cover of *Artforum International* in February 1982, it was perhaps the first time that

a prestigious art magazine had acknowledged contemporary fashion as art. The same year, Miyake's work was included in an influential exhibition, *Intimate Architecture: Contemporary Clothing at the Massachusetts Institute of Technology*. In the coming years, Miyake's clothing was often displayed in museums and art galleries. His *Bodyworks* exhibition, for example, traveled around the world from 1983 to 1985. By drawing simultaneously on Japan's cultural heritage and a contemporary approach to life, Issey Miyake was creating clothing that was more radically modern – and closer to art – than anything being produced within the western fashion system. But he was not alone.

Rei Kawakubo of Comme des Garçons and Yohji Yamamoto first showed in Paris in spring 1981. They rented a hotel room and presented the clothes on hangers to a very small number of visitors. The next season, they were allowed onto the official fashion calendar, in part because their first show had created ripples of excitement, and in part because French officials thought that the presence of foreign designers would help position Paris vis-à-vis Milan, then a rising fashion capital. Kawakubo and Yamamoto were certainly creating something new with their dark (usually black) clothes in voluminous and sometimes asymmetrical shapes, often with a deliberately impoverished look of tattered edges.

Rei Kawakubo was born in Tokyo in 1942. Her father was an administrator at the prestigious Keio University and her mother trained as an English teacher. When Rei and her two younger brothers entered school, her mother wanted to go back to work. When her father disapproved, Rei's mother left him and found a job in a high school. "She was unlike other mothers," Kawakubo says. "I always felt like an outsider."[31] Yohji Yamamoto was born in 1943. His father died in the Second World War and his widowed mother supported the family by working as a dressmaker.

Kawakubo studied the history of aesthetics at Keio University, a course which encompassed both Asian and western art. When she graduated in 1964, she left home, "without telling my parents where I was going or what I was doing."[32] She moved into a shared apartment in the vaguely bohemian Harajuku neighborhood of Tokyo. After

working in advertising and as a freelance stylist, she began designing her own clothes, although she never had any formal training in fashion design. After graduating from Keio University with a degree in Law, an accomplishment that testified as much to his mother's determination as to his own intelligence, Yamamoto attended Bunka College of Fashion, and earned a scholarship to study in Paris.

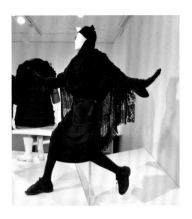

Kawakubo established her Comme des Garçons label in 1969, and began selling her clothes commercially in 1973. The phrase "Comme des Garçons," which translates as "like some boys," came from a song she liked, says Kawakubo. Although she denies that the name meant anything, such as the aspiration to live or dress like the boys, it is the name of her company, and CDG clothes have been widely interpreted as being in some way feminist. Yamamoto opened his own ready-to-wear company in 1972 in Tokyo. In 1975, Kawakubo started showing her women's collection in Tokyo, and in 1978 she designed her first men's collection. In the late 1970s, Rei Kawakubo began a relationship with Yohji Yamamoto. The two designers were a couple throughout the 1980s and stayed together until the early 1990s.

When Yamamoto convinced Kawakubo to come to Paris with him in 1981 and show their collections, they launched a fashion revolution. "These two designers push to the limits the deconstruction of clothing . . . and the simplicity of forms," wrote Claire Mises of *Libération*.[33] But many western journalists were confused and hostile. *Le Figaro*[34] described avant-garde Japanese fashion as "World War III survivors' looks" and "rags." Yamamoto's and Kawakubo's deliberate refusal to make "sexy" clothes and their insistence on female independence proved surprisingly controversial. When Yamamoto announced that his designs were "for the woman who stands alone," one American journalist quipped: "Who would want to be seen with her? Yamamoto's clothes would be most appropriate for someone perched on a broom."[35]

"The dread and hopelessness that pervade so many of the recent clothes by Japanese designers, notably Rei Kawakubo, are nowhere to be found in Saint Laurent's collections," declared another American journalist. "Japanese fashion in its more extreme forms prefigures

a world that no-one is looking forward to. The woman who wears Comme des Garçons . . . is . . . unwilling to dress herself up so that other people have something pleasing to look at, and overburdened by the news she reads every day in the paper."[36]

The ubiquity of black in the new Japanese fashion was frequently interpreted in terms of depression and destruction. In the west, of course, black has traditionally been the color of death and mourning. Yet many western designers from Cristóbal Balenciaga and Christian Dior to Thierry Mugler have favored black, because of its erotic and elegant connotations. Yamamoto and Kawakubo, however, eschewed all the traditional signs of elegance and eroticism. No Little Black Dresses for them! In place of "sexy" black, Kawakubo and Yamamoto used black for its abstract, androgynous power.

"Down the catwalk, marching to a rhythmic beat like a race of warrior women came models wearing ink-black coat dresses, cut big, square, away from the body with no line, form, or recognizable silhouette," observed Suzy Menkes of Kawakubo's Autumn 1983 collection, which she described as "feminist."[37] Kawakubo tended to brush off questions about black, saying only that she liked the color, but Yamamoto sometimes interpreted his use of black in terms of Japanese aesthetics. "The samurai spirit is black," declared Yamamoto. "The samurai must be able to throw his body into nothingness, the color and image of which is black." He also identified his use of very dark indigo in terms of the traditional clothing of Japanese peasants.[38]

Miyake, Yamamoto, and Kawakubo were all featured in American *Vogue* in April 1983 in a six-page spread photographed by Irving Penn. "The Next Dimension," subtitled "The New Wave of Fashion from Japan," praised the designers' "free-wheeling way of wrapping and fitting the body," as well as their "larger scale" and "free-spirited layering." "The most dramatic look – and the most provocative!" was an oversized T-shirt dress by CDG with "distinctive, stylized 'cut-outs'."[39] Predictably, this last dress was criticized in the Letters column of the June issue: "Are you kidding? Do you know anybody who would want to look like this besides a bag lady?"

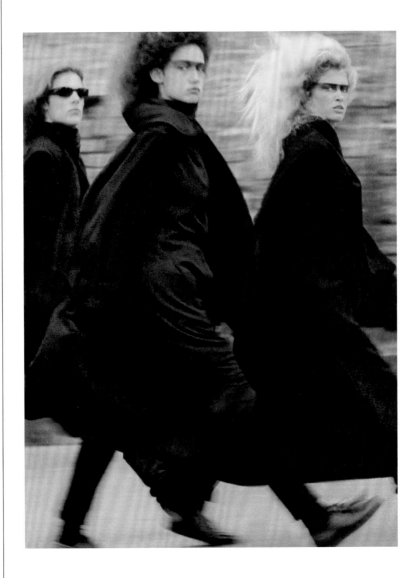

Vogue highlighted Japanese style again in the July 1983 issue in an article that explicitly contrasted "the polished style" of European designers (photographed by Helmut Newton) with "the freer spirit" and "more experimental" style of the Japanese (photographed by Hans Feuer). In one picture, for example, models with free-flowing hair and stylized make-up marched across the page wearing flat, mannish shoes and oversized black and indigo clothes by Yohji Yamamoto.[40] Avant-garde Japanese clothes were already being sold at fashion-forward stores like Charivari, Linda Dresner, Alan Bilzarian, and Henri Bendel.

Garments by Yohji Yamamoto,
Fall 1983–84,
photo: Hans Feurer,
courtesy Hans Feurer,
originally published in *Vogue*

Meanwhile, in Japan, followers of Kawakubo and Yamamoto were known as Karasuzoku (the Crow Tribe), because they dressed all in black. Although this is a mildly pejorative label, their sartorial sobriety was not without precedent in Japan, where novelist Junichiro Tanizaki had composed his famous essay "In Praise of Shadows." Darkness, poverty, and asymmetry were all respected within traditional Japanese aesthetics. Black is worn by Japanese Buddhist monks, as well as in the Bunraku theater where men in black "invisibly" manipulate puppets. Nevertheless, followers of avant-garde Japanese fashion represented only a small minority of the Japanese population, who resembled an austere fashion cult.

As early as 1983 in Osaka and Kobe there developed a very different – indeed, diametrically opposed – look, known as Bodi-con (body conscious) style, which featured tight, short clothes. It could be argued that neither the Crow Tribe nor the Bodi-con look was a true subcultural style so much as a style tribe or niche within the mainstream fashion world. Certainly, western and Japanese fashion magazines regularly featured both avant-garde, oversized, black fashions, and sexy, body-conscious clothes by European designers such as Azzedine Alaia. The late 1980s and early 1990s also saw the ascendance of the Shibukaji (Shibuya Casuals), young people associated with the trendy Shibuya neighborhood of Tokyo, who wore casual, but usually quite expensive, American-style clothes. For Shibuya girls, the styles were often sexy and trend-setting.

The 1980s were later known in Japan as the "Bubble Years." The economy was booming, everyone was making money, and a famous Harvard professor announced that Japan was "Number One." Certainly, Japan's new prominence contributed to the international interest in Japanese fashion, as well as Japanese food and Japanese electronics. Although Kawakubo, and to a lesser extent, Yamamoto and Miyake, rejected the label "Japanese designers," this was how they were perceived, both in the west and in Japan itself. Japanese fashion was always a "niche" market, although the designers acquired many fans, often amongst people in the arts. Comme des Garçons stores ushered in a radical new retail environment, and Kawakubo launched

an influential art magazine, *Six*. "The widespread popularity of the 'Japanese fashion' in the 1980s was a decisive factor in placing Tokyo on the list of international fashion capitals," observes Lisa Skov.[41]

Then in the early 1990s, the bubble burst, the stock market crashed, property values collapsed, and a long recession set in. As China's economy surged, Japan languished, trapped in a closed domestic system, characterized by the cozy relationships between government bureaucrats and business organizations. "This paralysis affects culture as well as business," warned resident foreigner Alex Kerr in the 1990s, and he cited fashion as an example. A decade earlier, leading fashion designers in Tokyo, including Issey Miyake and Rei Kawakubo, had founded the Council of Fashion Designers, "but the rigid organization of the domestic fashion world undermined them. The CFD was not open to foreigners, nor to new faces in Japan, and certainly not to up-and-coming Asian designers. It was too comfortable and predictable, so international fashion editors lost interest . . . And it was back to Paris."[42]

Meanwhile, back in Paris, the leading Japanese designers seemed, at least temporarily, to have lost their edge, merely continuing trends already explored in the 1980s. There were, however, a few innovations, especially in relation to textile technology. After several years of research and development, Issey Miyake launched his Pleats Please line in 1993. Of course, pleats were nothing new in fashion, but Miyake's mode of production and the resulting garments were completely new. Instead of cutting and sewing clothes from material that had already been pleated, he reversed the process, creating garments that were then placed in a special press from which they emerged with permanent pleats. Made of a light-weight, ultra-flexible polyester, the garments were designed to be comfortable, functional, and affordable. "I spent many years working on collections in Paris," recalled Miyake, "and my feeling was that, in addition to the clothes reserved for an elite, there should be another clothing style aimed at a wider female audience." Produced in a rainbow of colors, the Pleats Please garments could be worn on almost any occasion and by women of many ages and body types.[43]

Looking for something "special" that would add to the Pleats Please line, Miyake started a guest artist series in 1996. The first artist with whom he collaborated was Yasumasa Morimura, who was known for his gender-bending photographic impersonations. Miyake chose the artist for his interest in the body and presented him a basic format, asking him "how the plasticity of the body could be expressed through his work." Morimura created a striking series of dresses that drew on Ingres' painting of a female nude.[44] In subsequent years, Miyake collaborated with photographer Nobuyoshi Araki, as well as the artists Tim Hawkinson and Cai Guo-Qiang.

Next Miyake unveiled his new A-POC range, developed with colleague Dai Fujiwara. An acronym for "A Piece of Cloth," A-POC is a design-

LEFT:
Pleats Please Issey Miyake,
"Travel Through China,"
Spring/Summer 1998, photo: Yuriko Takagi,
courtesy Issey Miyake Inc.

RIGHT:
Issey Miyake,
Paris Collection Spring/Summer 1999,
A-POC LE FEU (created 1998),
photo: Yasuaki Yoshinaga,
courtesy Issey Miyake Inc.

and-production system that is driven by computer technology. The A-POC King and Queen lines use digital technology to create finished garments without needle-and-thread construction: yarn is fed into a computerized "loom" programmed with structural patterns, producing lengths of flat tubular knit garments. After purchasing a length of A-POC, the customer cuts along the perforated lines that faintly outline each garment. The resulting dress, shirt, or other form-fitting garment, functions as a seamless second skin. (A-POC continues to evolve, and serves as a central driving force for the Issey Miyake Collection. Today it includes wovens, as well as knits, some of which do use sewing, but the focus is still on design solutions and new visions about how clothing can be made.)

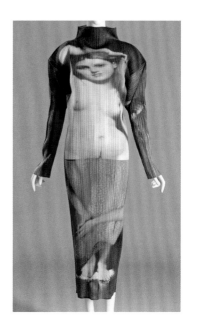

Miyake's approach to fashion had always been closely allied to art. He viewed clothes as tools for living, emphasizing comfort and freedom over sexiness or trendiness. Texture and volume were central to his aesthetic, and he collaborated closely with textile designers such as Makiko Minagawa. Although he still oversees the collections created by his designers, Miyake increasingly focuses on art projects, and especially on running the museum 21_21 Design Sight.

Meanwhile, many Japanese consumers remained obsessed with western luxury brands. Today Louis Vuitton sells more in Japan than in any other nation, and revenue from Japan amounts to one third of the company's total global sales. An astonishing 94% of all Tokyo women in their 20s own something by Louis Vuitton, but customers also include many older women, from housewives to office workers. This Vuitton fixation is justified by customers on the grounds of quality. However, the Japanese psychologist Masao Miyamoto, author of *Straitjacket Society*, has argued that the Japanese use brands "like fetishes" – comparable to a child's security blanket – because status symbols assuage a sense of inferiority. Other observers believe that the Japanese obsession with brands has to do with the desire to symbolize membership in a group.[45] Certainly, in Japan even non-conformity is visually expressed through membership in particular style tribes.

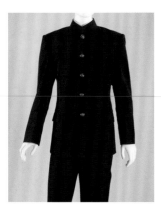

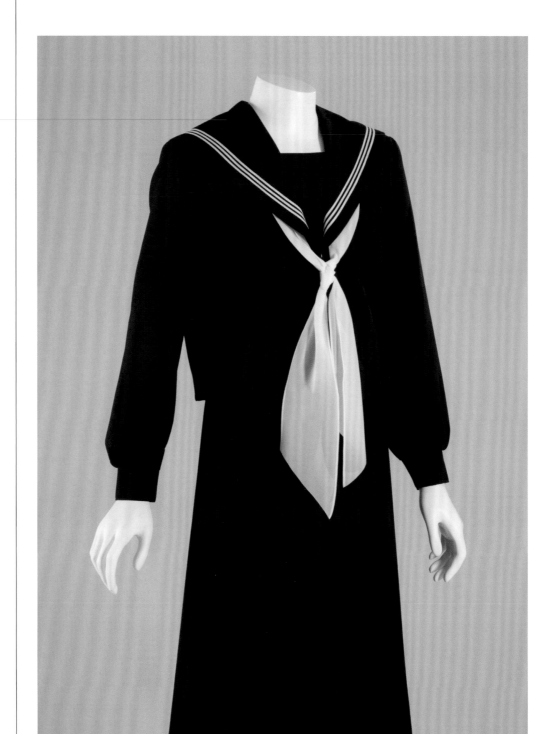

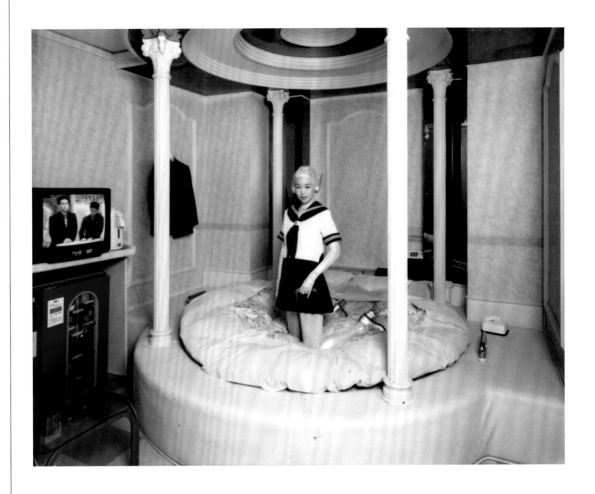

REBELLION IS CUTE

In 1981, the same year that Rei Kawakubo and Yohji Yamamoto first showed in Paris, Japanese teen idol Hiroko Yakushimaru appeared in the film *Se-ra-Fuku to Kikanju* (*Sailor Suit and Machine Gun*), in which she plays a high-school girl who blows away the members of another gang while wearing her sailor uniform. The Japanese school uniform is a fashion icon with a long and controversial history. For many years, Japanese schoolgirls wore a sailor-style school uniform, which derived from the late nineteenth-century European fashion for putting young girls in dresses with sailor collars. The famous *Sailor Moon* manga and anime have popularized this look in the west, but for Japanese the uniform is not just cute, it is also a symbol of rebellion and sexuality.

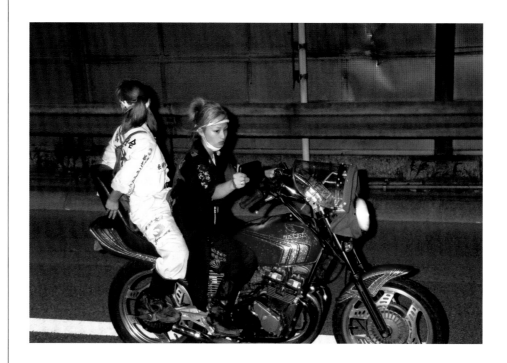

Japan's first all-girl gangs, the *sukeban* (*suke* = female, *ban* = boss), appeared in the 1970s. Certain elements of "classic Sukeban style," such as long skirts and Afro-style hair, have disappeared, but one important component of the style remains and has made "a major contribution to the universally accepted image of the Japanese bad girl." Members of the various Sukeban gangs, such as Tokyo's United Shoplifters Group and the Kanto Women Delinquent Alliance, always wore their school uniforms.[47] High-school boys in Japan have also traditionally worn a military-style uniform in black wool with a high collar and brass buttons, and this, too, has been associated with gang activities. The look was spoofed in Satoru Tsuda's 1981 photographs of cute kittens wearing a combination of school uniforms and biker insignia, emblazoned with the tough-guy slogan *Namennayo!* ("I'm not going to take any of that crap!").[48]

Motorcycle gangs (collectively referred to in the 1950s as the Thunder Tribe) became the subject of an intense moral panic in the late 1970s and early 1980s, when groups of up to 1,000 motorcycles and cars would roar through Japanese cities. Renamed the Bosozoku (Speed Tribe), Japanese bikers abandoned the classic combination of black

leather jacket and jeans in favor of elegant and bizarre costumes that they called kamikaze suits (*tokkofuku*) and combat gear (*sentofuku*). Despite the name, these are not the uniforms of kamikaze pilots. Rather, the style combines elements from working-class clothing, such as construction workers' jackets and overalls (often dyed red, purple, or pink), together with elements of gangster (*yakuza*) subculture, modified school uniforms, and American punk, surfer, and rock-and-roll gear.[49]

Like the punks in England who sported swastika arm bands and t-shirts, Bosozoku deliberately courted outrage by wearing arm bands and headbands decorated with nationalist and right-wing symbols, such as the Rising Sun (the Japanese war flag) and the chrysanthemum (an imperial symbol). Yet as Ikuya Sato, author of *Kamikaze Biker*, points out, few Bosozoku have any interest in politics at all; they are not right wing and they don't worship the Emperor. Their "outrageous paraphernalia" is intended primarily to enhance their tough image. Gang names – such as Black Emperor or Devil Wheels – tend to emphasize power, as well as evil, the grotesque, and mobility. The name of the gang is embroidered on the back of jackets,

often using complicated Chinese characters with multiple meanings, much as American fraternity boys use Greek letters to create a sense of mystery and exclusivity.[50] Related to the Bosozoku are other ways of life and sartorial styles popularly associated with juvenile delinquents, such as Yankee (*yankii*) style. The etymology of the term is uncertain, but it may derive from the widespread perception in Japan of American vulgarity and gaudiness, and Tsuppari (flamboyant defiance) style.[51]

In her essay "What's Behind the Fetishism of Japanese School Uniforms?" Sharon Kinsella points out that school uniforms, which are historically derived from Imperial Army and Navy uniforms, are as central to Japanese clothing culture as blue jeans have been to America. Their significance has changed radically over the years, however, and today they represent "a key symbol, and anti-symbol, of the political system and the education system." Because traditional school uniforms have played such a significant role in rebellious and erotic fantasies, over the past fifteen years most schools in Japan have changed to a blazer and skirt design, as though a new design would be immune from unauthorized reinterpretations. But, at least in the case of schoolgirl uniforms, the new style has proved equally susceptible to a transformation of meaning.

The Kogal style emerged in the early 1990s, when schoolgirls started wearing their school uniforms (pleated skirts and blazers) with very short skirts and loose knee socks. The etymology of the word is unclear – some say that *ko* comes from *kodomo* (child) and *gal* comes from the English word; others suggest *kokosei gyaru* (high-school girls). But the Kogal look is basically a young gal's style. The Japanese media, always salacious about young women's style tribes, reported that some Kogals wore mini-skirts so short that their underwear showed, a practice called *misepan*, "showing pantsu [underpants]." These were apparently a special kind of underwear, like the bottom of a bathing suit, worn over regular underpants.[52] Other features of Kogal style include (or included, since the style has waned) towering platform shoes, childish accessories, like stuffed animals, and sexy ones, like visible bra straps.

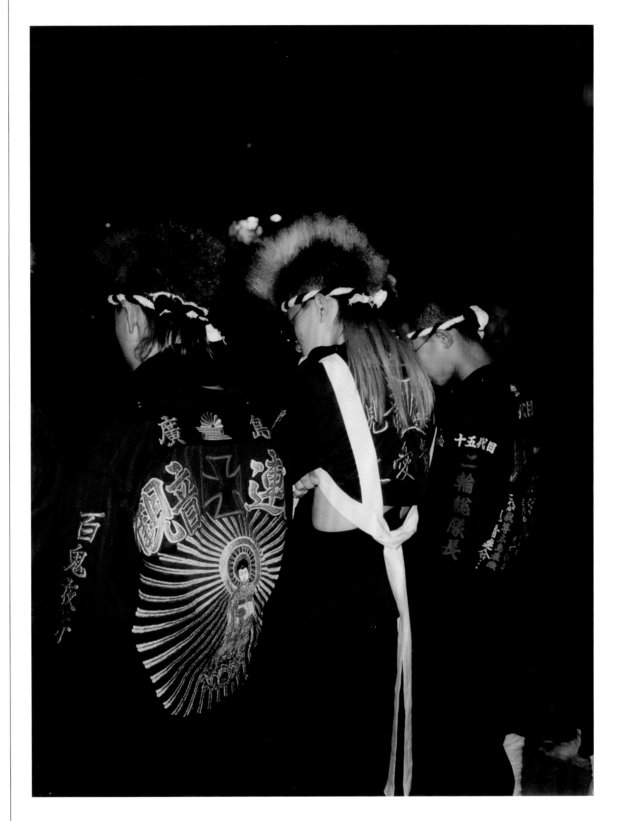

Followers of Kogal and subsequent, related styles tend to refer to themselves as *gyaru* ("girl" or "gal"). They are associated with the Shibuya district, the heart of trendy, teen Tokyo. The Parco Department Store opened in Shibuya in 1978 and remains important, but the primary shopping destination today is the 109 Building, nicknamed Marukyu ("0–9"). Paris Hilton and Victoria Beckham have both shopped here, and their look is extremely influential. Gyaru are often said to favor expensive foreign accessories, such as Burberry scarves and Louis Vuitton handbags. Journalists have alleged that some Gyaru engage in "paid dates" with older men who provide the money for such prestige items.[53]

The Ganguro ("black faces"), sometimes derisively known as *yamamba* ("witches" or "mountain hags"), were an extreme version of Gyaru or Kogal styles. The Ganguro used tanning machines and make-up to make their skin as dark as possible. They also bleached their hair, and applied pale makeup on their lips and around their eyes for a weird panda-like effect. Fashion elements included enormously high platform boots, very short skirts, neon bright colors, and gold jewelry. It was said that the Ganguro admired hip-hop culture so much that they wanted to become black. Certainly, their aesthetic was very different from conventional Japanese beauty practices, which focus on whitening the skin. Less common today than in the 1990s, the Ganguro now tend to be known as Mamba. (For more on this style, see Hiroshi Narumi's essay "Japanese Street Style: Its History and Identity," pp. 229–52, below).

Hip-hop style has long been very popular among young Japanese men and provides the foundation for street-style companies like A Bathing Ape and Billionaire Boys Club. Baggy trousers and camouflage prints are now a truly universal men's style. The late 1990s also saw a female version of the hip-hop look, known as B-Girl style. In Japan, this involved artificially tanning the skin, something that was also characteristic of Japan's Surfer Girl style. Like youth cultures internationally, those in Japan often adopt elements of retro and "ethnic" styles, drawing, for example, on elements of Chinese, Indian, and Southeast-Asian dress and beauty traditions.

Hip Hop Shibuya girl in furry blue,
March 2009,
photo courtesy Ulfert Janssen,
gannetdesign.com

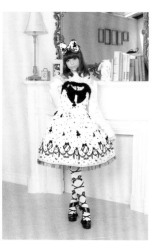

The most famous of all the contemporary Japanese tribes are the Lolitas or Lolis, who were first identified in Tokyo in the 1990s in the Harajuku neighborhood, and have now evolved into a number of different sub-genres including the Classic (or Traditional) Lolita, the Sweet Lolita, and the Gothic Lolita. The term "Lolita" (Rorita) presumably derives from Nabokov's infamous novel and usually references the sexual fetishization of young girls by older men, known in Japan as *rorikon*, an abbreviation of *rorita conpurekksu* ("Lolita complex"). Yet the Japanese Lolita subculture has significantly redefined its meaning, as well as adopting at least two non-standard ways of writing the word to distinguish it from the sexualized term.[54] Japanese Lolis are young women (and some young men) in their teens and twenties; they are not young girls, although they dress in a self-consciously girlish and fancifully archaic style.[55]

The classic Lolita look features a frilly, *Alice in Wonderland* style of dress, often pink or pale blue in color, with a full skirt over petticoats, partly covered by a white apron, and with accessories such as Mary Jane shoes, a parasol, and doll-like purse. A stuffed animal or doll may also be carried. The look as a whole is often said to resemble a nineteenth-century French doll or *jumeau*. Although popularly associated with Harajuku, many observers believe that the Lolita style originated in Osaka, which has a lively subcultural fashion scene of its own. The designer Hitomi Okawa, who founded the Harajuku boutique Milk in 1970, was probably a precursor of the Lolita style, as was the designer Isao Kaneko of *An-An* with his "romantic Victorian-meets-*Little-House-on-the-Prairie*-style outfits that were lovely, pink, and ruffled."[55]

The Sweet Lolita or Ama Rorita (abbreviated as Amarori) also wears pastel dresses inspired by Victorian or Rococo styles, liberally decorated with bows and ruffles. Accessories, such as heart-shaped purses and frilly caps, are romantic and feminine. Baby, The Stars Shine Bright, founded in 1988 by Akinori Isobe, is a fashion brand closely associated with Lolitas and Sweet Lolitas. "I love the frills, the lace, the ribbons. They look like doll clothes," says a salesgirl. "It's so cute . . . It's about being completely absorbed in your own world."[56] Other popular Lolita brands include Angelic Pretty, Alice and the Pirates, Juliette and Justine, and Victorian Maiden.

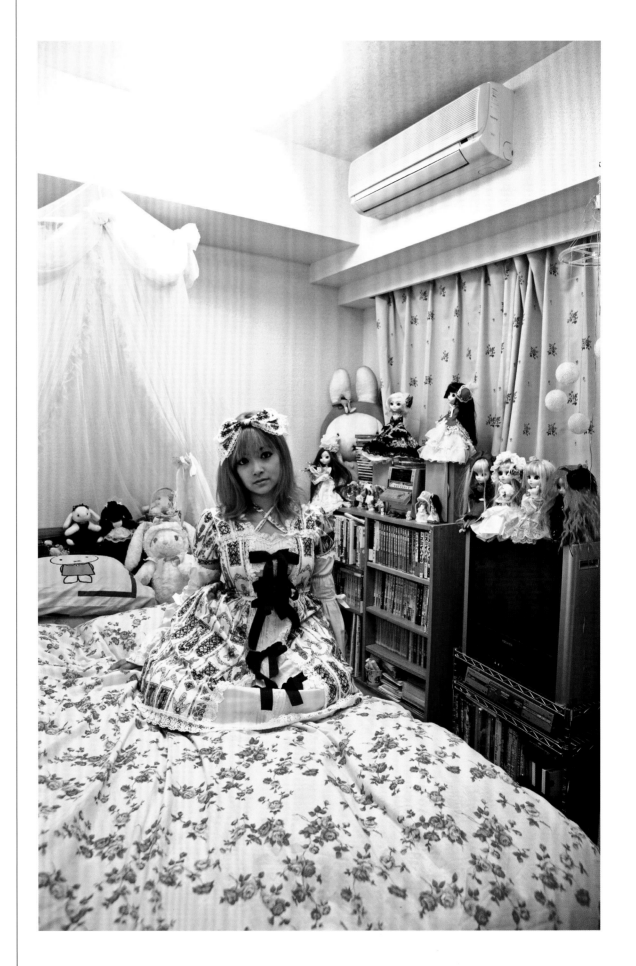

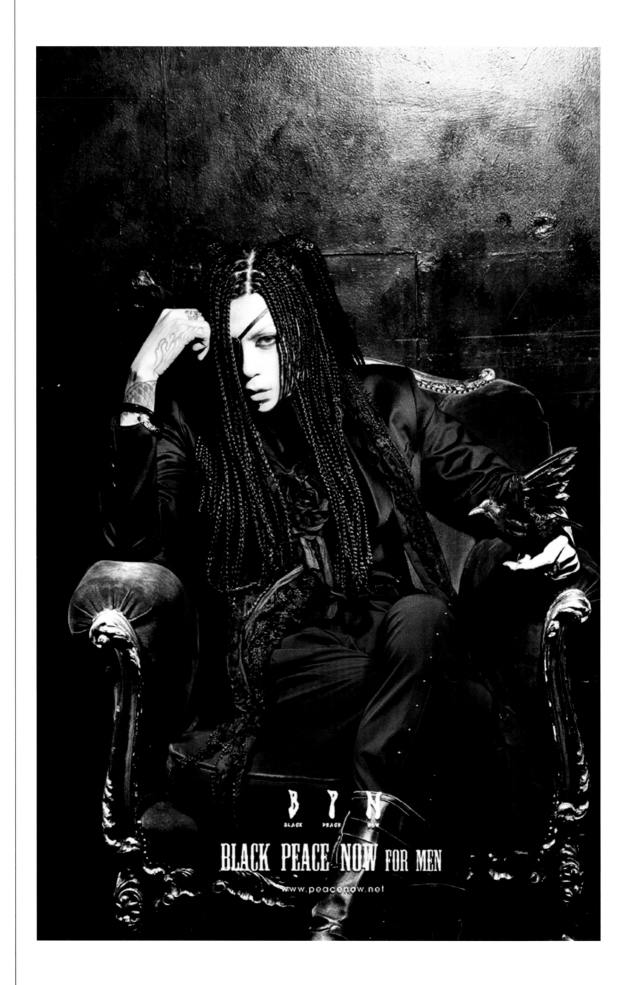

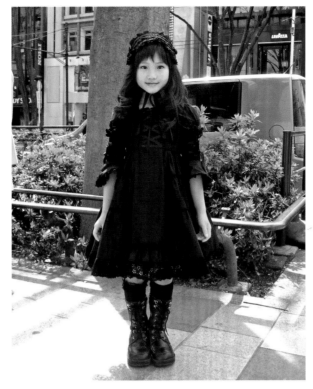

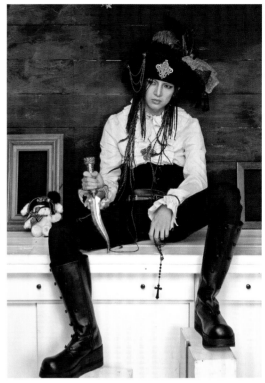

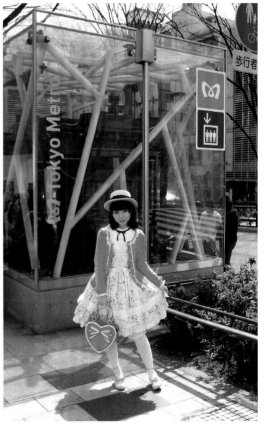

CLOCKWISE FROM TOP LEFT:

A little Lolita posing for a magazine
competition, 2010; Tokyo, Japan,
photo courtesy the author

Alice and the Pirates,
photo courtesy Alice and the Pirates

A Lolita posing for a magazine competition,
2010, Tokyo, Japan,
photo courtesy the author

A doll in the offices of Baby, The Stars Shine
Bright, 2010, Tokyo, Japan,
photo courtesy the author

Inside the offices of Baby, The Stars Shine
Bright, 2010, Tokyo, Japan,
photo courtesy the author

Baby, The Stars Shine Bright was featured in the 2004 movie *Kamikaze Girls* (*Shimotsuma Monogatori*), which depicts an unlikely friendship between a tough biker girl and an ultra-feminine Lolita. It was also among the first Lolita brands to collaborate with doll and toy manufacturers. "Lolita girls are nostalgic for childhood," explains Kumiko Uehara. "They don't want to be adult." Hence the attachment to dolls. It is also "exclusively a culture for girls – boys are not allowed." Her colleague, Akinore Isobe is a rare man in the world of Lolita fashion. Although he began as a designer, he says that today "Our designers are all female." There are currently eight designers at Baby, and another two at spin-off brand Alice and the Pirates, which was created "for tomboyish girls." At that time, there was a trend in Japan for young people going to clubs dressed as pirates in the style of Vivienne Westwood and Adam and the Ants. As Kumiko Uehara puts it, "If Alice in Wonderland jumped into the age of pirates, she couldn't just be innocent and cute. She'd have to fight, too!"[57]

"The image of Angelic Pretty is to look like a princess in a fairy tale," explained Hiroko Honda, who founded her company after years of running a boutique. "I liked cute stuff and I got more ambitious and wanted to make my own brand." Today the company has two young designers, Asüka and Maki, who not only create designs featuring cupcakes and toys, but also represent the brand.[58]

By the late 1990s, there was also a darker variant, known as Gothic Lolita, or Goth-Loli. Unlike the Classic and Sweet Lolitas who favor saccharine pastels, the Gothic Lolita dresses primarily in black, referencing Victorian mourning dress. Accessories, such as a coffin purse, have a morbid flavor. The Gothic Lolita style seems to have originated in Osaka and has always been closely associated with the musical genre visual-kei, whose bands wear elaborate costumes, which are copied by fans. Kazuko Ogawa, a designer from Osaka, created clothes for Mana, guitarist for the seminal visual-kei band Malice Mizer, before Mana established his own fashion brand, Moi-même-Moitié, in 1999. Mana told anthropologist Philomena Keet, "I added a dark element to the cuteness of Lolita."[59]

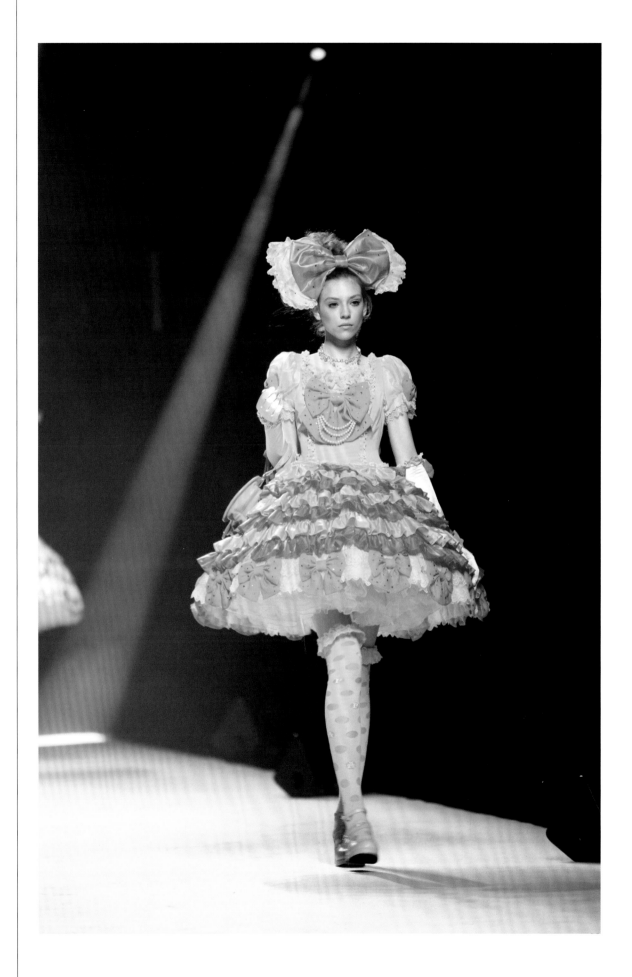

Dress by Angelic Pretty featured at the
Japan Expo, July 2009, Paris,
photo courtesy Angelic Pretty

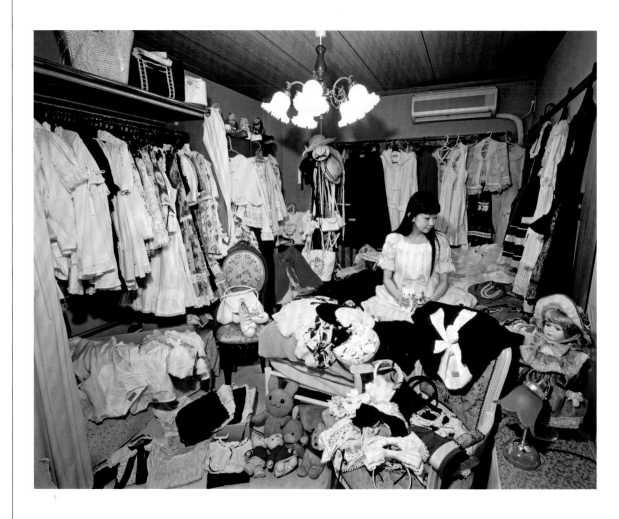

BABY, THE STARS SHINE BRIGHT

As trends go people tend to lump "Gothic" and "Lolita" together as "GothLoli". Poor trendies, such a cold reception. Yet recently, Baby, the Stars Shine Bright made something of breakthrough in the *Shimozuma Sotry* in which the musician Pudding appears as a dedicated fashion victim. Active in music for ten years now, this one-time teen idol wannabe decided "It wasn't the thing for me" and left her production agency. Now deep into the indies scene, she keeps busy working four or five days a week at Baby in Aoyama. Pudding lives in this two-bedroom apartment with her hamster Poco, portraits of herself, a Beardsley poster, dolls, roses and angel knickknacks, all the necessities of the consummate Lolita lifestyle (the Kraftwerk records and song com- posing gear are nice musician touches, too). In her queen- size bedchamber, along with the many dolls she just can't part with, this impossibly huge yet tidily arranged inventory of Baby clothes. Lolita styles are frilly, which means lots of troublesome upkeep. Plenty of mending and button stitching, so her vexed sewing box bulged, while days off are days off are given to ironing. That and "the dry cleaning bills are horrendous." We can imagine. So she scrapes and saves by cooking her own meals, sometimes foregoing lunch, just to pay the cleaners (sniff). And why does she like Baby so much? "The use of lace is tasteful, and the pieces are well-made. Orthodox, yet more honestly priced than Lolita brands." She's been a Baby-phile for six years now. She's worked at the boutique for three years, but hasn't tired of her 24/7 Baby immersion (nightwear included, naturally). Maybe once a month she wears "normal" clothes, but confesses "I really don't know what to buy or how to wear it." Dolling up in Lolita fashions all the time isn't so difficult, you just have to take care to wear black for rainy days and housecleaning. As Pudding tells it, "Lolita-ism isn't cosplay (costume play)"; Sunday-outing Lolitas are an inferior breed.

Text and photography by Kyoichi Tsuzuki. Reprinted from book *Happy Victims* (2008) by Kyoichi Tsuzuki.

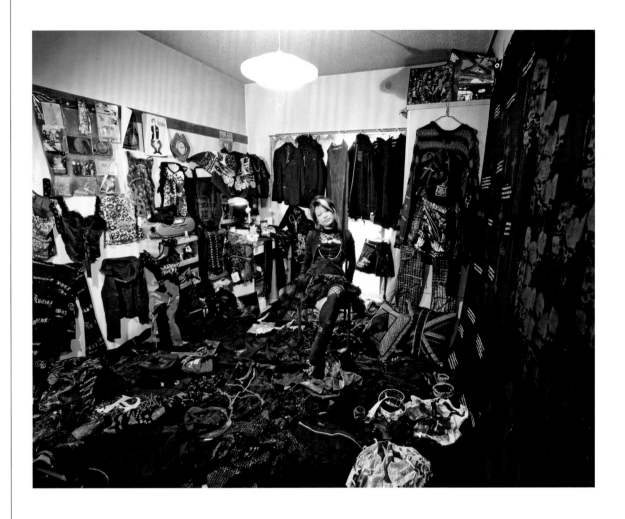

h.NAOTO

Deep in an industrial landscape of steel over canals and high-rise office buildings dotted with residential projects, the Tokyo Bay waterfront is a jumble of new and old. Just across a bridge in a weathered old public housing block, her home since birth, she lives with her parents and sister. Open the cat-clawed sliding door, here's her own private room, her little universe where she surrounds herself with her beloved h.NAOTO clothes and Hide posters and "Mari- man" CDs (that's Marilyn Manson to you). She first encountered h.NAOTO just before graduating high school. Sure, she'd often worn black before, but from her very first impression – "Unbelievable, the exact designs I'd been looking for!" – she began frequenting the shop right away. Then, after entering vocational school, an inspired thought told her, "Well, I was going into fashion anyway..." so she dropped out and decided to go to work for h.NAOTO. Now three years later, she's gainfully employed at H, a "black shop" in the backstreets of Harajuku, where she enjoys meeting people of all different backgrounds and ages who yet share the same sensibility. From what was a one-line brand when she first discovered it, h.NAOTO" has the added attraction of always evolving," now branching out into decorator items such as picture frames, curtains and cushions, with many other new lines in the works, "It's like we're growing up together", is her considered observation. And just for your information, besides Hide and "Mariman," the shelf under the stereo player features a consistent taste in CDs: Pierrot, Sex Pistols, Shiina Ringo, Linkin Park. But now always having to man the shop on weekends, her concert-going forays are limited to mid-week daytrips.

Text and photography by Kyoichi Tsuzuki. Reprinted from book *Happy Victims* (2008) by Kyoichi Tsuzuki.

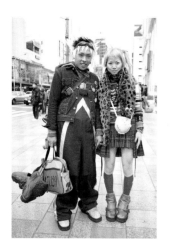

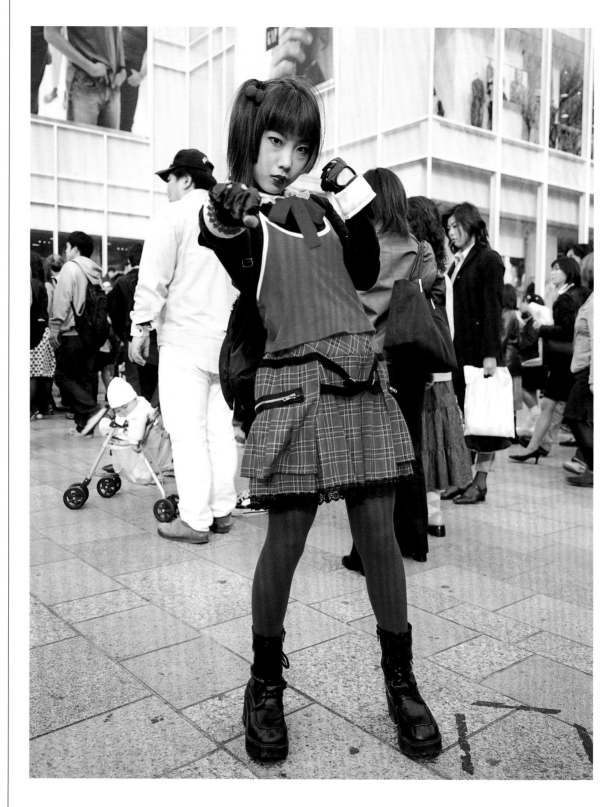

Variants of the Gothic Lolita include the Elegant Gothic Lolita and the Elegant Gothic Aristocrat. Well-known Gothic Lolita brands include Black Peace Now, Atelier Pierrot, and h.NAOTO, especially h.BLOOD and h.ANARCHY. Alice Auaa is an outstanding Gothic Lolita brand designed by Yasutaka Funakoshi. In 1993, Funakoshi opened a shop in Kobe called Alice in Modern Time, featuring punk, new wave, and gothic styles. By 1997, he had established a new shop and a brand, both called Alice Auaa.

The street-fashion magazine *FRUiTS* covered the Gothic and Lolita looks – and other youth styles – as did other periodicals such as *CUTiE* and *KERA*. In 2000, *KERA* published a special issue called *The Gothic & Lolita Bible*, which was soon a regularly issued periodical and is now widely available in the west. In addition to Classic, Sweet, and Gothic Lolitas, there are Black, Pink, White, Country, Punk, and Erotic Lolitas, as well as male versions such as Prince. Erotic Lolitas wear primarily red and black, often leather and/or vinyl, and usually corsets. Wa-Lolis wear a combination of kimono tops and Lolita skirts, while Qi-Lolis wear Chinese-style tops. The development of these fashions was paralleled by the spread of manga-influenced art works often featuring girls wearing similar styles.

"The Lolita subculture occupies a complex place within both Japanese culture and international popular culture," observes Theresa Winge, a professor of fashion and one of a growing number of commentators. To be a Lolita is not merely a question of clothing, but of an identity that is achieved through a "ritualized performance" involving poses and mannerisms that reinforce the aesthetic conveyed by a specific style of dress. When groups of Lolitas gather, for example, near the La Foret department store in Harajuku, it is evident that their shared aesthetic "visually communicates membership" in the Lolita subculture.[61]

Cuteness extends far beyond the classic Lolita look to embrace a host of related styles, from the Himekei ("Princess style") popular among pretty-in-pink, ultra-feminine Shibuya girls with lots of sparkly, cute and frilly accessories to the Decorakei ("Decoration style") popular in Harajuku, which is cute overload – with pink everywhere, with

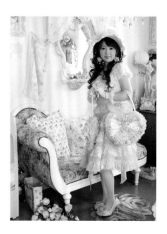

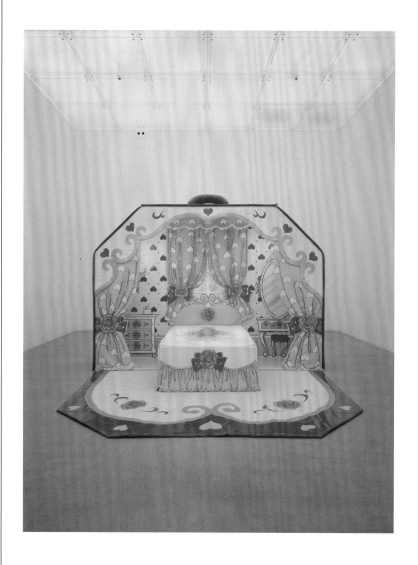

LEFT:
Naomi Yamamoto, aka Hina,
in Hime-Deko (Princess Decoration) style,
hat, bag, earrings, ring, and shoes
by Hearty & Hearty; cardigan sweater
by RF; gloves by Jesus Diamante; umbrella
by Baby, the Stars Shine Bright,
no label on dress, photo: Takashi Osaki

RIGHT:
Minako Nishiyama,
The PINKU House, 1991,
acrylic on plastic cloth,
urethane mat, iron, etc.
310 x 400 x 370 cm,
collection: 21st Century Museum of
Contemporary Art, Kanazawa,
photo: Mareo Suemasa,
courtesy 21st Century Museum of
Contemporary Art, Kanazawa

a plethora of cute accessories, such as multiple barrettes, tiaras, and bows decorating curled and dyed the hair. But what is the significance of all these cute styles? Why do so many young Japanese girls want to look hyper-cute? Sometimes dismissed as mindless "bad-girl" consumers, the members of Japan's style tribes may also, at least sometimes, express "an independent girls' culture."[62] Certainly, girls' tribes are a conspicuous feature of the Japanese streetscape and their influence is spreading in a kind of "pink globalization."

Kawaii (cute) culture is pervasive in contemporary Japan. The most famous icon of cute is probably Sanrio's flagship character, Hello

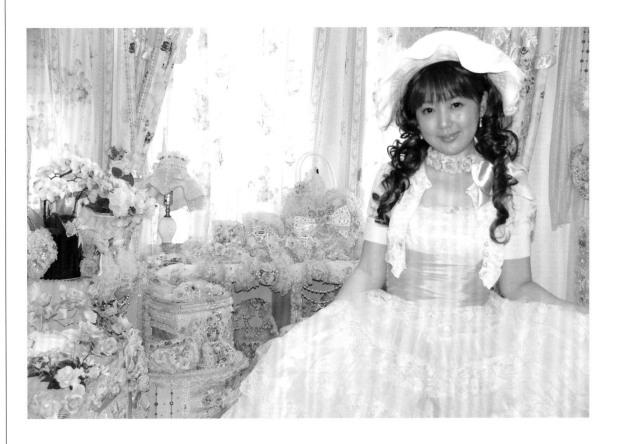

Kitty, which has been incredibly popular in Japan since its invention in 1974. Of course, this type of cute character appeals to children around the world, just as little girls everywhere seem to love cute, pink, sparkly clothes. But many Japanese remain fixated on cuteness. "In Japan, even self-respecting adults will consider a Hello Kitty wedding," and other cute characters, such as Hello Kitty's evil rabbit friend, Kuromi, decorate everything from airplanes to condoms and cell phones.[63] Cuteness is just as much a part of the Gothic Lolita aesthetic, whose reigning mascots are h.NAOTO's characters HANGRY and ANGRY, stuffed animals, who have scars, eye patches, and blood stains, but remain as cute as can be.

Some observers have labeled the Japanese obsession with cuteness as "infantilization," and have argued that it is related to the trauma associated with Japan's defeat in the Second World War. Others argue that the fetish for cuteness is related to changing gender codes and the rise of modern girls' culture. Scholars such as Sharon Kinsella

Naomi Yamamoto, aka Hina, in Hime-Deko style, dress by Betsey Johnson; cardigan sweater by Jesus Diamante; hat and choker by Hearty & Hearty, photo: Takashi Osaki

point out that the cute craze began in the early 1970s when Japanese schoolgirls invented stylized, rounded characters, known as "kitten writing" or "fake-child writing." The rise of cute handwriting was accompanied by the spread of infantile slang words, as when "sex" was referred to as *nyan nyan suru* ("to meow meow"). Kinsella emphasizes that "Cute culture started as youth culture amongst teenagers, especially young women. Cute culture was not founded by business. But in the disillusioned calm . . . after the last of the student riots in 1971, the consumer boom was just beginning, and it did not take companies . . . very long to discover and capitalize on cute style."[64]

Companies like Sanrio, then the Japanese equivalent of Hallmark Cards, began producing a variety of fancy goods, which were often decorated with cartoon characters. This led to other cute products and soon cute clothes, which tended to be white or pastel in color, with puffy sleeves and ribbons. Accessories included white tights and frilly white ankle socks, as well as the notorious loose white knee socks worn by schoolgirls. "Cuteness! Go for the young theme!" advised the fashion magazine *An-An* in May, 1975. "On dates we only want feeling, but our clothes are like old ladies! It is the time you have to express who you really are."[65] Cuteness was thus presented as the antithesis of conventional adult female fashion ("our clothes are like old ladies"). In the 1980s, one of the most popular fashion companies in Tokyo was Pink House, Ltd.

The magazine *CUTiE* was launched in 1986. Subtitled "For Independent Girls," it was among the first popular magazines to use the word *kawaii* in its modern sense of "cute, pretty, feminine," suggesting that to be cute was to be daring, even rebellious, not (just) pathetic or vulnerable.[66] Like the British street-style magazine *i-D*, *CUTiE* published many photographs of young people wearing their own clothes on the street or in clubs.

It is often said that the 1990s was the decade of Japan's "lost generation." But Japanese fashion did not disappear when the economic bubble burst. Despite the dismal economic environment (which had dragged on for a second decade, into the twenty-first century), new forms of creativity emerged. In fashion terms, the most important

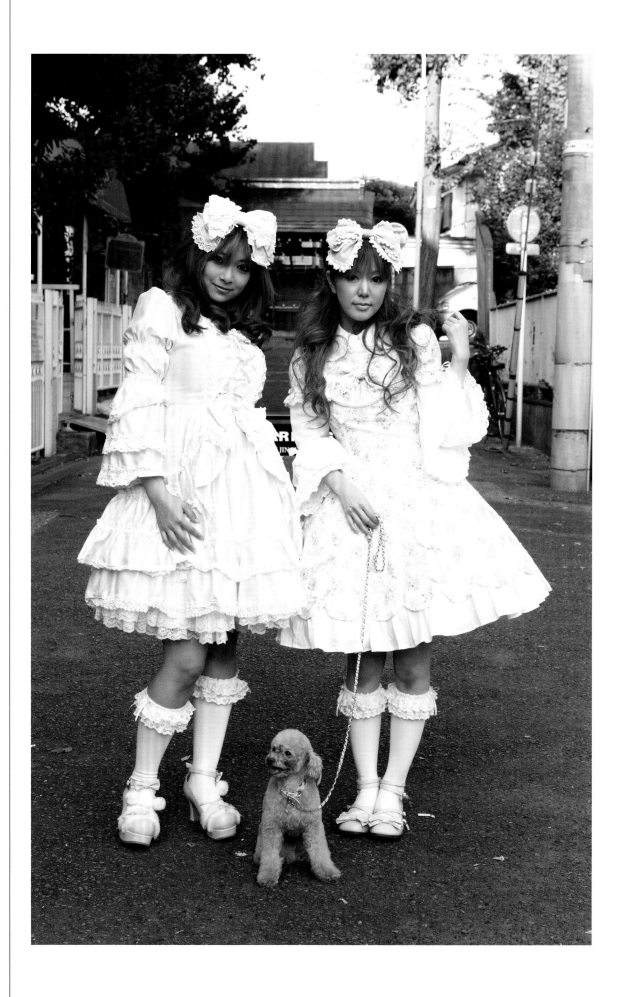

Lolita fashions, *Goth-Loli #3466,* 2006,
photo: Masayuki Yoshinaga

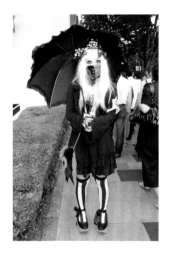

phenomenon was the growth and proliferation of subcultural and street styles.

After interviewing many young people in Japan in 1992, Sharon Kinsella concluded that cute style was associated with the desire to retain a sense of childlike innocence and emotional warmth, while avoiding adult responsibilities. "Cute fashion was, therefore, a kind of rebellion or refusal to cooperate with established social values and realities." Admittedly, it was a "demure" rebellion, unlike the "aggressive and sexually provocative rebellion . . . typical of western youth cultures. Rather than acting sexually provocative to emphasize their maturity and independence," members of the predominantly female cute culture in Japan "acted pre-sexual and vulnerable in order to emphasize their immaturity and inability to carry out social responsibilities."[67] The appeal of prolonging childhood is compelling, especially since Japanese society as a whole has a highly romanticized image of childhood.

Yet the attraction of cuteness also derives from the way it can veer toward the edgy and erotic. Pink, for example, is not only the ultimate cute, little-girl color, it is also in Japan the color associated with pornography. What we call "blue movies" are known as "pink movies" in Japan. In biological terms, pink is associated with sweetness (certain fruits), flowers (the sex organs of plants), and the genitals, lips, and tongues of primates. Girlish cuteness may be pre-sexual in some respects, but it can easily veer into the sexualized, even if this remains largely unacknowledged by the Lolis themselves. However it is interpreted, there is no question that today "Japanese Cute" is grabbing headlines around the world, especially in East Asia.

In many ways, Japan's "cult of cuteness" is the flip-side of its emphasis on uniforms and uniformity. In his important book *Wearing Ideology: State, Schooling and Self-Presentation in Japan*, Brian J. McVeigh argues that "Japan is a uniformed society," and that uniforms are "tangible symbols of the ability of the enormous and extensive politico-economic structures to shape bodily practices, and by implication, subjectivity and behavior."[68] Against the dominant, male, productive, official ideology of uniformity, "the powerful

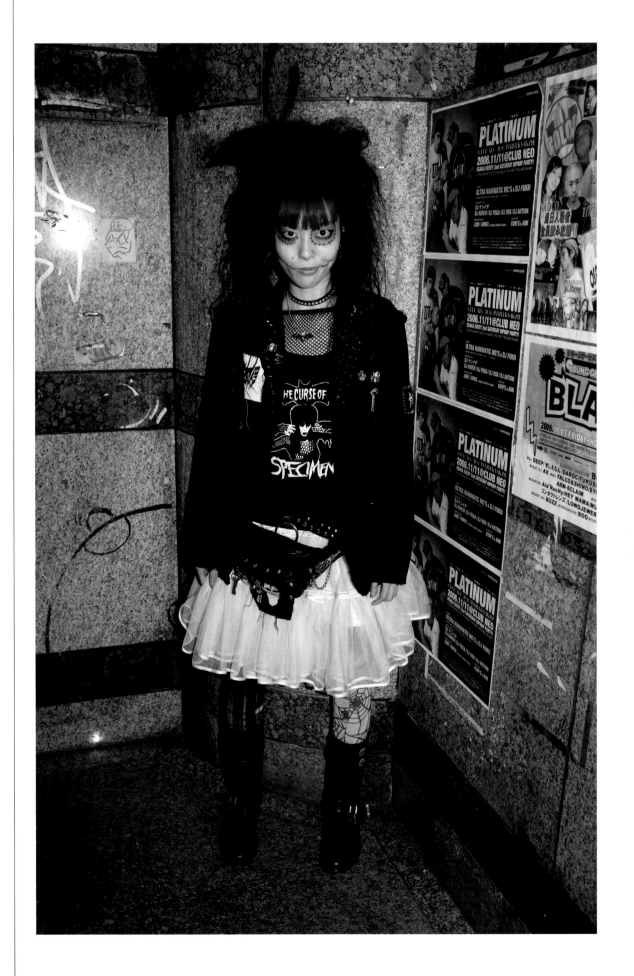

Gothic Lolita, *Goth-Loli #4371*, 2006,
photo: Masayuki Yoshinaga

bureaucratizing forces of statism and corporate culture," cuteness represents a form of "resistance" associated with women and children, leisure, and self-expression.[69] Of course, as he points out, cuteness is often co-opted by the forces of authority and functions as an integral part of power relations; at most, it only temporarily positions the subject outside the capitalist order, and even that is dubious since being cute costs money.[70]

And yet cuteness can be rebellious. McVeigh identifies three ways in which style can "display sentiments of resistance." These sentiments are appropriation, subversion, and conversion. That is, one can appropriate or "adopt clothes, objects or a style of presentation that is foreign to what is usually expected by the community." Alternatively, one can "alter, damage or remove" clothing. Or one can "change the meaning of the garment or ensemble." This is the most subtle and perhaps the most effective form of resistance. As McVeigh observes, "If a student dons a uniform yet does not alter it in any way but nevertheless reinterprets its meaning, there is very little a school can do."[71] For example, rather than changing into their Harajuku outfits when they arrive at the station, many girls "just show up in their school uniforms, because as everyone knows, no street fashion comes close to the power and aura of a schoolgirl uniform."[72]

There is another clothing category that is also significant within Japanese popular culture. Cosplay (short for "costume play") is not a subcultural or street style, nor is it type of fashion. Instead, it might be described as a kind of role play involving dressing up as characters, often those from popular manga (comic books), anime (animated films), or videogames. Cosplayers not infrequently come from the ranks of *otaku* (literally "in-the-house people," often translated as "geeks"), who are obsessive fans of manga and related media. Cosplayers have been compared to "Trekkies," fans of the science fiction series *Star Trek*, and they face some of the same disapprobation. Nevertheless, their numbers seem to be growing, not only in Japan, but elsewhere in Asia and in the west, as well. The Japanese magazine *Cosmode* recently published an English-language book, *Cosmode USA: The Glamour Issue*, which documents popular char-

Cosplayers posing at meeting spot
just outside Tokyo, 2003,
photo: Martha Camarillo/Orchard

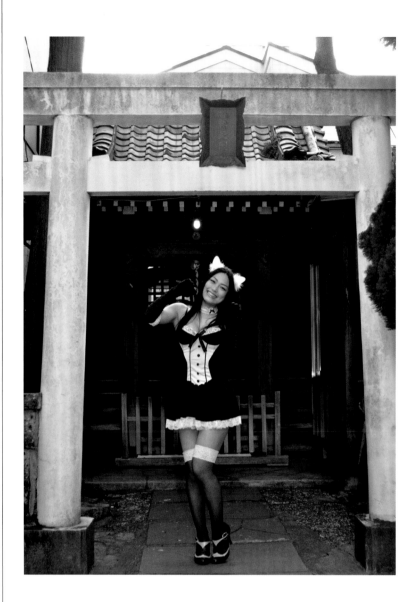

acters and their appropriate costumes and wigs. Costumes can be purchased fairly inexpensively on the internet, but many cosplayers make their own.

Tokyo's Akihabara neighborhood is a center of cosplay activity, with many cafés where the waitresses dress as anime characters. Maid costumes are especially popular, and the maid café is a recognized genre. The Cat Maid (with little cat ears) is an especially fetching variant. There are a number of "Lolified" costumes, including French Maid,

Nurse, and Princess. Members of the Lolita subculture are sometimes mistaken for cosplayers, to the formers' dismay. "What are you, an alien?" asked one clueless parent. "Having an ignorant mother who doesn't want to acknowledge Lolita and calls it 'cosplay' is really tiring," complained one teenaged Japanese blogger in 2006.[73]

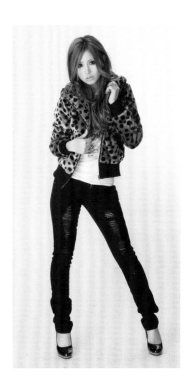

For some time now, neophiliacs have been complaining that Lolitas are passé, and there is a constant search for "new tribes." The "Antique Doll" or "Dolly Style" has recently received attention. Even the *New York Times* reported on the "Cult of the Living Doll in Tokyo." But this was hardly cutting-edge news in 2010, since many Lolitas have long sought to look like antique Victorian dolls. There is also a sub-genre of girls who dress up as broken dolls. There is a Japanese clothing brand called Dolly, and even a website called Broken Dolly: A Gothic and Lolita Fashion Site. Yet the *New York Times* focused on two other styles, "Mori, or forest, girls, and the 'Ageha' or swallowtail butterfly girls," suggesting that the first wanted to resemble handmade dolls from the Black Forest, while the latter tried "to look as much as possible like the blow-up figurines men buy online."[74] The reality is more complicated.

Styles in Japan change constantly, and the Japanese media are more than a little obsessed with identifying style tribes, their genealogies and affiliations. Onesankei ("Older Sister style"), for example, has been described as a more conservative look for young women who have graduated from teenybopper Shibuya style. Such nuances may not be apparent to outsiders, however. The new brand Madame-Killer is simply described by owner Shinichi Kashihara as a typical "Tokyo Gyaru style," alluding to the style "born on the streets of Shibuya," "based on western street styles," and influenced by "hip-hop culture, surf culture, and celebrity fashion" – all "rearranged" by the girls of Tokyo.[75] Just as there is Gal style, so also is there Guy style, whose proponents have big hair, distressed jeans and an American casual look. They match up with Shibuya gals.

The style also references the immensely successful Tokyo Girls Collection (TGC), a giant fashion show held twice a year. First launched in 2005, the show sells out within a few hours, and is attended by

Contemporary Tokyo Girl style by Madame Killer, Autumn/Winter 2009–10, courtesy Nichi Kashihara/ Madame-Killer Inc

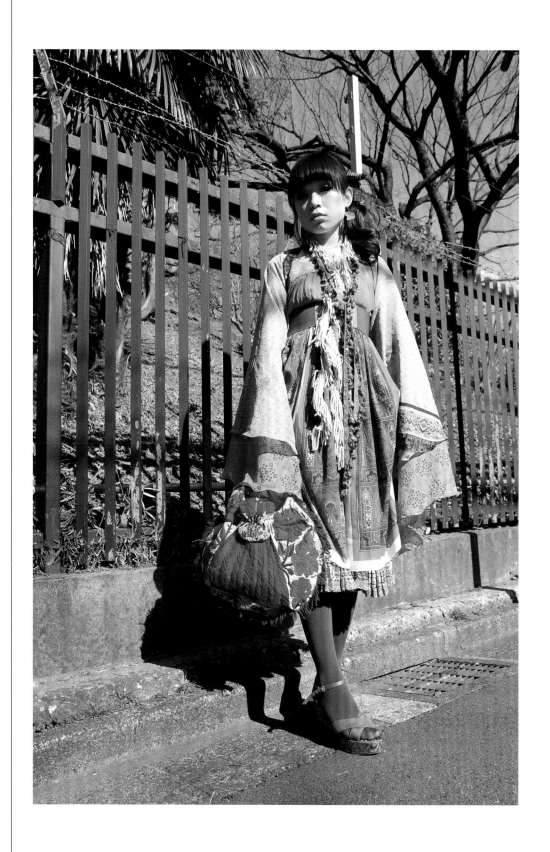

Mori Girl style,
February 20, 2010,
photo: Kazuma Iwano,
courtesy of Drop Snap

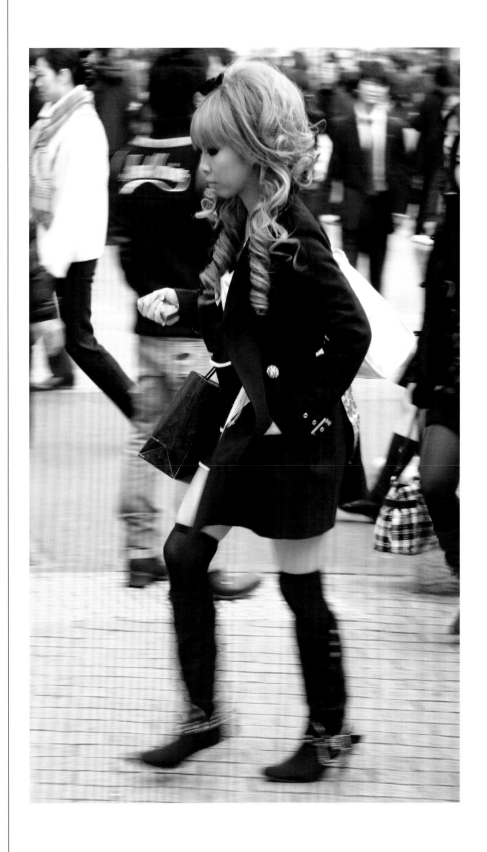

Ageha girl on the go in Shibuya,
January 2010,
photo courtesy Ulfert Janssen,
gannetdesign.com

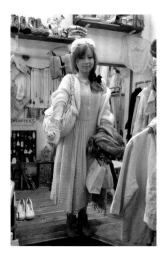

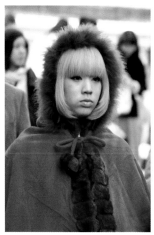

more than 20,000 young women, who shop in a radically new way: they point their cell phones at selected fashions as they come down the runway, and order particular styles without going through the filters normally set up by editors and store buyers. The Tokyo Girls Collection features a wide range of trendy brands including best-selling Japanese brand Cecil McBee, as well as a growing number of foreign fast-fashion brands, such as Topshop.

New styles are also frequently associated with particular media. For example, there is the fashion magazine *Koakuma Ageha* (*koakuma* means "little devil"), and the subtitle of the magazine is "Seduction and Desire Book for Beautiful Gals Who Want to become Cuter." The Ageha look emphasizes curly hair, big eyes with lots of make-up, decorated cellphones, and a style that is sexy and cute. The sexy side of the spectrum evokes the somewhat louche style of hostesses who work at clubs for men. It is also similar to the so-called Celebrity Style that imitates figures such as Paris Hilton. The salesgirl at Jesus Diamante even had imitation diamonds glued to her fake eyelashes. The male equivalent of the Hostess look is Host style, which features sharp suits, sometimes with a rock or military feel, such as the use of zoot-suit-type long jackets.

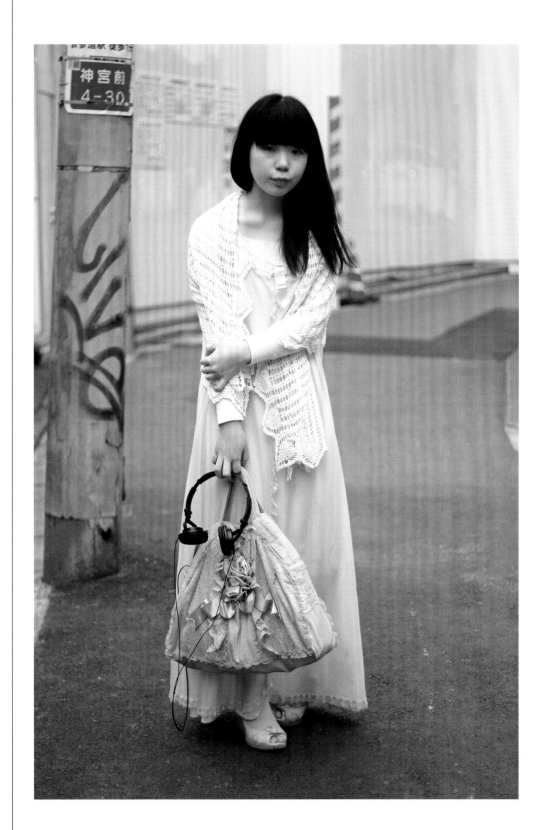

NAME: Haruka
CITY: Tokyo
LOCATION: Harajuku
OCCUPATION: Student
AGE: 18
DATE: April 27, 2010
STYLE: Mori Girl

Dress - calt party - JPY 7,000
Stole - N/A - (friend's)
Bag - N/A - JPY 2,000
Sandals - N/A - JPY 1,000

Photo: Emi Kusano,
JapaneseStreets.com

Then there are social networking sites like Mixi (where the term "Mori girl" first appeared in 2006). Forest girls favor loose-fitting layered clothes, leggings, flat shoes, and cloth tote bags. It is a folkloric look (think Little Red Riding Hood) that evokes a love of nature and fantasy. One of the first Mori girls was Hitomi Nomura, manager of the little shop Grimoire, which is filled with Eastern-European blouses, aprons, and marionettes, along with 1970s hippy dresses, shawls, scarves, crocheted caps, floral hair pieces, clogs, embroidered ribbons, and lace collars picked up on her travels with the store owner, Naoki Tobe. In Conocoto, another vintage store much frequented by Mori girls, an art student dressed in a symphony of white (cotton gauze dress, vintage hat with veil, sweater, shawl) explained that the look evoked Alice in Wonderland via Camden Market.[76]

Several magazines are now devoted to the look, featuring articles that explain "How to make a Mori girl." Coordinate your patterned tights and your low-heeled boots, practice tying your scarves, and make floral hair ornaments. For a boyish take on the style, add jeans and a knapsack.[77] The Mori Girl look is relatively easy to assemble, a number of brands, such as Furfur, cater to Mori girls, and the style is spreading – to the annoyance, it seems, of some Lolitas, one of whom tartly asked me: "What exactly *is* a Mori girl ?"

Misako Aoki is Japan's official Ambassador of Cute, and part of her job is "spreading Lolita style around the world." I asked her about the significance of cuteness in Japan and its relation to Lolita fashion. "In other countries, there are words like 'very cute'," she explained, "but they don't mean exactly the same thing as *kawaii*. 'Very cute' is a term to describe little girls and puppies, but 'kawaii' is a broader term. It doesn't just refer to small things. It can be used for Lolita fashion or even for an old man. If a little old man has a cute smile, he'd be kawaii. Foreign people now often use the word *kawaii* which is probably a sign that the idea is spreading."

"Lolita embodies the feeling of *kawaii*," she continued. "Like any trend, Lolita style keeps evolving. Pink has the power to make girls

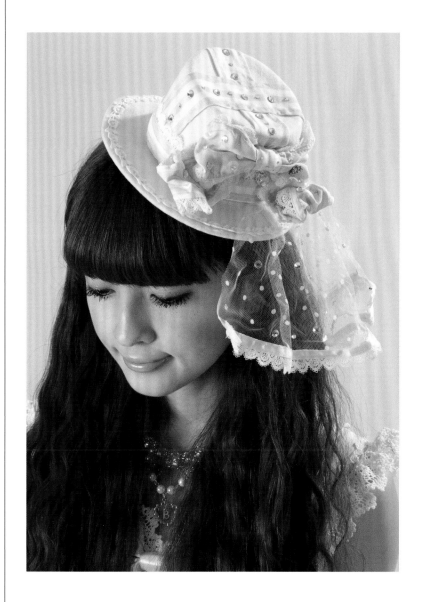

look very cute, so that's probably why it's so popular. But recently, a sweets motif has become very popular. On my skirt, for example, there are images of cookies and candy. Animal prints like rabbits and bears are also rising in popularity. Even when I grow older, I want to retain the playful, girlish youthfulness that comes with Lolita style. Girls prefer being called cute [*kawaii*] rather than pretty or beautiful, because 'pretty' seems superficial, even a little cold, whereas *kawaii* is not just about your outer appearance, it's also about your heart."[78]

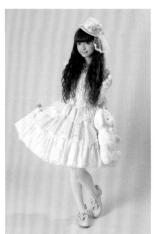

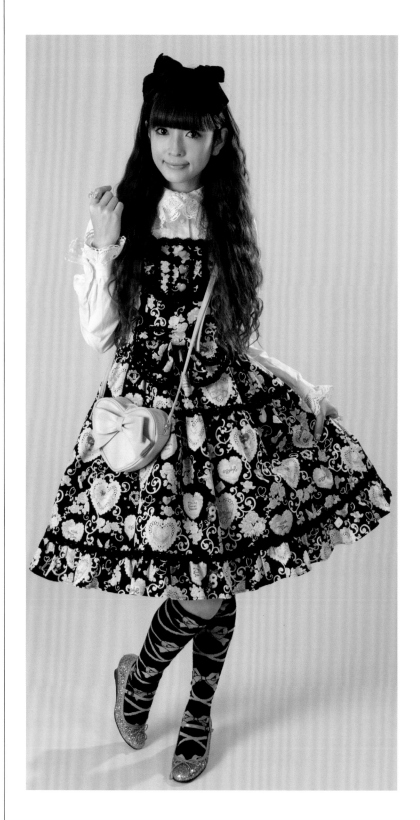

Misako Aoki,
Japan's official "Ambassador of Cute"
wearing Baby, The Stars Shine Bright, 2010,
photo copyright The Museum at FIT

Tokyo Girls Collection, 2009,
photo courtesy Branding, Inc

三月兎

帽子屋

眠り鼠

亜梨子

As Japanese pop culture has swept the world, young people everywhere read manga, watch anime, and play videogames. Contemporary artists have also been inspired by what Takashi Murakami calls "Japan's Exploding Subculture." Today this new visual aesthetic has become internationally recognized. Some scholars even argue that just as *japonisme* led to a visual revolution in nineteenth-century Europe and America, so also has the "New Pop" or "J Pop" placed Japanese artists in the position of reorienting the way everyone sees the world – as if on a computer or television screen, flat, colorful, formally simple, even cartoonish, often cute, although sometimes also erotic and grotesque, and absolutely artificial.[79]

Japanese fashion is also benefiting from the rise of Japanese popular culture. In an article in *Foreign Policy* entitled "Japan's Gross National Cool," Douglas McGray argued that "Japan is reinventing superpower – again. Instead of collapsing beneath its . . . political and economic misfortunes, Japan's global cultural influence has quietly grown. From pop music to consumer electronics, architecture to fashion, and animation to cuisine, Japan looks more like a cultural superpower today than it did in the 1980s, when it was an economic one."[80]

Anime, art, and fashion have come together in a number of collaborations. In 2004, for example, Naoki Takizawa, then designing for Issey Miyake, collaborated with the young Japanese artist Aya Takano, whose work is an expression of Japanese popular culture. Her painting *Moon* was used as the basis for a textile design, which was then made up into a dress. The Miyake boutique in Tokyo has also featured work by the artist known as Mr. and – even before Takashi Murakami's hugely successful collaboration with Louis Vuitton – the Japanese art superstar had collaborated with Miyake.

Japanese *Vogue* has also explored the relationship between fashion and manga, most exhaustively in a fashion special, "Manga X Mode." The feature "Manga Takes the Catwalks" was divided into four categories: My Manga Sweetheart, Power Play, Sexy Planet, and School-

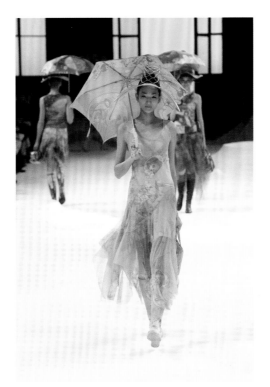

girl Chic. Each was identified with a particular style of dress and a different manga character or story. My Manga Sweetheart depicted a variety of romantic, hyper-feminine garments and accessories, mostly by European brands such as Chanel and Lanvin. These fashions were then juxtaposed with an image from the popular 1970s *shojo* (girls') manga, *The Rose of Versailles* about a girl raised as a boy who becomes general of the imperial guards, and a friend of Marie Antoinette and other court ladies. According to *Vogue*, the slightly rococo fashions depicted appeal to women who have a "princess complex."[81]

"Costume Play!" dressed minor celebrities as characters, ranging from Takashi Murakami's busty Miss Ko2 to Disney's Minnie Mouse. One of the most interesting characters is Moyoco Anno's Kiyoha, a young Edo-period courtesan from the manga Sakuran (2001–2003). Other articles in the same issue of Japanese *Vogue* juxtaposed runway photographs of European fashions with manga images.[82] For obvious reasons, *Vogue* focused on female manga characters, whether cute and sweet, or sexy and futuristic, or tough and militaristic. But for every

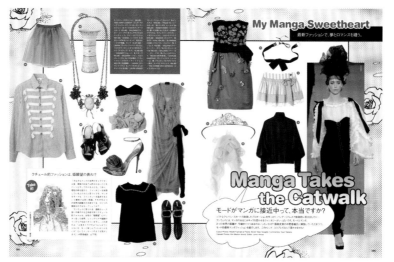

CLOCKWISE FROM TOP LEFT:

Spreads from VOGUE NIPPON,
VOGUE NIPPON, July issue 2009,
Courtesy VOGUE NIPPON

Marie Antoinette (left) and Oscar (right)
from *The Rose of Versailles*,
© Ikeda Riyoko Production

Illustrated by STUDIO4/ Hideki Futamura,
VOGUE NIPPON, May issue 2007,
Courtesy VOGUE NIPPON

Illustrated by Peach-Pit,
VOGUE NIPPON, May issue 2007,
Courtesy VOGUE NIPPON

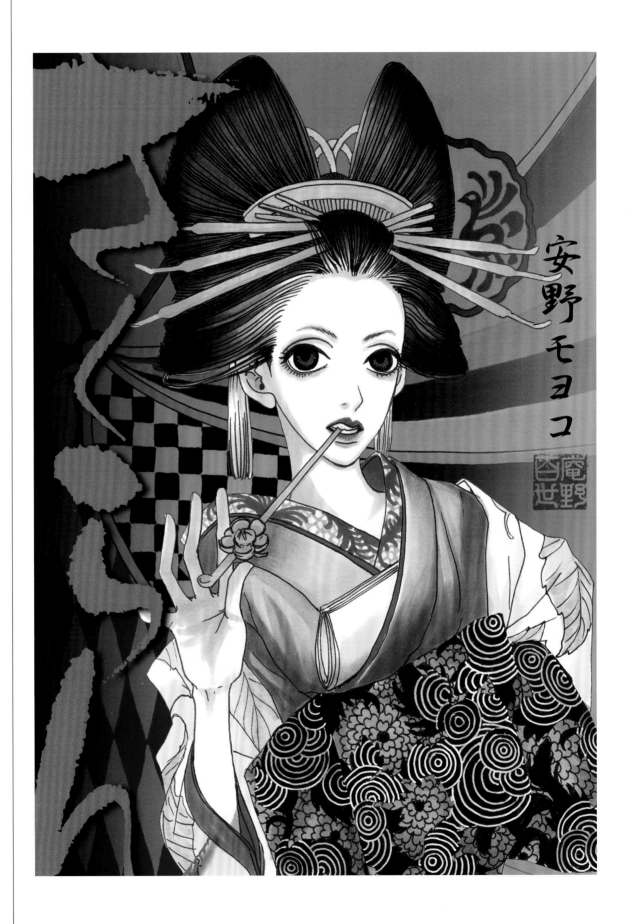

安野モヨコ

Moyoco Anno, *Sakuran*, 2003,
copyright Moyoco Anno/Kodansha

Tank Girl, there is also an Astro Boy or a biker like those in the anime *Akira*, whose style may have implications for fashion. Especially intriguing is the figure of the doll, exemplified by the character Chi, a *persocom* – a personal computer in human form.

Takashi Murakami's rise to celebrity status was reinforced when he collaborated with Louis Vuitton to design a new version of the com-

pany's famous Monogram canvas. The original symbols were themselves indebted to late nineteenth-century *japonisme*. In 2003, the first Murakami bag for Louis Vuitton, the "Monogram Multi-Color," was produced, utilizing thirty-three colors. This was followed by the "Cherry Blossom" bag and the "Eye Love Monogram" series, printed in sixty-two colors with ninety-three silk screens. All of Murakami's bags for Louis Vuitton shared a pop and *kawaii* sensibility.[83] More recently, Comme des Garçons and Japanese *Vogue* have also collaborated with Murakami on a store concept called Magazine Alive (and Comme des Garçons also collaborated with Louis Vuitton). Yet the influence of manga and anime on fashion goes far beyond such collaborations, striking as they may be.

Perhaps ultimately more significant is the indirect influence of Japan's Exploding Subculture that can be perceived, for example, in the way certain fashion designers link the cute and the scary, the beautiful and the ugly, the animate and the inanimate, the strange and the strangely beautiful. Among the leading designers whom I would place in this category are Jun Takahashi of Undercover, together with the Comme des Garçons "Army" (Rei Kawakubo, Junya Watanabe and Tao Kurihara), as well as Hirooka Naoto, whose punk-gothic Lolita styles push beyond genre boundaries.

Jun Takahashi, creator of the cult label Undercover, was a fashion star in Japan for a decade before he made an impact internationally. Before each collection, Takahashi puts together a collage of inspirations, such as an image from Stanley Kubrick's *A Clockwork Orange*, antique wallpaper, taxidermy animals, and figures from manga. His Tokyo studio, Undercoverlab, is filled with an equally eclectic assortment of objects, as well as his own surreal, highly detailed paintings. As he says, "You enter into the universe of the interior – I am surrounded by objects – and I don't go out a lot." Described by Suzy Menkes in 2006 as "the essence of Japanese cool" and "a powerful new fashion force," Jun Takahashi's style is characterized by a "disturbing romanticism and eerie poetry." His clothes, she writes, are "strange, but beautiful."[84]

Takeshi Murakami,
"Cherry Blossom Monogram" handbag,
© 2003 Takashi Murakami/
Kaikai Kiki Co. Ltd.
for Louis Vuitton, monogram canvas,
natural cowhide leather,
collection of Margot Siegel,
photo: Petronella J. Ytsma

Born in 1969, Takahashi discovered punk rock as an adolescent. He especially liked the Sex Pistols' music – and their clothes, which, he soon discovered, had been designed by Vivienne Westwood. Accepted at Bunka Fashion College, he moved to Tokyo, where he divided his time between studying and nightlife. Notoriously, he became the singer for a band called the Tokyo Sex Pistols. While still a student, he also started his own fashion label, Under Cover (initially two words), and began to sell to small boutiques. He has said that the name Undercover was supposed to evoke something conspiratorial. In 1993, his friend Tamoaki (or, as he became, "Nigo") suggested that the two of them start their own store in Harajuku. The store – Nowhere – became popular, but the partnership dissolved, and Nigo created his own successful streetwear label, A Bathing Ape.

Takahashi began showing his punk-inspired clothes at the Tokyo collections in 1994 and opened his first Under Cover shop in 1998. He first met Rei Kawakubo in 1999, although they had already been corresponding for the previous two years, and he had long admired her work. Kawakubo encouraged him to show in Paris. His 2002 Paris debut collection, entitled "Scab," featured radically deconstructed clothes, torn apart and sewn back together with red thread and intentionally haphazard stitches. "I wanted to take something that was beautifully made and add something ugly to it," said Takahashi, who described his style as "cute but scary, beautiful but ugly." In an interview published in the Tokyo-based English-language magazine *Metropolis*, he explored this paradox, suggesting that beauty is not necessarily "good" and ugliness "bad," but that both could be brought to "the same level" – made "flat."[85]

Subsequent collections drew on potentially uncanny subjects, such as dolls and twins. The idea of dressing paper dolls emerged from Takahashi's longstanding obsession with making dolls. For Spring 2004, he not only showed his collection on pairs of identical twins, but dressed each in different versions of the same outfit – khaki trench coats, striped sailor shirts, blue jeans and t-shirts – one traditional, the other like "a visual meltdown of the look" or "a reflection in a fairground mirror."[86] The next season continued this theme of how

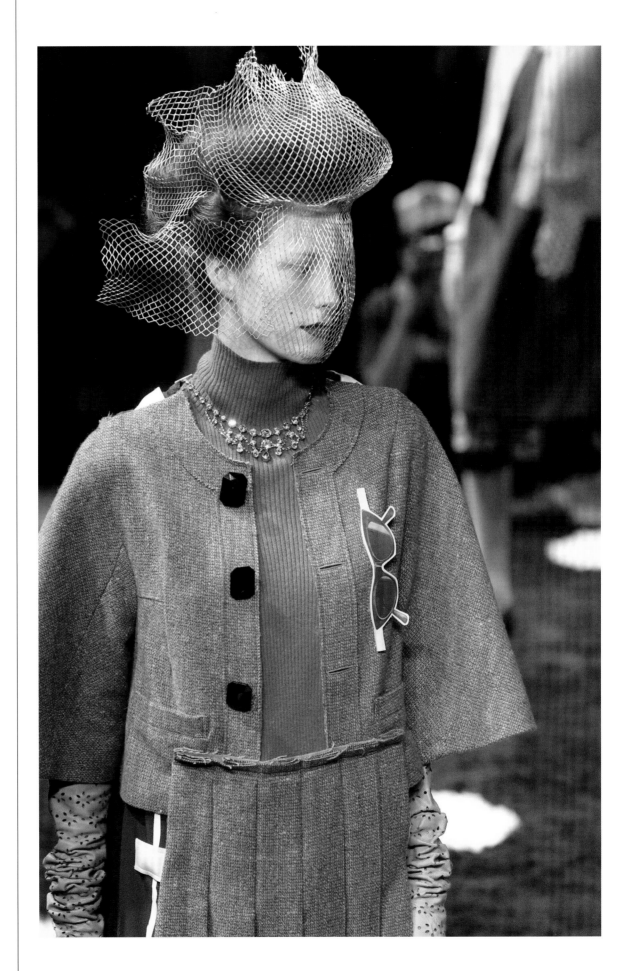

Undercover, dress ensemble
from the "Paper Doll" collection,
Autumn/Winter 2003–4,
photo courtesy Maria Chandoha Valentino

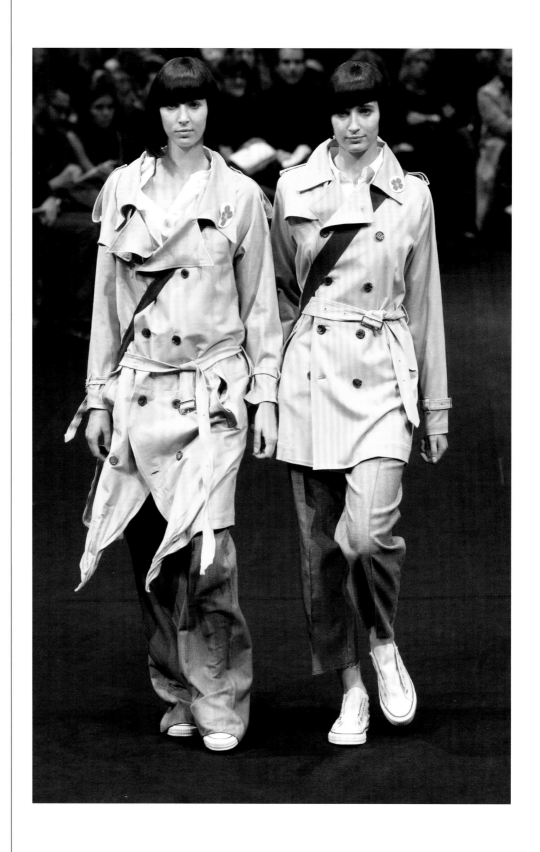

Undercover, trench coats
from the "Languid" collection,
Spring/Summer 2004,
photo courtesy Maria Chandoha Valentino

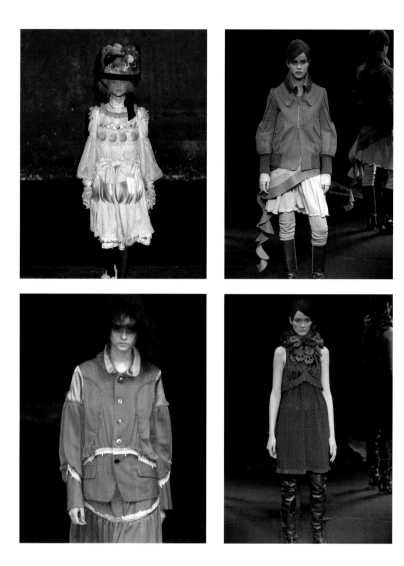

CLOCKWISE FROM TOP LEFT:

Undercover, ensemble
from the "but beautiful II 'homage to Jan
Svankmejer'" collection,
Spring/Summer 2005,
photo courtesy Maria Chandoha Valentino

Undercover, ensemble
from the "Arts & Crafts" collection,
Autumn/Winter 2005–6,
photo courtesy Maria Chandoha Valentino

Undercover, dress ensemble
from the "Arts & Crafts" collection,
Autumn/Winter 2005–6,
photo courtesy Maria Chandoha Valentino

Undercover, ensemble
from the "But Beautiful II 'homage to Jan
Svankmejer'" collection,
Spring/Summer 2005,
photo courtesy Maria Chandoha Valentino

clothes change over time, becoming stretched out or acquiring random buttons.

A film by Czech surrealist Jan Svankmejer based on *Alice in Wonderland* and featuring malevolent antique dolls in a decaying interior inspired Takahashi to create a wonderfully weird collection for Spring/Summer 2005, in which buttons resembled eyeballs, trim looked like teeth, and dresses sprouted long blond hair or entrails of pink fur. The Dark Side was much in evidence in his strong Fall/Winter 2005 show, held in the elegant gilded ballroom of the Grand Hotel. Models wore punk-influenced menswear for women – razor blades embedded in a

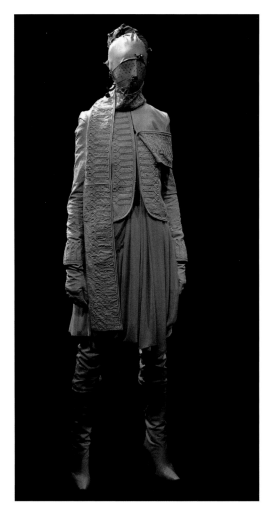
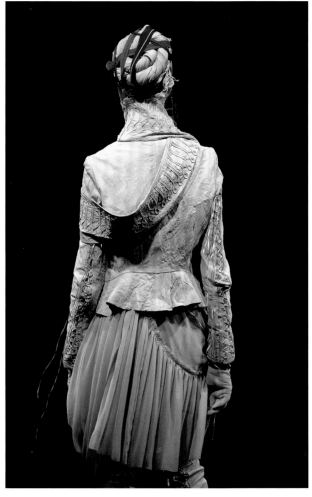

tuxedo jacket, a vest appliquéd onto a white shirt, crushed-down bikers' boots. Among the most striking pieces were long evening coats made from intricately cut felt in the shape of myriad skulls.

Fall/Winter 2006 is widely regarded as Takahashi's breakout collection: the models' bodies and faces were completely covered; jackets were wrapped and bandaged together, while faces were completely shrouded in mummified masking. Many in the audience were disturbed by a look that resembled that of prisoners in hoods, although the clothes underneath were quite wearable. "Why did I cover everything up?" the designer asked. "There was no reason, except to efface all feeling, like a destroyed doll. It was not about bird flu or some deep

Undercover, ensembles
from the "BBV (But Beautiful V)" collection,
Autumn/Winter 2006–7, photo courtesy
Maria Chandoha Valentino

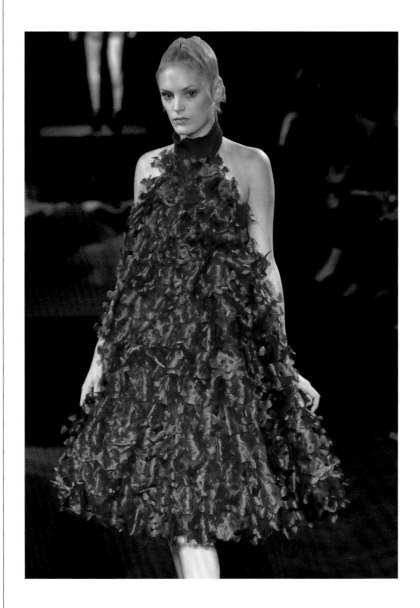

meaning. It was something aesthetic – I wanted to envelop them."[87] In another interview, he said that the idea of completely "covering the body . . . looked very scary but beautiful at the same time."[88]

The next collection, Spring/Summer 2007, seemed at first glance more light-hearted and lady-like, but Takahashi's ladies were twisted sisters – very pretty in fuschia and chartreuse, but also pretty weird. Skulls and spiders decorated dresses the following spring, along with a pattern that initially resembled a floral print, but which turned out

to be lips opening to reveal vampiric sharpened teeth. Meanwhile, cold-weather collections increasingly explored wearable sportswear separates. Takahashi began using NASA technology in Fall 2007, incorporating a variety of "smart" textiles into his garments.

Ever since childhood, Takahashi has made objects, and he still obsessively creates weird stuffed animals and dolls. Even the night before a fashion show, he sometimes stays up late transforming old toys and teddy bears into mysterious new creatures. Perhaps the most famous of his doll-creatures are the "Graces," fluffy white beings with glowing eyes made from vintage bicycle lights. Wearing dresses and jewels, the Graces resemble a cross between an alien and a monkey. In Takahashi's fantasy world, the uncanny Graces coexist with humans, although they keep a watchful distance from one another. A secret organization called Gila protects and breeds the Graces.

"The story . . . may depict the sense of distance I feel between myself and the fashion industry," writes Takahashi. "I also feel that the existence of Gila . . . is very similar to Undercover itself."[89] Fashion shows with live models and music are the usual way to present a new

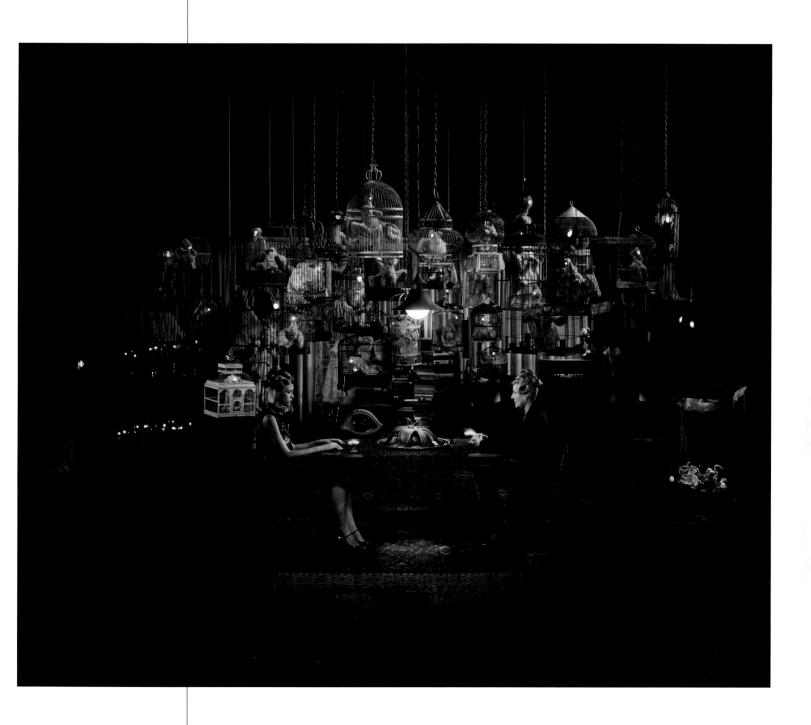

Undercover, "The ritual of GILA," from the
"Grace" collection, Spring/Summer 2009,
photo: Katsuhide Morimoto/Undercover,
courtesy Undercover

CLOCKWISE FROM TOP LEFT:

Undercover, dress from the
"Summer Madness" collection,
Spring/Summer 2008,
photo courtesy Maria Chandoha Valentino

Undercover, coat from the
"Earmuff Maniac – Evolving Comfort"
collection, Autumn/Winter 2009–10,
photo courtesy Maria Chandoha Valentino

Undercover, dress ensemble from the
"Grace" collection, Spring/Summer 2009,
photo courtesy Maria Chandoha Valentino

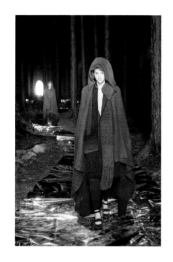

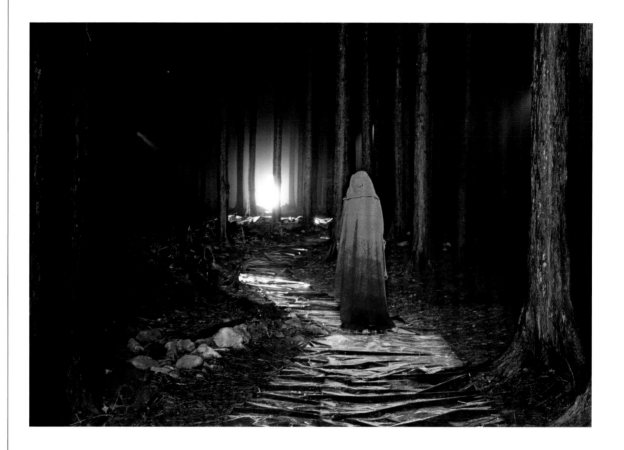

collection, but Takahashi has also experimented with installations and photography, in place of what he calls "runway entertainments." He originally unveiled his Graces in 2006 in a special issue of *A-Magazine*. In 2008, he built a series of elaborate sets in Japan, in which he posed his Graces according to a storyboard he had created featuring sketches of mysterious scenes, such as "melting Grace" and "Grace in water." The resulting vignettes were photographed by Katsuhide Morimoto and collected in a book, *Grace*. They also decorated the walls of an art gallery in Paris, where Takahashi presented his all-white "Grace" collection of Spring/ Summer 2009 in the form of an installation of mannequins.

Technology and functionality have played a growing role in Takahashi's work, as he focuses more on the wearer's experience of the clothes. "Less but Better" was the theme of his Spring/Summer 2010 collections, the menswear shown at Pitti Uomo in Florence, the

womenswear in an installation in Paris. He has continued with this idea subsequently.

"I stopped doing runway shows, because I'm no longer interested in creating show pieces for people in the fashion industry," says Jun Takahashi. "Most designers focus on the new or the elegant or the sexy. But fashion is not just dress-up clothes. In the past I tried to astonish people. Now I'm focusing on real clothes for everyday life – but made with quality and design and love." As he explained in the text for his Autumn/Winter 2010–11 collection, "Current ready-to-wear collections are primarily aimed at celebrities or fashion insiders. This fashion produced for the catwalk only lives in magazines, it is totally detached from reality." At the same time, "ordinary consumers are attracted to fast fashion." In contrast to both runway fashion and the "soulless mass production of cheap garments," Takahashi asserts his belief that "fashion enriches our daily lives."[90]

Rei Kawakubo made a rare public appearance at Jun Takahashi's first Paris runway show, where she sat in the front row. The evening before the show, she invited Takahashi to dinner, where she toasted him: "This is for the beginning of Jun's fight in Paris!" Recalling it later, he laughed: "It was very heavy."[91] Several years later, in the same defiant vein, Kawakubo described her relationship with "co-combatants," Junya Watanabe and Tao Kurihara – and, by extension, allies such as Jun Takahashi. "We are the Comme des Garçons army," declared Kawakubo. "When I began, I was fighting the resistance to change. It was more about a personal struggle. But through the years, it's become more . . . Now the fight is against the outside system . . . the multinational corporations, and the way society . . . is motivated solely by money."[92] Despite the military terminology, members of the CDG "army" insist that they fight to stay "free" and to "do things that other people have never done before. To achieve these two things is very difficult."[93]

In another essay in this book, Patricia Mears analyzes the work of Rei Kawakubo and Yohji Yamamoto in detail. Here, I would like only to draw attention to a few key themes. Rei Kawakubo and Yohji Yamamoto both continued to design throughout the 1990s, but their styles

increasingly diverged. Yamamoto moved in two directions simultaneously. He became increasingly interested in the haute couture of the past, creating collections that became more conventionally beautiful, and he also established a successful partnership between his Y-3 line and the Adidas sports company. His daughter, Limi Feu, also became a fashion designer.

Kawakubo, meanwhile remained relentlessly conceptual, and like the punks, whose style she sometimes referenced, she was unafraid to present "ugly" clothes that raised big questions such as "What is beauty?" Her Spring/Summer 1997 collection, widely mocked as the "Bump" or "Quasimodo" collection, was one of her most controversial ever. Kawakubo said that she "wanted to explore new body forms, to make new clothes, so that the body and the dress become one . . . Body becomes dress becomes body becomes dress."[94]

Widely regarded as one of fashion's least "sexy" designers, she has experimented with lingerie-inspired fashions, creating looks evoking an avant-garde harlot (Autumn/Winter 2001–2). Her Biker/Ballerina collection of Spring/Summer 2005 paired frothy pink skirts and black leather biker jackets with hand-sewn Frankenstein stitches that alluded to the physical strength and endurance of ballerinas, implicitly questioning conventional images of the delicate and the strong. Her Bride collection (Autumn/Winter, 2005–6) brought many viewers to tears. With collections such as these, Kawakubo has repeatedly interrogated the body–clothes unit and fashion's relationship to women's lives. Her 1995 "Sweeter Than Sweet" collection was full of tulle frills, ruffled pinafores, and the color pink. She returned to the theme again in 2007, when she presented dresses in girlish pink or lavender, on the front of which she appliquéed child-sized, or doll-sized, dresses. Obviously, Kawakubo has not abandoned her experiments in deconstruction and reconstruction. But, I would argue, she and her colleagues have also responded to the changing world of Japanese visual and popular culture.

Kawakubo denies that she ever intended to support younger designers. "I don't want to be seen as the big benefactor of fashion," she told Cathy Horyn.[95] Yet, rather than creating cheaper spin-off brands, the

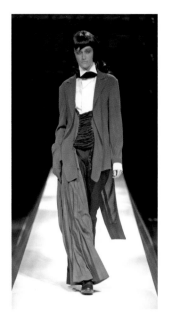

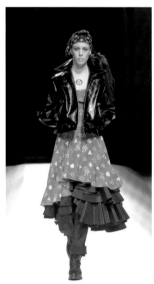

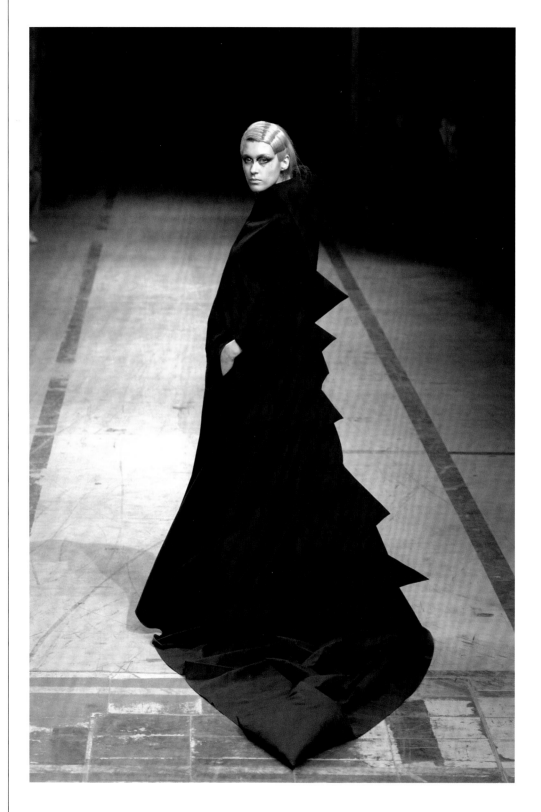

CLOCKWISE FROM TOP LEFT:

Yohji Yamamoto, suit ensemble,
Spring/Summer 2007,
photo courtesy Maria Chandoha Valentino

Yohji Yamamoto, coat,
Spring/Summer 2006,
photo courtesy Maria Chandoha Valentino

Yohji Yamamoto, dress ensemble,
Autumn/Winter 2007–8,
photo courtesy Maria Chandoha Valentino

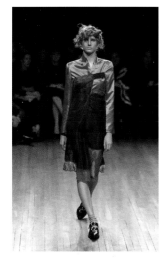

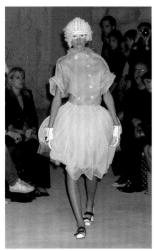

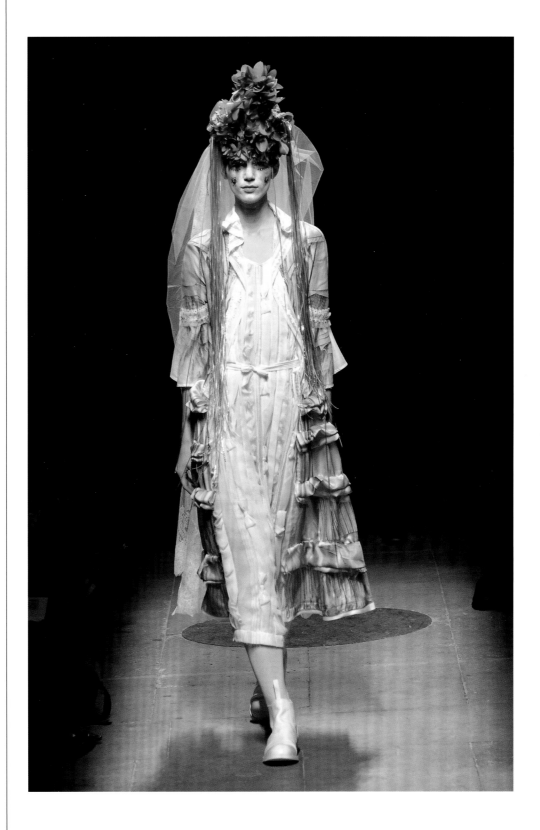

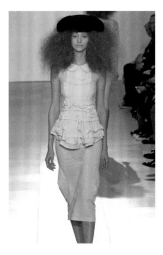

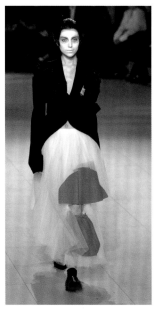

way most designers do, Kawakubo created a multi-brand company under the Comme des Garçons umbrella with separate collections by some of her most talented employees. Junya Watanabe was the first.

Born in 1961, Watanabe graduated from Bunka Fashion College in 1984 and immediately began working for Comme des Garçons as a pattern cutter. Three years later he was promoted to chief designer of Tricot, the CDG knitwear line, and then also to head of CDG menswear. "Isn't it about time you started your own label?" Kawakubo said in 1992, and the following year he officially launched his own line, Junya Watanabe Comme des Garçons, which he showed in Paris. At first the fashion press described Watanabe, not inaccurately, as "clearly a Kawakubo disciple, but [with] . . . some ideas of his own."[96] Within only a few years, however, it was said that "this Rei Kawakubo protégé has become an editorial darling – and a designer with plenty of retail promise."[97]

It was the end of the millennium, and as journalists and buyers waited for his runway show to begin, it suddenly began to rain – or, rather, water sprouted from pipes above the catwalk, simulating a spring shower. As the models strolled out, their heads covered in kerchiefs or futuristic headgear, it became apparent that their clothes were waterproof. Working with the Japanese textile mill Toray, best known as the source of Ultrasuede, Watanabe had made all of his clothes in his Spring/Summer 2000 collection out of special new fabrics. Rather than using fabric finishes, the waterproofing was built into the textiles through the use of special fibers and weaves.

Often described as a "techno couture" designer, Junya Watanabe is known for his innovative cutting and draping techniques. Collections such as "Geometric Sculpture," Autumn/Winter 2008/9, utilized draped grey jersey, evoking the classical gowns of Madame Grès. Yet his couture shapes are often realized with advanced "techno textiles." Watanabe's Autumn/Winter 2004 collection, for example, featured down-filled garments in shapes evoking, for example, an Edwardian evening gown or a Paul Poiret cocoon coat from about 1910. Similarly, his "Feathers and Air" collection of Autumn/Winter

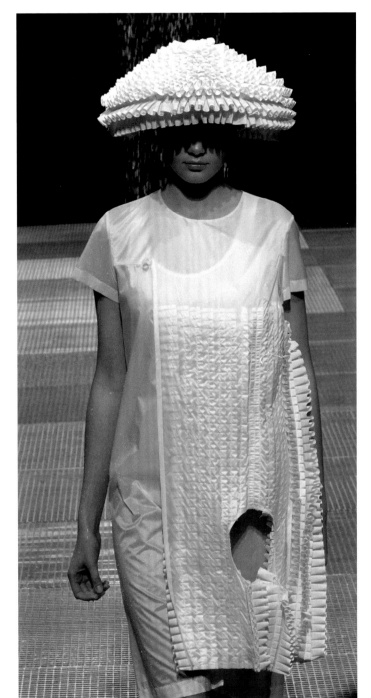

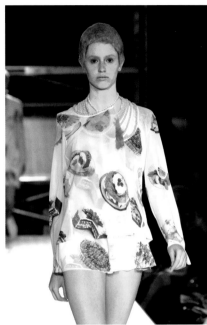

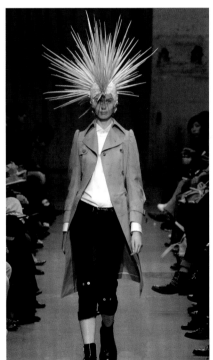

CLOCKWISE FROM LEFT:

Junya Watanabe for Comme des Garçons,
dress ensemble, Spring/Summer 2000,
photo courtesy Maria Chandoha Valentino

Junya Watanabe for Comme des Garçons,
ensemble, Spring/Summer 2001,
photo courtesy Maria Chandoha Valentino

Junya Watanabe for Comme des Garçons,
ensemble, Spring/Summer 2006,
photo courtesy Maria Chandoha Valentino

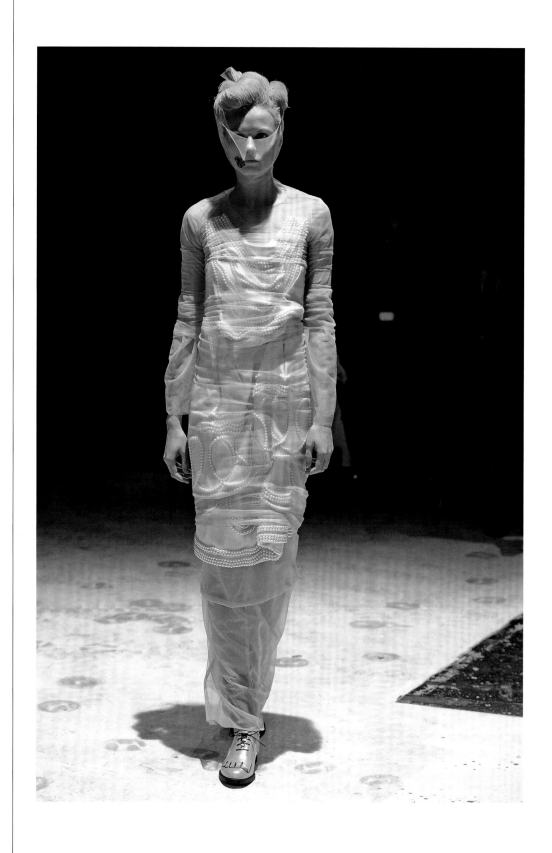

Comme des Garçons, dress,
Autumn/Winter 2009–10,
photo courtesy Maria Chandoha Valentino

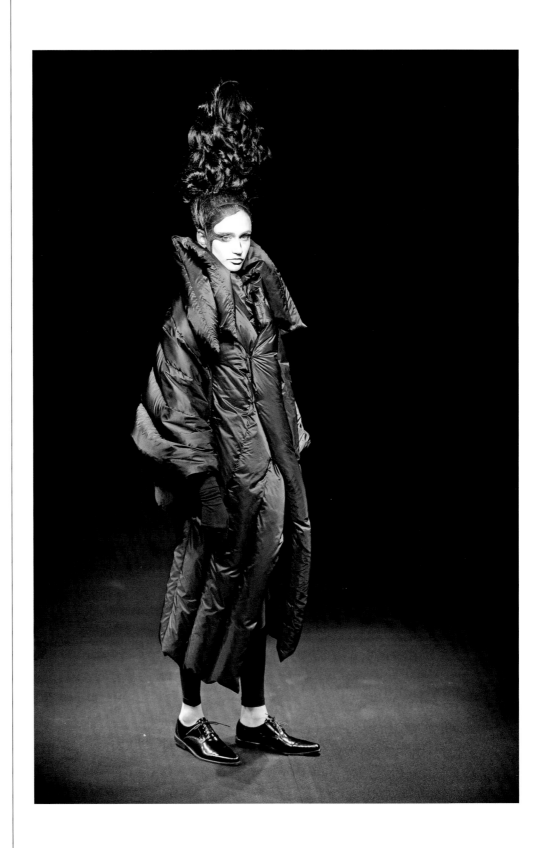

Junya Watanabe for Comme des Garçons,
Coat, Autumn/Winter 2009–10,
photo courtesy Maria Chandoha Valentino

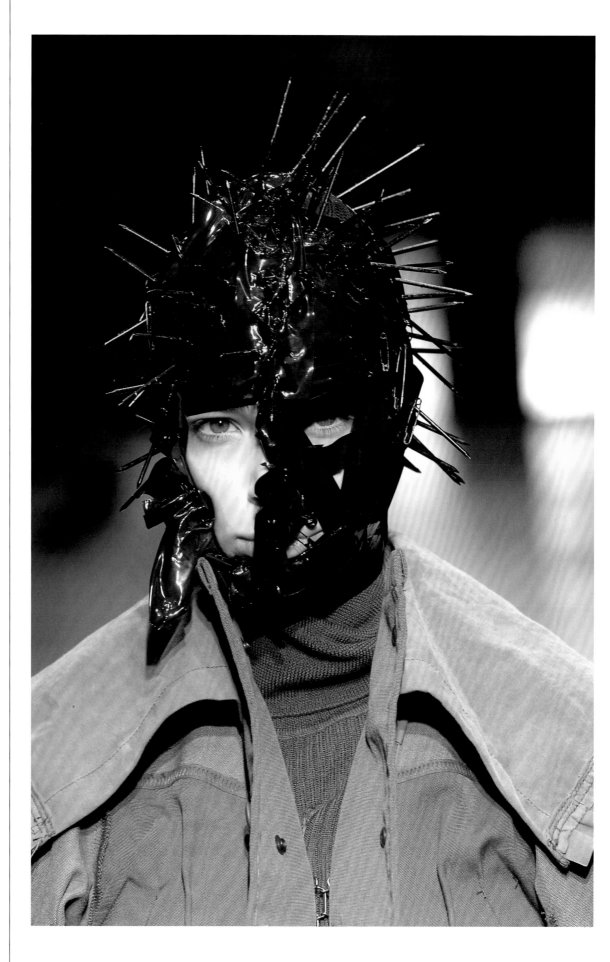

2009–10 re-imagined the "puffer" down-filled coat as cocoon-shaped wraps, capes, and dresses.

Watanabe frequently returns to signature themes, such as aged denim (sometimes mixed with African textiles), military style, and punk anti-fashion. In her essay, Patricia Mears analyzes one of Watanabe's most extraordinary denim dresses, but here I focus on punk and military themes, evident both in his men's and women's collections. For his Spring/Summer 2006 collection, Watanabe was inspired by the Japanese band Mad Capture Maggots: models wearing punk-inspired, spiked paper hairdos strode down the runway in skinny cropped bondage pants and heavy boots. This was probably the most overtly punk collection of Watanabe's career to date, but a punk sensibility underlies much of his work.

The Sex Pistols' "Anarchy in the UK" blared from the runway as Watanabe's Autumn/Winter 2006/7 collection began. As models of both sexes paraded down the runway in army green trench coats, tailcoats, and other military looks, accessorized with black, spiked head gear, the soundtrack segued into an eighteenth-century minuet. Before heading backstage, the laconic Watanabe was quoted as saying three words: "Anti. Anarchy. Army."[98] Almost all designers do military styles occasionally, but Watanabe returns repeatedly to military looks, from his wonderful Edwardian-style cutaway trench coats to outfits reminiscent of First World War uniforms. On the other hand, when Watanabe does a sweet collection, it is very sweet indeed, like the dresses printed with colorful desserts and decorated with ropes of pearls.

Her clothes are often described as "kawaii," but Tao Kurihara says: "I like the word *utsukushii* (beautiful) more than *kawaii* (cute). I am not trying to make cute things, so I feel strange when I'm told that. But it seems many people have that impression." She does admit, though, to liking the color pink, and when she first came to work at Comme des Garçons, she painted her office door bright pink. "I think in those days, pink was the color that gave me the most pep." On the other hand, she also likes white, and wore all-white clothing to her first interview at CDG.[99]

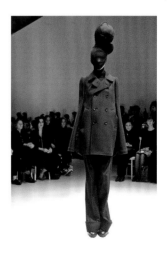

When Tao Kurihara graduated from Central Saint Martins College of Art and Design in London, she joined Comme des Garçons, where she became part of the "idea planning team," working under Junya Watanabe. She recalls that he would give her "a very abstract idea," sometimes only a word, to indicate where he wanted to go with the next collection. (This is famously also Rei Kawakubo's method of working.) "So I'm looking for what it is," Kurihara recalls. Ultimately, he would design his collection, but she "tried to produce some ideas that he may be interested in."[100] Looking back, Junya Watanabe recalls that Tao "was different from the others. She isn't the type to aggressively promote herself, but she did have a quality of hidden passion, unlike others. She had something I didn't have, and I could count on her."[101]

After collaborating with Watanabe, Kurihara was eventually put in charge of the CDG Tricot line, where, she says, "I tried to focus more on daily clothes, which contain pureness, lightness, that sort of feeling." Then one day Rei Kawakubo asked: "Why don't you do your own label for the Paris collection?" Looking back, Kurihara says, "It was frightening! My own collection has to be completely different from Comme des Garçons and Junya Watanabe." For her first collection in 2005, "My idea was just one concrete item. That's why I presented knitted lingerie. To me, lingerie is always fascinating, because it is very functional; yet at the same time, it shows its own beauty. So I wanted to make something opposite to the stereotype of lingerie. That's why I focused on knitted material. I also wanted a hand-made feeling."[102]

Her next collection was small, perfectly formed, and beautifully focused – inspired by a single idea: handkerchiefs. First she sourced a number of beautifully embroidered handkerchiefs – some in Swiss *voile* with a monogram in the corner, others with hand-embroidered *broderie anglaise*. Then she pieced them together to make garments such as a coolly feminine trench coat. "Usually a trench coat has a strong function," Kurihara told me. "But again, I wanted to do the opposite, so I focused on very fragile material, rather than waterproof cotton twill. I also wanted to continue the hand-made feeling and to use embroidery."[103]

Tao for Comme des Garçons,
corset, wool jersey,
Autumn/Winter 2005, Japan,
collection of The Museum at FIT,
photo copyright The Museum at FIT

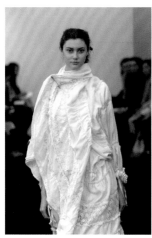

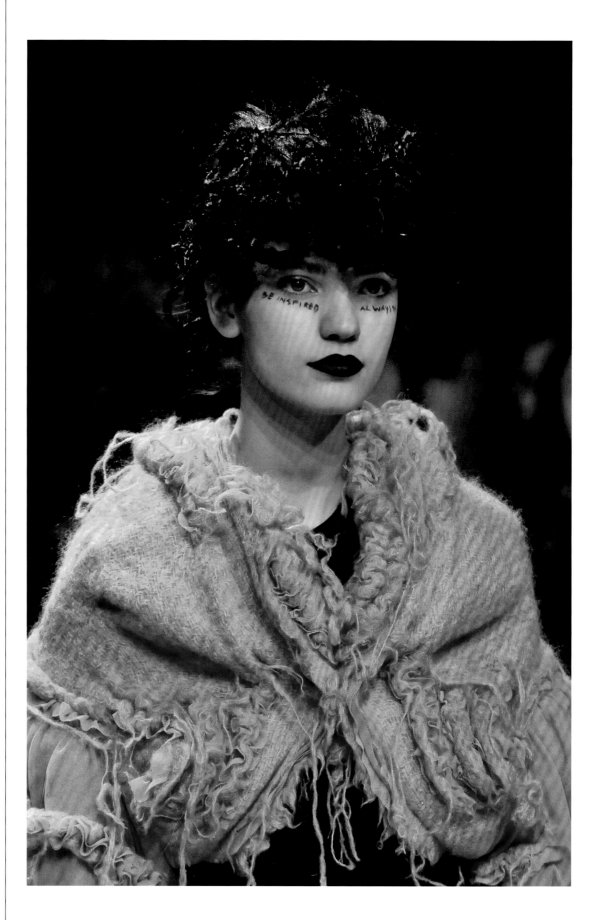

CLOCKWISE FROM TOP LEFT:

Tao for Comme des Garçons,
handkerchief coat, Spring/Summer 2006,
photo courtesy Maria Chandoha Valentino

Tao for Comme des Garçons,
jacket from the "Glittering Fantasy"
collection, Autumn/Winter 2008–9,
photo courtesy Maria Chandoha Valentino

Tao for Comme des Garçons, dress, Autumn/
Winter 2006–7,
photo courtesy Maria Chandoha Valentino

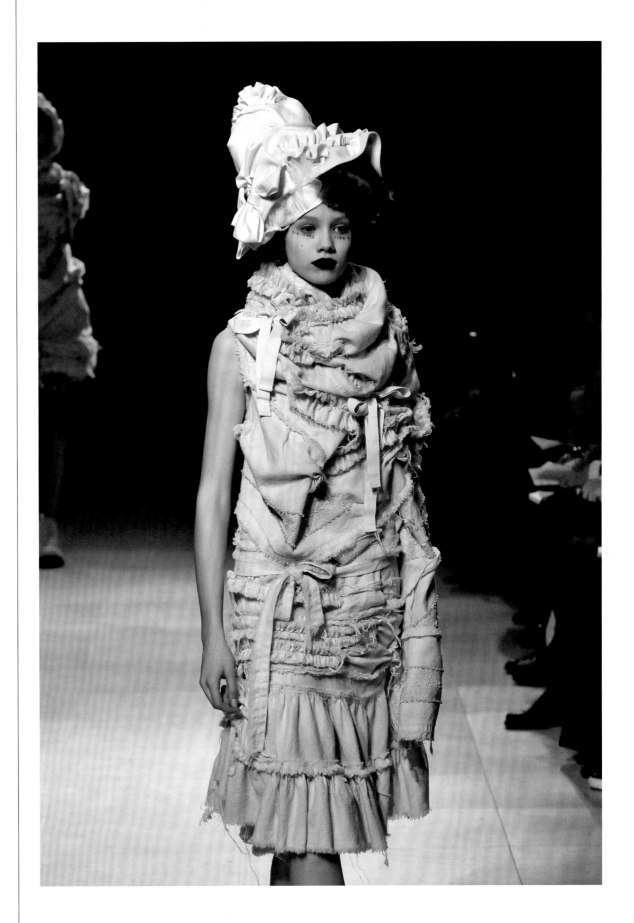

Tao for Comme des Garçons,
dress from the "Glittering Fantasy"
collection, Autumn/Winter 2008–9,
photo courtesy Maria Chandoha Valentino

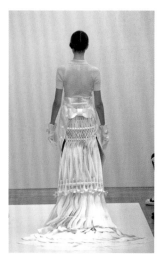

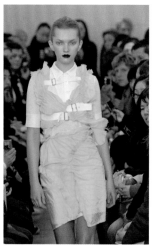

For her third collection, Autumn/Winter 2006/7, Kurihara's idea "was not to make a garment. I wanted to do something shapeless – and a stole is just a piece of cloth."[104] Cloaks, capes, scarves, and wraps in tulle, lace, and silk were tie-dyed in a range of gentle pinks, blues and violets, as well as cream and black. They were practical, but the more voluminous evening wraps also had great drama and style.

After only three seasons, Tao had become a must-see show in Paris, and journalists scrambled to attend her extraordinary all-white "Shirts and Weddings" collection of Spring/Summer 2007. Marrying the timeless white shirt – a garment that she loves – with the special-ness of the wedding dress, Kurihara showed a host of ruffle-front white shirts, tiered skirts, and romantic white cotton dresses. All of the models wore circlets of white paper flowers in their hair and bal-let slippers on their feet. At the conclusion of the show, there were a group of wedding dresses cut from white paper and elaborately folded.

"I thought the idea of a man's shirt meeting a wedding dress was a beautiful one," Kurihara told journalist Susannah Frankel. "I think the best way to express myself is to do a small but concentrated, very condensed collection. I believe that when one sets limitations some kind of strength occurs. What attracts me the most this time is how special the wedding dress is. That is because it is worn only once." Hence her choice of paper dresses at the end of the show: "Paper is so fragile and not appropriate for over-use. I thought a paper wedding dress would be more special than one that was crafted out of a more traditional and typically extravagant material."[105]

Kurihara's collections do not always derive from a type of garment, but sometimes from an abstract idea. Her "Glittering Fantasy" col-lection, Autumn/Winter 2008, for example, emerged from a desire to "stress exciting moments in daily life, and reproduce the same kind of excitement in those who wear dresses." She told Maya Nago of *High Fashion* magazine: "Conventional ways of dressmaking are much too commonplace to evoke an uplifting sense of freshness in the people who wear those dresses. That's why I decided to play catch with my assistants, throwing abstract, fantasy-themed words at them, and

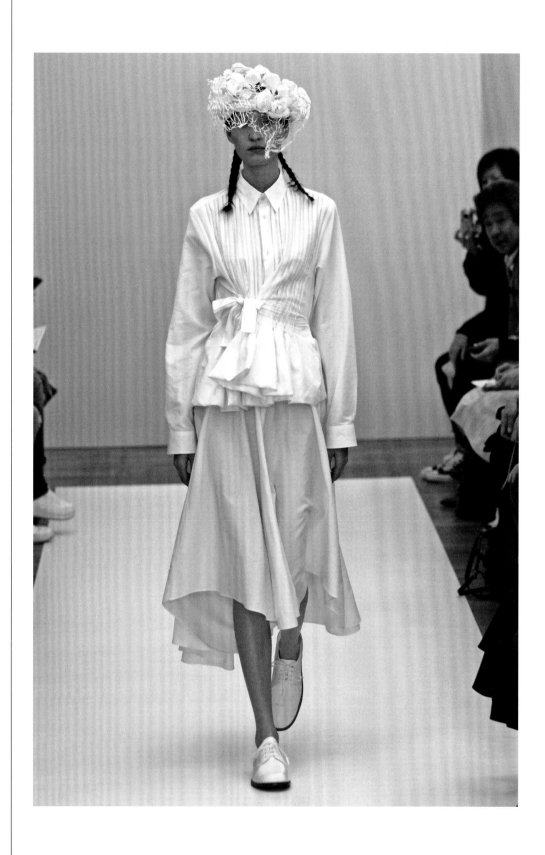

Tao for Comme des Garçons, dress
from the "Shirts and Weddings" collection,
Spring/Summer 2007,
photo courtesy Maria Chandoha Valentino

having them catch the meanings and translating them quite sensuously into concrete designs."[106]

Working within the CDG vision, Kurihara is clearly developing her own aesthetic vocabulary: Although one season may be sportif with shorts and tanktops in neon pink and black, while another is inspired by Eastern European folklore and cake decoration, her aesthetic tends to be marked by extreme femininity – lace, frills, ribbons, bows; a fantasy of girlishness. Yet there is also often an undertone of something dark and eccentric mixed with her look of romantic cuteness. When Maya Nago asked what she considers beautiful in everyday life, Kurihara replied: "Sometimes I see beauty in perfect, clean-cut things, or I find myself attracted by things with a rather dark atmosphere. For example, I find it extremely beautiful when the force of gravity pulls a withered flower to the ground."[107]

Hirooka Naoto, the designer behind h.NAOTO, is a highly successful designer of spectacular subcultural styles, especially Gothic and Punk Lolitas. Whenever people in Japan asked me which younger designers I liked best, I always said h.NAOTO – and people laughed. But his work is fantastic, and while he may not have a normal fashion brand, he can laugh all the way to the bank, because he has built a fashion empire. There are now 29 specialized collections under the h.NAOTO umbrella, many with their own specialized shops: h.ANARCHY is gothic-style punk; h.BLOOD is gothic black elegance; DARK RED RUM is occult gothic; FRILL is angelic, gothic, white Lolita; and NAOTO7 is gothic-style art mode. He says he was "very much influenced by CDG. It's not that I'm so philosophical, but I do question the meaning of fashion."

Born in Kobe, he graduated from Bunka Fashion College and went to work for the S-inc company. In 2000, he proposed a Gothic Lolita Punk collection. "At first, I didn't know anything about these Gothic Lolitas," he told me. "I knew they existed. Apparently the style started in Osaka and was influenced by visual-kei bands. But I had the impression that the Gothic Lolita look never changed, so I wanted to deconstruct that look and create something new, like adding something punk to the Lolita look."[108]

Naoto is the first to admit that he is not a goth or a punk, and, "spiritually speaking," his clothes are "not authentic." As he puts it: "If I myself was gothic spiritually, I wouldn't be able to create these clothes. I don't have these spirits, but that's why I can play with them." "I myself don't quite understand why my clients wear these clothes," he continues. "I think that some of the girls want to escape from reality. If you dress like that from head to toe, you are saying, 'I don't belong to this world'. In a sense, my clients are mentally vulnerable. But if they have the guts to go outside in these clothes, they have strength, too."[109]

Naoto also works with the illustrator known as GASHICON, who draws the *gurokawa* (grotesque-cute) characters Hangry and Angry, who inspire yet another h.NAOTO brand. Hangry and Angry are also a Gothic/Punk duo, composed of girl singers Hitomi Yoshizawa and Rika Ishikawa. According to their back story, Hangry and Angry are female cats who came from the H44 Star Nebula to save the world from global warming. Hangry has a punk image, but is actually very sweet. Angry has a gothic image and a secret devilish side. Theirs is not the "heavy gothic and extreme punk" style, however, but something closer to Harajuku street fashion, with a futuristic "cyber feel."[110]

In an interview in which he discussed his "Crime and Punishment" collection of Spring/Summer 2010, Naoto said that he wants "to make something that cannot be found anywhere else – a Tokyo style. Sometimes I see foreigners shopping passionately [in his Tokyo stores], and I think 'Why not sell overseas?'" Asked his ultimate goal, he replied, "I aim to be the most extreme and scandalous brand in the world."[111]

There are many independent designers in Japan, which is not surprising, since there is so much interest in fashion. But most of these designers have very small companies, and they face increasing challenges as the economic environment remains hostile. Not only are more people buying "fast fashion," but few retailers, even in Japan, are willing to gamble on lesser-known labels. In addition, many Japanese customers prefer European brands, while western customers may be daunted by the relatively high price of Japanese

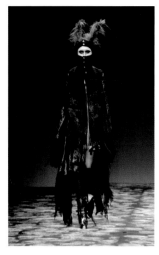

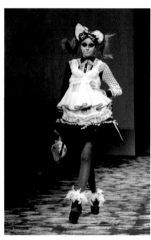

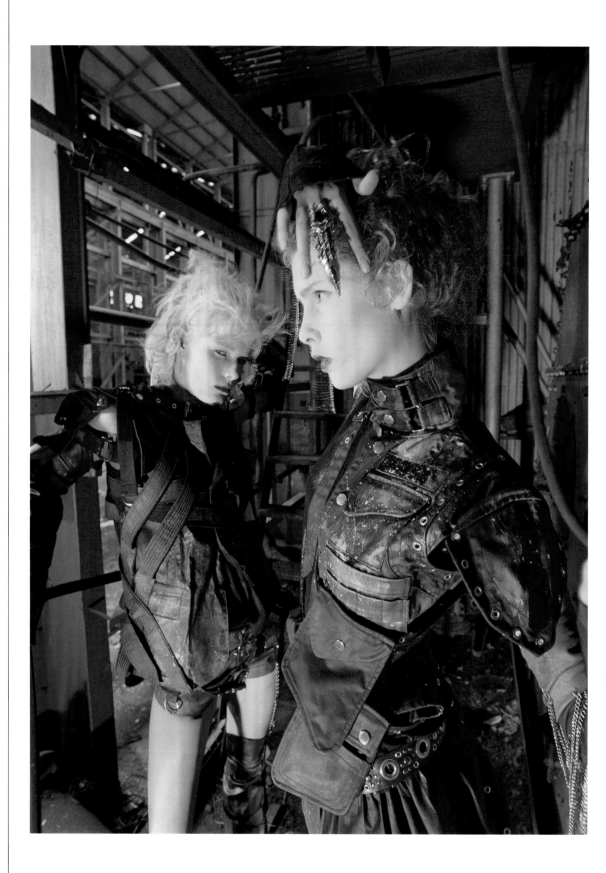

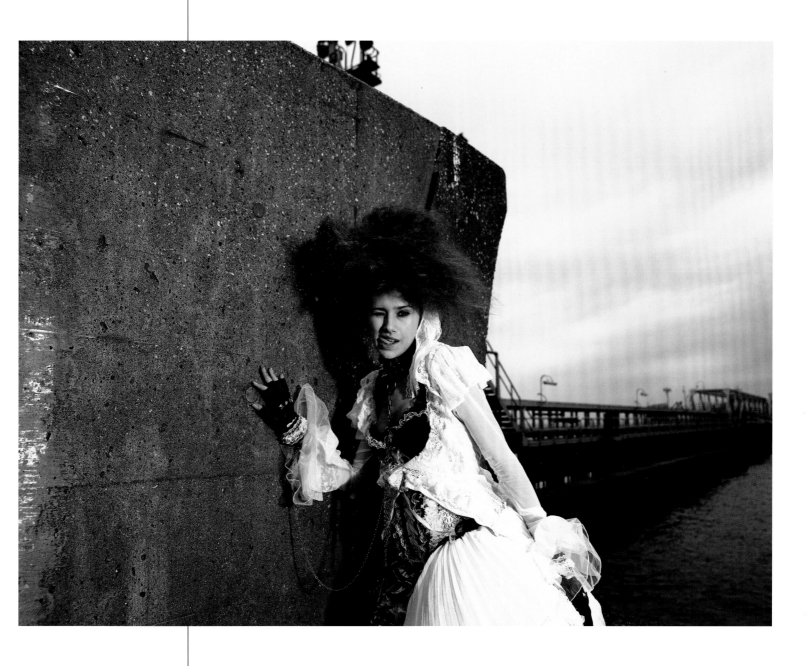

h.NAOTO, Spring/Summer 2007,
photo: Kushida,
courtesy h.NAOTO and S-inc

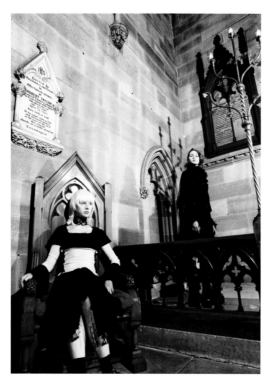

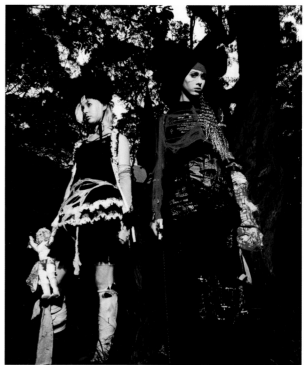

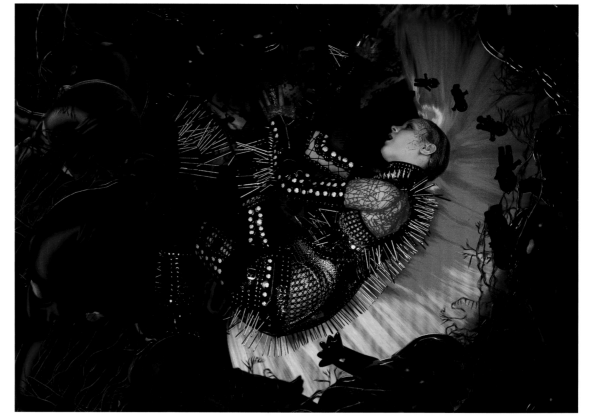

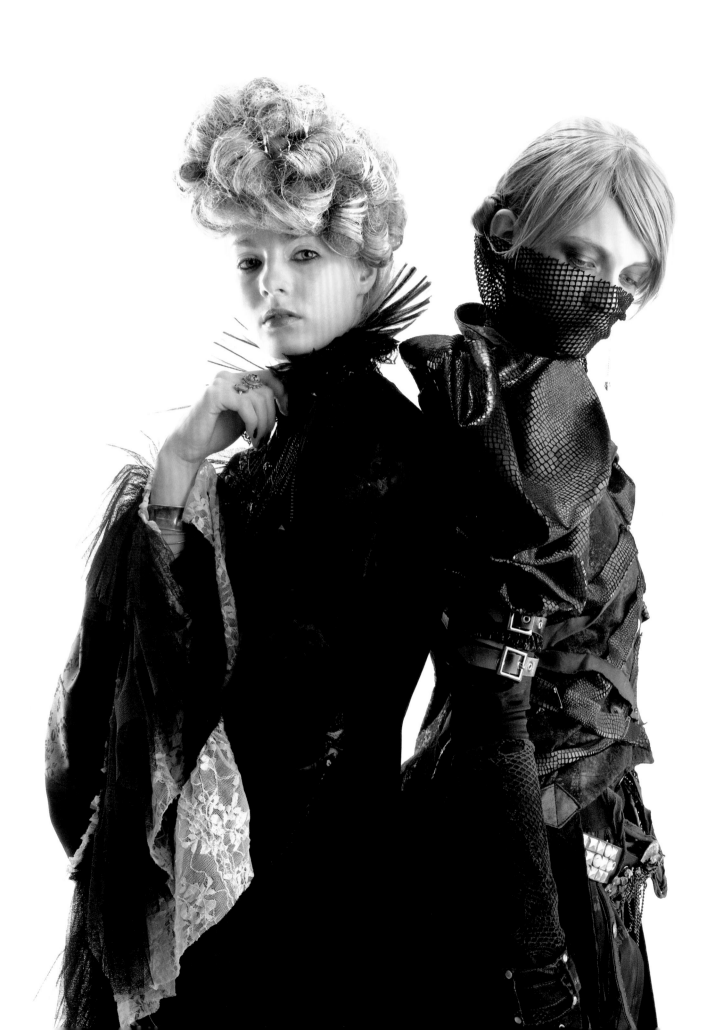

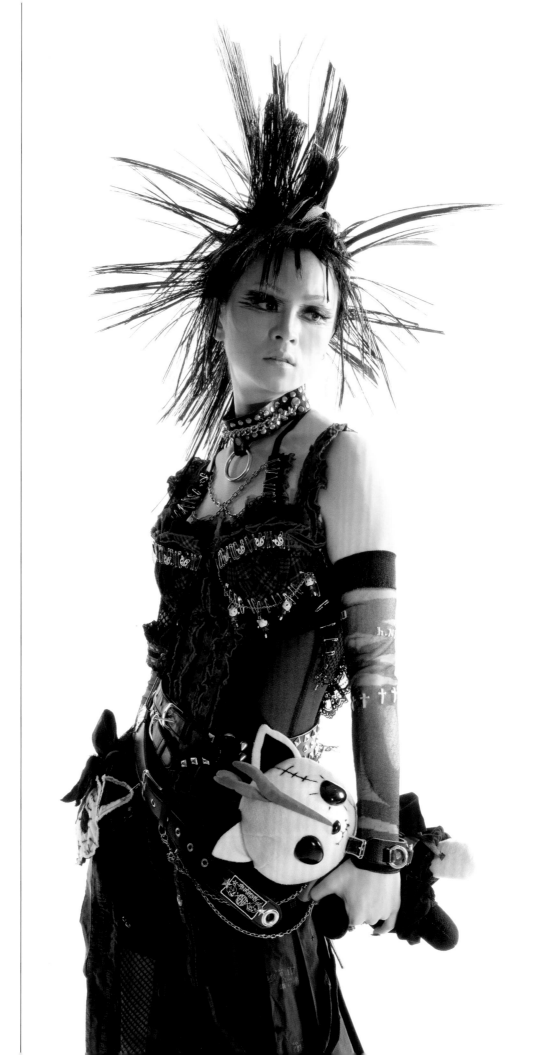

Singer HANGRY (Hitomi Yoshizawa)
wearing h.NAOTO, 2008,
photo: Kushida, copyright HANGRY&ANGRY
2008 Project, courtesy S-inc

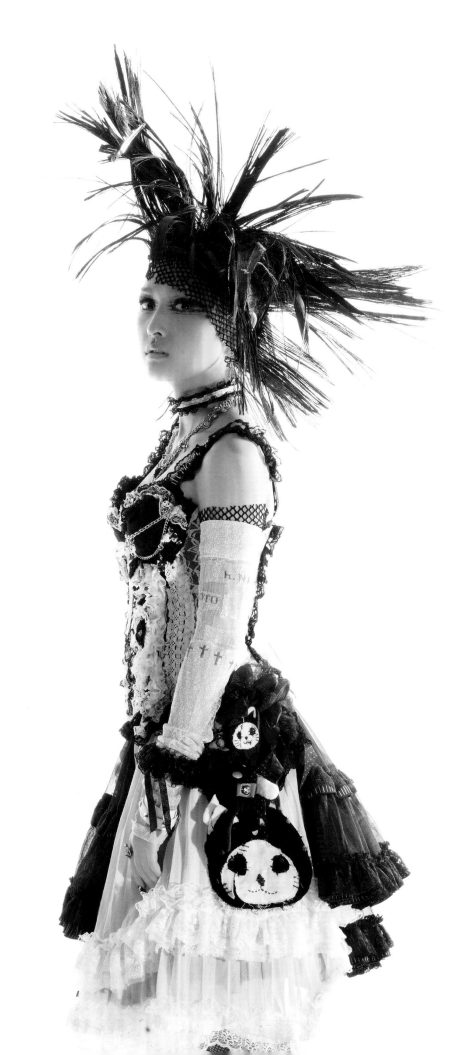

Singer ANGRY (Rika Ishikawa)
wearing h.NAOTO, 2008,
photo: Kushida, copyright HANGRY&ANGRY
2008 Project, courtesy S-inc

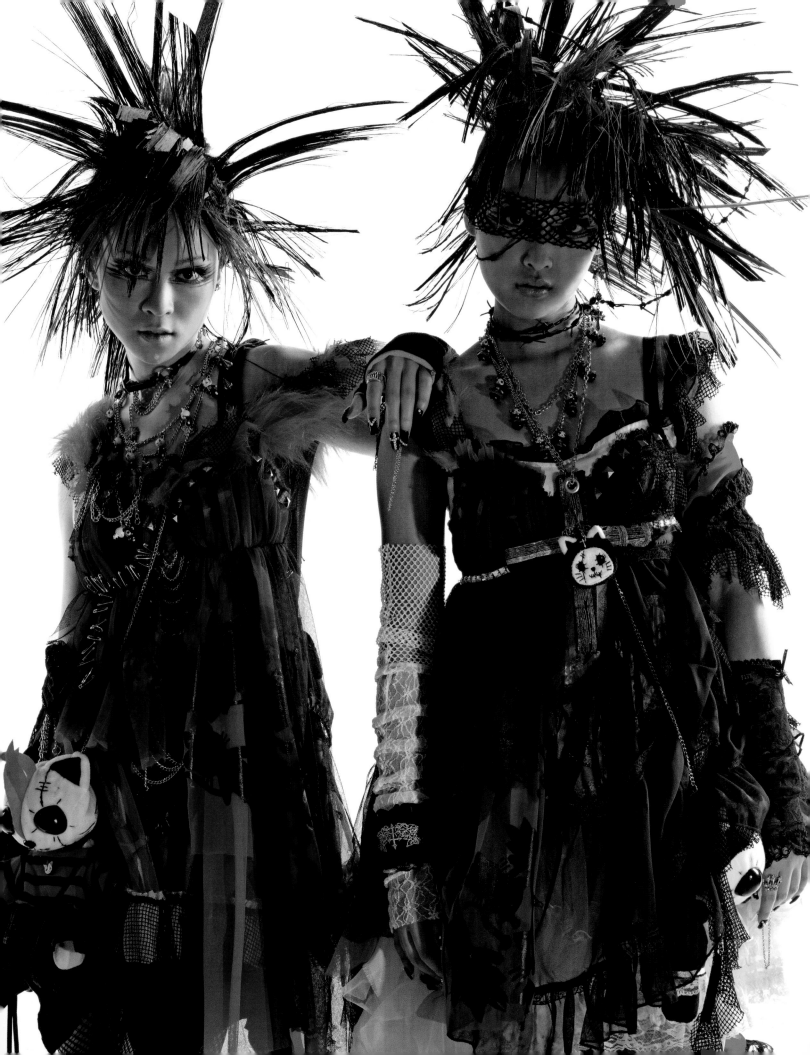

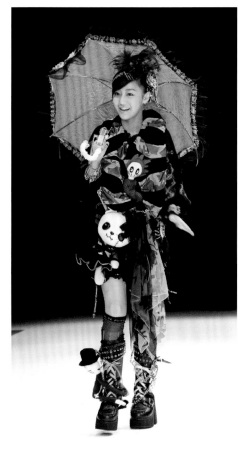

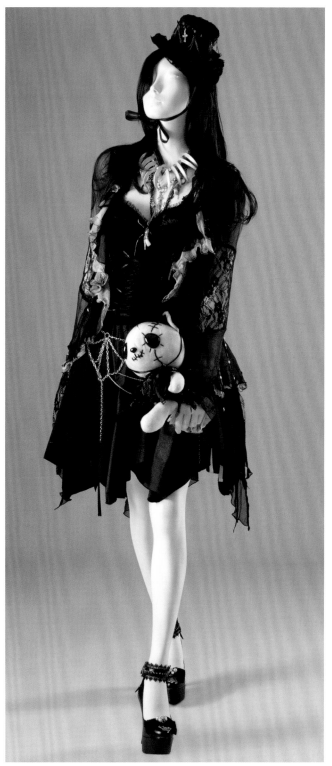

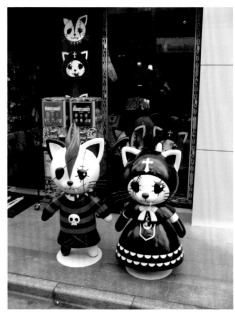

CLOCKWISE FROM TOP LEFT:

h.NAOTO, ensemble, Spring/Summer 2009, photo courtesy h.NAOTO

h.NAOTO, Gothic Lolita dress ensemble, Autumn/Winter 2008–9, Japan, Collection of The Museum at FIT, photo copyright The Museum at FIT

Statues of cartoon cats Hangry and Angry outside one of the h.NAOTO stores in Tokyo, photo courtesy the author

FACING PAGE:

Gothic/Punk duo HANGRY & ANGRY (singers Hitomi Yoshizawa and Rika Ishikawa) wearing h.NAOTO. The singers' alias were inspired by the cartoon cats Hangry & Angry created by illustrator Gashicon for h.NAOTO. Art direction and photography by Kushida, © HANGRY&ANGRY 2008 Project, courtesy S-inc

fashion. Nevertheless, among the many interesting new Japanese designers, some stand out as especially exciting.

Chitose Abe launched her company sacai in 1999 – the name, all in lower-case letters, is a "twisted" variant of her maiden name, Sakai. At the age of 34, she had spent ten years as a knitwear designer for Comme des Garçons and Junya Watanabe, before taking time off to have a child and reassess her career. She describes herself as "very much influenced by Comme des Garçons," but her work is also very personal: "I make clothes for everyday wear for someone like me." Her designs "revolve around [her] life" as a working woman, modern and creative, but also grown-up enough to have a husband and child.[112]

Abe's designs for sacai are classics (such as a man's cardigan sweater or vest) to which something new and different has been added. This could be as simple as adding ruffles to the shoulders, or could involve completely disassembling a sweater and recombining it with a chiffon blouse. "I like basic designs," she says, "but I like to change them into something elegant that you can wear every day." You can also wear it all day, because in contrast to the west, where "clothes are simple in the day time and people dress up at night, in Japan we wear the same outfit all day." As a result, Japanese women want to combine the practical and the stylish for an effect that Abe calls "everyday sexy."[113]

Abe once said: "I want to make the clothes that seem to exist already but don't." When she first started, her knits were rather simple, but she has researched materials and fabric combinations in innovative and unpredictable ways that take advantage of the qualities of knitwear, while also, in a sense, upgrading knits by juxtaposing them with lingerie details and delicate fabrics. The overall form tends to be simple and comfortable, but attention is paid to details such as the sleeves or the collar, resulting in a well-designed and special garment. This attention to detail is often described as "typically Japanese," she notes, adding that her own "conception of elegance is a very Japanese one." It is not about "frills and glitter," but rather is "based on standard elements." It is what she calls "Tokyo elegance."[114]

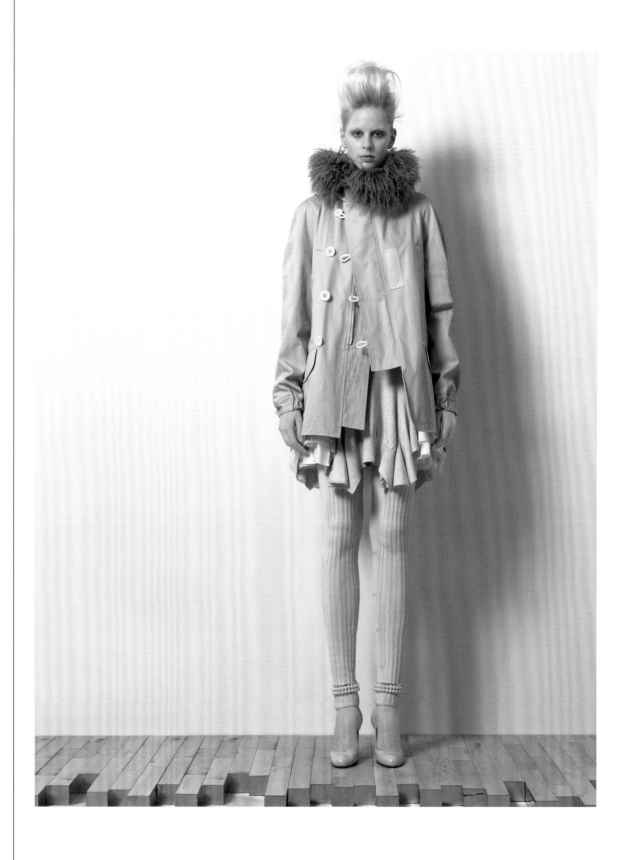

sacai, ensemble, Autumn/Winter 2009–10,
photo courtesy sacai

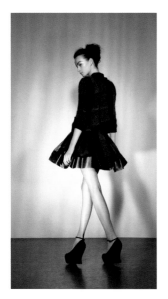

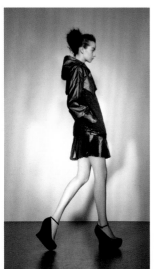

Chitose Abe founded her company in Tokyo in the late 1990s. Tokyo is an edgy, competitive, fashion-forward city, but the economic climate, post-bubble, was, and remains, tough. She does not organize a catwalk show, although she has a showroom in Paris during Fashion Week. sacai is worn by stylists, editors and other fashion professionals, and is sold in cutting-edge shops, such as Barneys (New York), 10 Corso Como (Milan), and Dover Market (London). Yet observers question whether sacai is really a "fashion brand." Seldom featured in fashion shoots or on red-carpet occasions, sacai has something else, which Hirofumi Kurino calls a sense of "reality." He suggests that there is something "extremely tough" about brands like this, something that appeals to people who "consume in a different way," who want "to wear real and yet fantastic clothes."[115]

Almost uniquely among younger Japanese designers, Makiko Sekiguchi and her husband, Hiroyuki Horihata, design clothing based on Japanese aesthetics. Today the majority of young Japanese women wear kimono no more than once a year, and men hardly ever, but in 2001, this young couple, graduates of Bunka Fashion College, began wearing kimono every weekend. Horihata recalls that "Makiko and I . . . began talking about the essence of the kimono and thinking deeply about the Japanese sensibility." From this emerged the concept of their brand, matohu, which they launched in 2005. As former pattern-makers, he at Comme des Garçons, she at Yohji Yamamoto, they have a sophisticated grasp of clothing construction, and their patterns deviate from those typically utilized in the west. But their designs derive from passionate belief as much as from technical skill. They also produce their own textiles, and they think in the long term: from 2005 to 2010, they have focused on the audacious aesthetic of the Keicho period (1596–1615).

For their first ten seasons, the designers were inspired by the aesthetics of the Momoyama period. The art of the Momoyama typically featured gold and brilliant colors, but dark colors and exaggerated forms were also part of the aesthetic, and inspired some of matohu's most striking designs. Their latest collection is the first of a new series that will draw not on a particular period in Japanese history, but, rather, on a "more abstract idea of Japanese beauty." Thus, although

TOP AND BOTTOM:
sacai, ensemble, Autumn/Winter 2010–11,
photo courtesy sacai

108

they evoke the colorful layers of *kosode* fashionable in the Heian era, their goal is not to evoke a period style, but to allude to spiritual ideas of beauty.

Hiroyuki Horihata expressed puzzlement as to "why other Japanese designers only see European beauty, when we already have an aesthetic treasure inside Japan." Yet he acknowledged that because of historical developments surrounding the shift away from kimono toward western clothing, "to be westernized signified being modern." The creators of matohu insist that they "do not want to go back to kimono, but to create something new." But, they add, "the word 'new' has various meanings: it could be the latest trend, something a little different, or it could be avant-garde, like Comme des Garçons, something that no one has seen before, or it could indicate a fresh point of view. For example, we see the moon every night, but maybe one night we see something special, and we find the beauty in that. Or layering colors – we see many colors every day, but we may see a fresh effect if we put certain colors together in a new way. By changing our point of view toward ordinary things, we may do something creative and new."[117]

Rei Kawakubo offered them their own label under the Comme des Garçons umbrella, like Junya Watanabe and Tao Kurihara, but when Horihata said they wanted to explore Japanese culture, she suggested that they start their own company. "She wanted to be free from history or nationality or things like that," Horihata says of Kawakubo. "She wanted to make clothes that nobody has ever seen . . . extreme beauty." Yet he wondered: "Why do we need something we've never seen? I'm looking for something new, too, but not avant-garde new."[118]

Hidenobu Yasui is another young designer, who compares himself to a traditional Japanese craftsman. A graduate of Central Saint Martins College of Art and Design, he returned to Japan for high-quality Japanese textiles and production techniques.

One very talented designer who recently went out of business (we hope not for good) is Yoshiki Hishinuma. In 1984, he worked briefly

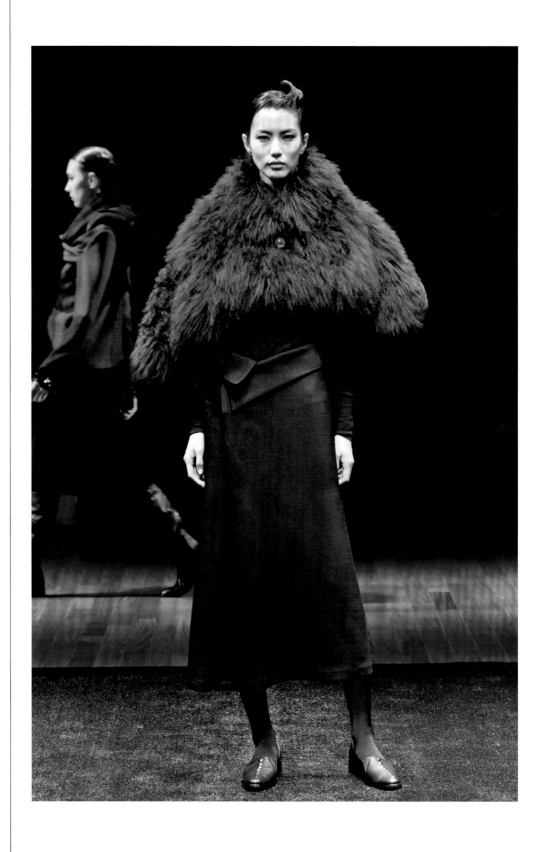

matohu, ensemble, from the Autumn/Winter
2009–10 Kabukimono collection,
photo courtesy matohu

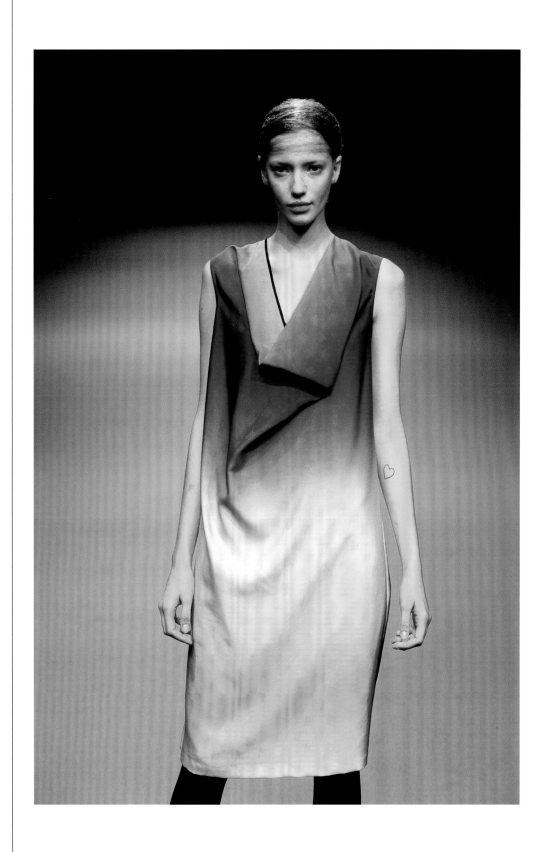

matohu, "Winter Morning" ensemble,
from the Kasane (Layers) collection,
Autumn/Winter 2010–11,
photo courtesy matohu

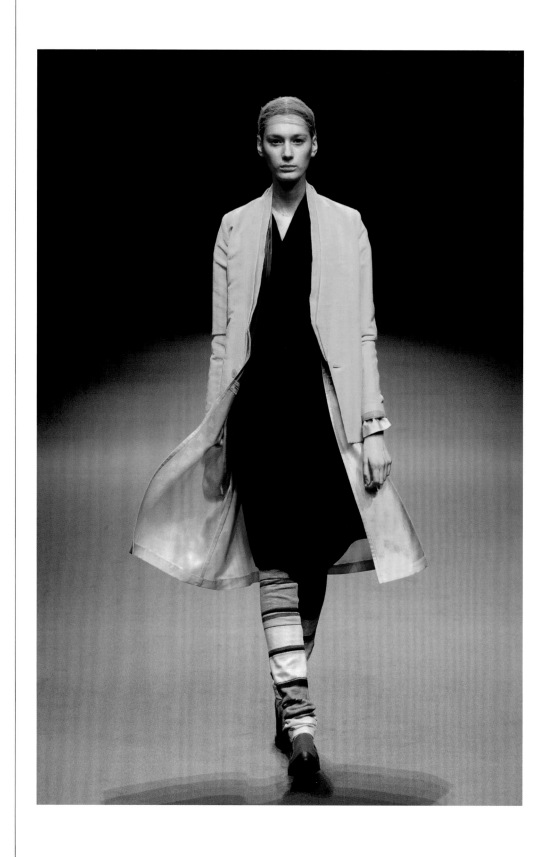

matohu, "Fallen Petals" ensemble,
from the Kasane (Layers) collection,
Autumn/Winter 2010–11,
photo courtesy matohu

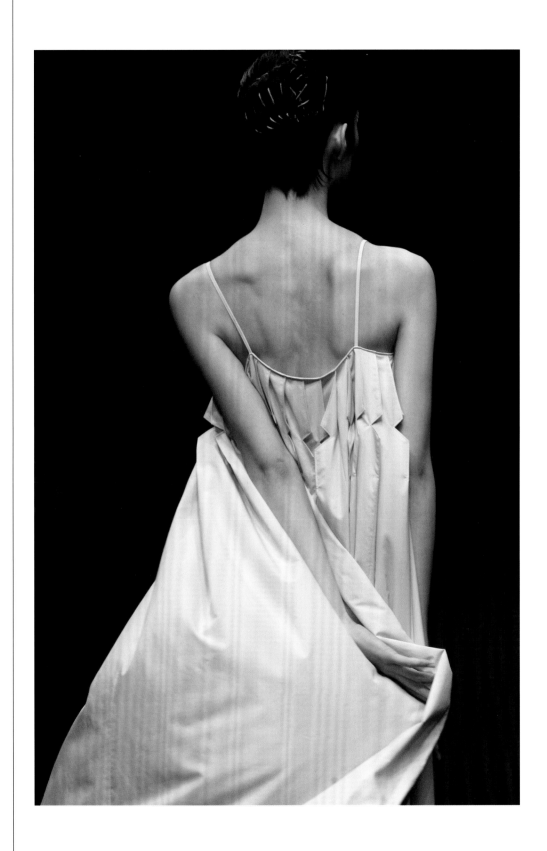

Hidenobu Yasui, dress,
Spring/Summer 2009,
model: Tao Okamoto/
Supreme Model Management,
photo courtesy Hidenobu Yasui

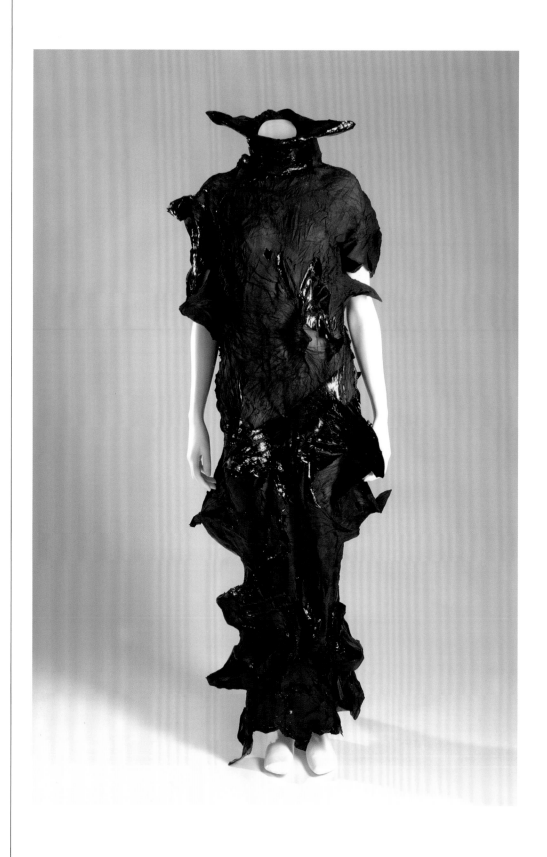

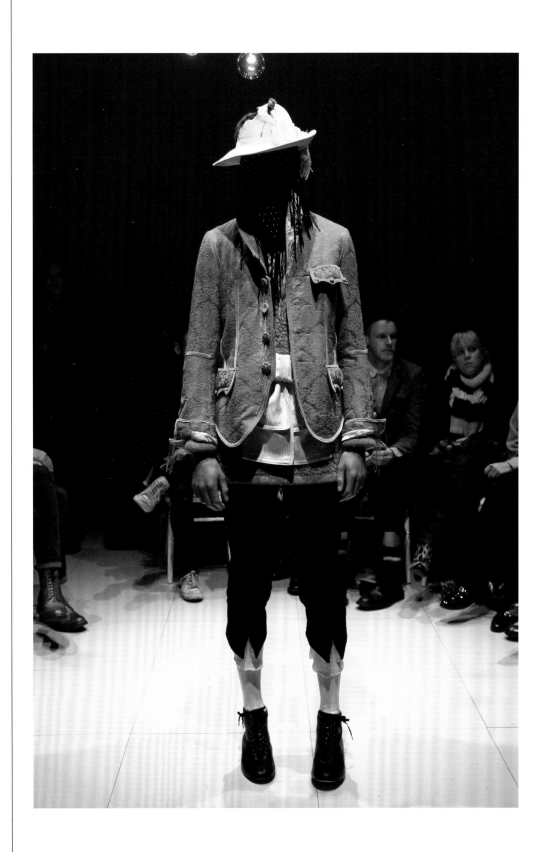

Number (N)ine, man's ensemble,
Autumn/Winter 2009,
photo: Mr. Mamoru Miyazawa,
courtesy Number (N)ine

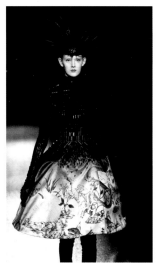

as an assistant to Issey Miyake. "It was really fun, and I learned a lot," Hishinuma recalls. "His studio was so creative." But Hishinuma was a messy worker and when Miyake suggested that he tidy his desk, he responded by sweeping everything onto the floor and quitting. After a period designing costumes for stage and film, he began designing fashion again, and launched his own label in 1996. Like Miyake, Hishinuma is known for his use of high-tech materials combined with traditional Japanese techniques, such as *shibori* or tie-dying. He spent a lot of time and energy working with new technology, such as three-dimensional knitting machines. After a decade, he received external funding from a Korean company, expanded – and then suddenly went out of business. "It was horrible, losing the company," he says now, "but I was also excited, because I could start a new life. For the past fifteen years, there's been no new technology, so at the moment I'm not so excited about making clothes, because I don't want to do the same things."[119] But for every designer who closes his or her business, a host of others spring up.

Toshikazu Iwaya first came to prominence as designer for the cleverly named company Dresscamp, which was known for its unique prints (not surprisingly, since Dresscamp was owned by a textile company). A graduate of Bunka, Iwaya began his career designing textiles, and segued into designing both men's and women's fashions. After establishing one of the hottest collections to show in Tokyo, he left Dresscamp and started his own company, DRESS33. He also began showing in Paris.

Iwaya's designs are bold, sexy, and colorful. "I always liked Versace," says Iwaya. "He created something flashy and flamboyant – really creative, too." More surprisingly, he also admires the work of the much older Japanese designer Hanae Mori. "Her style is very European, with couture technique, but she also expresses Japanese traditions and culture. I think that's wonderful." Unlike many other Japanese brands, which emphasize casual street styles, Iwaya's aesthetic is "high fashion," making few allusions to Japanese popular culture. Asked about Comme des Garçons and Yohji Yamamoto, he says: "They're great. Their clothes are valuable, because they were born from a sense of rebellion against straight European fashion." Yet he

TOP:
Toshikazu Iwaya for DRESS33,
photo: Leslie Kee, courtesy DRESS33

BOTTOM:
DRESS33, dress ensemble,
Autumn/Winter 2009–10,
photo courtesy DRESS33

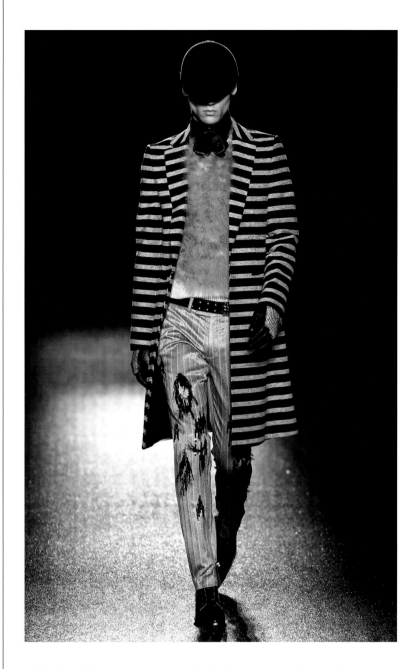

adds that "there is no sense of rebellion today, it's just about making beautiful-looking clothes." His own philosophy, he says, can be summed up as "Fashion is fun."[120]

Among the most interesting designers in Japan are those who work in menswear, many of whom are inspired by retro American or British

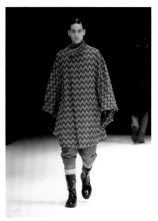

styles, from punk to preppy, and from grunge to Savile Row. Takahiro Miyashita launched his menswear company Number (N)ine in 1997. It closed in 2009, but during those twelve years he designed an influential line inspired by his love of music. It was more subdued than many other Japanese brands that shared its rock and punk inspiration. Although it is a cliché to say that his clothes gave a modern twist to classic styles, this remains the most accurate description. He loved a wide range of mostly American menswear classics, from cowboy-style Stetsons to grunge plaids, but in his hands they became new and vital.

Preppy style may seem "as all-American as it gets," and certainly the look has "its roots in the United States," as journalist David Colman observes. But the Japanese have made the Ivy look their own as part of an ongoing enthusiasm for classic American styles, from Levis to khakis. During the 1980s, when the yen became strong, many Japanese traveled to the United States to scout for vintage Americana and classic American brands to import to Japan. "It's funny – this authentic Americana, people in the States didn't care about it at all," recalls designer Daiki Suzuki. "But I would take it back, and everybody would say, 'Wow, this is really great.'" Certain classic American companies became, in effect, Japanese, over time. J. Press, the Ivy League clothier founded in New Haven in 1902, for example, was bought by Kashiyama in 1986, and now sells vastly more in Japan than in the United States. By the twenty-first century, Colman concluded that "the spirit, rigor and execution of today's prep moment is as Japanese as Sony."[121]

Daisuke Obana is founder of the label N.HOOLYWOOD. After dropping out of school, Obana began working at a used-clothing store. After opening a more high-end vintage shop, he started N.HOOLYWOOD in 2000 and began presenting collections in 2002. Obana's style is clearly inspired by classic vintage garments, such as work wear, but each collection has a subtly different feeling. One season, the look may be reminiscent of New York's East Village, while another season, Obana will bring Ivy style up to date. The Autumn/Winter 2007-8 collection, for example, was inspired by the idea of a 1960s football match between Harvard and Yale. While readily admitting that "Ivy League

TOP:
N.HOOLYWOOD, man's ensemble from the Medical collection, Spring/Summer 2003, photo courtesy N.HOOLYWOOD

BOTTOM:
N.HOOLYWOOD, man's ensemble from the Skyscraper collection, Autumn/Winter 2009–10, photo courtesy N.HOOLYWOOD

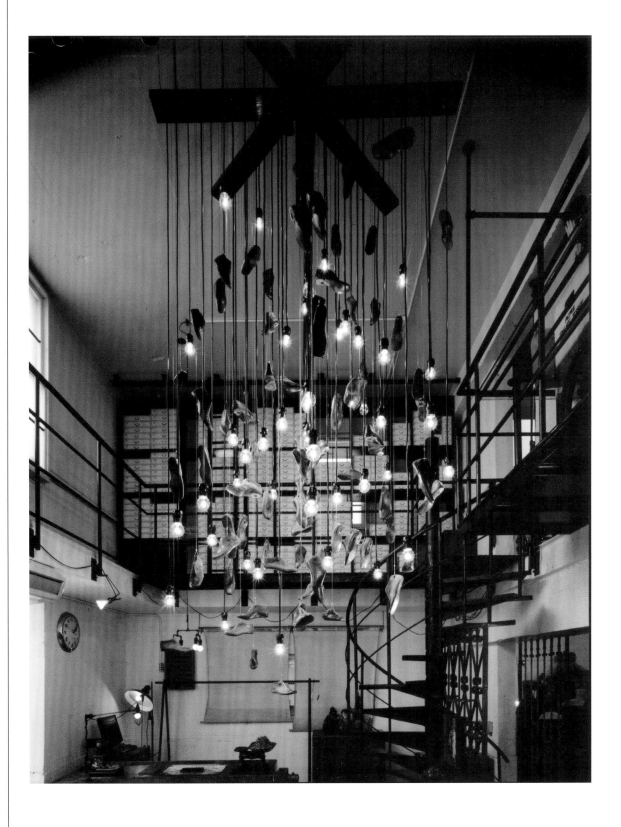

ABOVE:
N.HOOLYWOOD, store exterior,
Tokyo, Japan,
photo: Kozo Takayama,
courtesy N.HOOLYWOOD

RIGHT:
N.HOOLYWOOD, store interior,
Tokyo, Japan,
photo: Kozo Takayama,
courtesy N.HOOLYWOOD

fashion has already been interpreted many times," Obana further observed that "it's not necessarily the coolest look." He visited both Harvard and Yale and did research on their traditions and unique characteristics before adding his own "twisted point of view."[122]

Arashi Yanagawa was born in 1975 and achieved national recognition as a professional boxer. Obsessed with fashion even then, he "liked the way British style was based on tradition and history." Visiting London's Savile Row, he was captivated by the classic tailoring and "amazing materials," and he was deeply impressed by the "specialized expertise of the tailors" there. He also liked shopping in London's vintage stores, and he thought of opening a vintage shop of his own in Japan. Then it occurred to him that maybe he could "create clothes."

"I liked British things so much that I chose an English name for my company," he recalled. "Then I found out that John Lawrence Sullivan was an Irish-American boxer." Because his professional background was not in the fashion industry, he found people in Japan with the specialized skills needed to make high-quality, British-style menswear, often older workers in their fifties or sixties. He began by bringing classic jackets to the factory, and discussing how he wanted subtly to adjust the styles. For example, Japanese men in their twenties and thirties want a narrower silhouette and an "edgier" attitude than is typical for Savile Row. Arashi Yanagawa admires Ralph Lauren "because he does things the British way, but what his clothes express is actually very American. I want to do that for Japanese style."

Junichi Abe founded his brand kolor in 2004. He avoids themes, focusing instead on making each individual garment comfortable and interesting. His clothes are available in Japan at prestigious stores such as United Arrows District and International Gallery Beams, as well as at L'Eclaireur in Paris and Browns in London. His wife is Chitose Abe of sacai.

Yasuko Furuta named her company TOGA because it was "an easy, short word" that referred back to "a draped garment worn by the ancient Romans that is considered to be the prototype of western cloth-

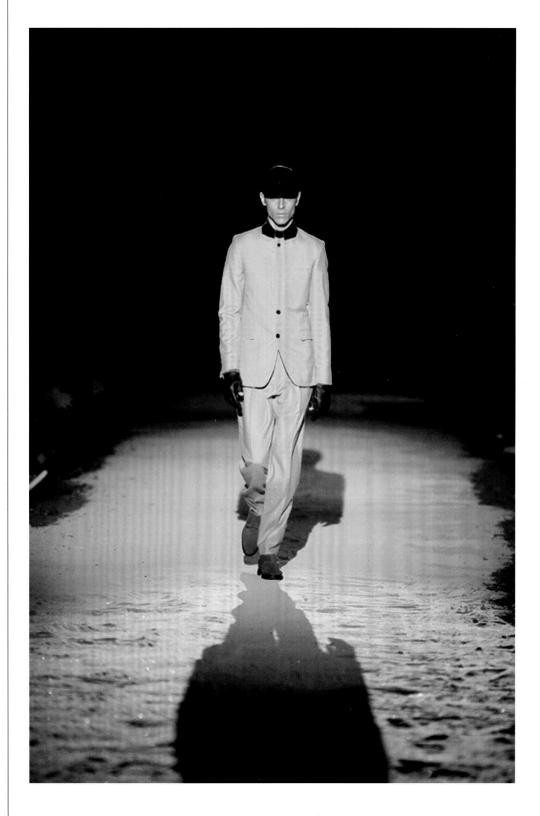

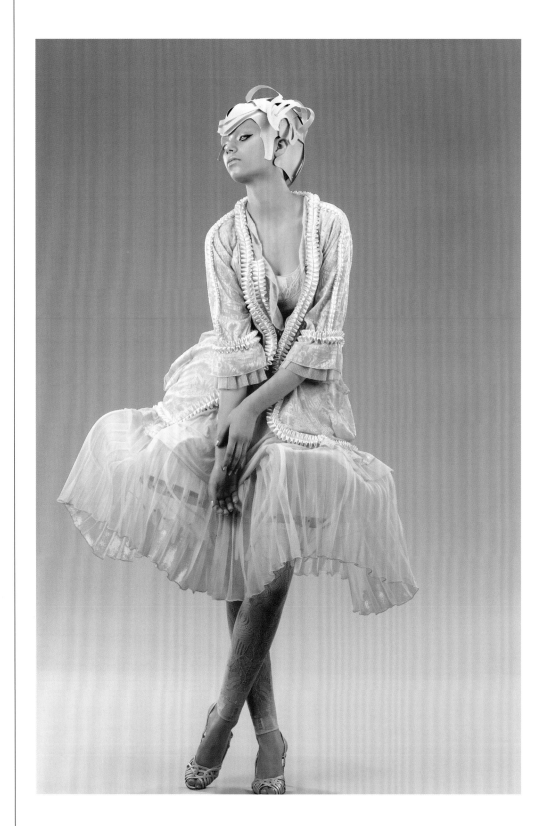

SOMARTA, Jellyfish dress,
Spring/Summer 2009,
[EVOLUTION–BODY] AD&D:
Takeshi Fukui +Tamae Hirokawa/
SOMA DESIGN,
photo: Keita Sinya (ROLLUP studio),
hair: Jun Matsumoto (tsuji management),
makeup: Mariko Tagayashi
and the MAC PRO team,
makeup provided by MAC,
CG: SOMA DESIGN,
photo courtesy SOMARTA

TOGA, dress, Autumn/Winter 2009–10,
photo: Tetsuya Toyoda, courtesy TOGA

ing." She studied at the French design school ESMOD and remembers: "When I was living in Paris, I felt I was so Japanese – I was trying to move people's souls." Her aesthetic remains dramatic, often expressing conflict and emotion, with each collection inspired by a theme, such as "birds hiding in the dark forest." Her collections have names, such as Trojan Horse, Phantom, and Metal Machine Dress. She believes, correctly, that her work is "more erotic than [that of] other Japanese designers." It is even a little "fetishistic," she suggests.[123]

Tamae Hirokawa founded her company SOMARTA in 2006, combining the Sanskrit words *soma* and *amrta*, thus alluding to Hindu mythology. Her clothes are often inspired by fantasy and futurism, but she also seeks to create for adult women who work and who love fashion. She formerly worked on knitwear for Issey Miyake, and continues to be interested in the relationship between technology and garment making. "Miyake tries to please and entertain people – I learned that from him."[124]

Japan Fashion week in Tokyo features many designers and brands, from Tiny Dinousaur and mint designs to G.V.G.V and Theatre Products. Although often charming, most have only a niche market within Japan and probably little likelihood of expanding internationally. The menswear brands are more interesting. In addition to those already mentioned, certain shows in Tokyo made a very strong impression.

Miharayasuhiro is designed by Yasuhiro Mihara, who began his career designing shoes and sneakers before moving on to menswear and now also womenswear and accessories. He has collaborated with Puma and with dress for Playstation. His wife is a well-known jazz pianist who often performs in New York, and there is a jazzy insouciance about his designs, many of which feature exceptional textiles. The menswear brand Factotum also presented a strong, sexy collection based on layering.

White Mountaineering is another very hot menswear brand. Designer Yosuke Aizawa worked at Comme des Garçons before starting his own company, which combines function and fashion, utilizing

Tenth anniversary sneaker sketches from Miharayasuhiro's collaboration with Puma, 2010, courtesy Miharayasuhiro

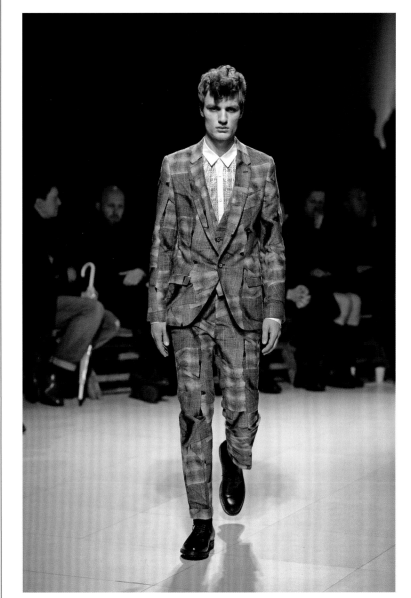

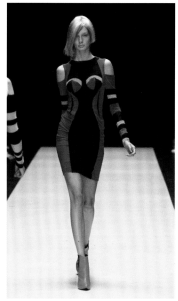

CLOCKWISE FROM LEFT:

Miharayasuhiro, man's "Photo Jacquard" suit
ensemble, Autumn/Winter 2010–11,
photo courtesy Miharayasuhiro

G.V.G.V. dress, Spring/Summer 2009,
photo courtesy G.V.G.V.

Han Ahn Soon, dress from the Toy collection,
Autumn/Winter 2008,
photo courtesy Han Ahn Soon

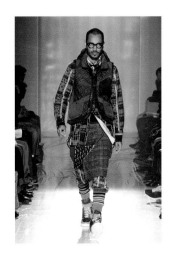

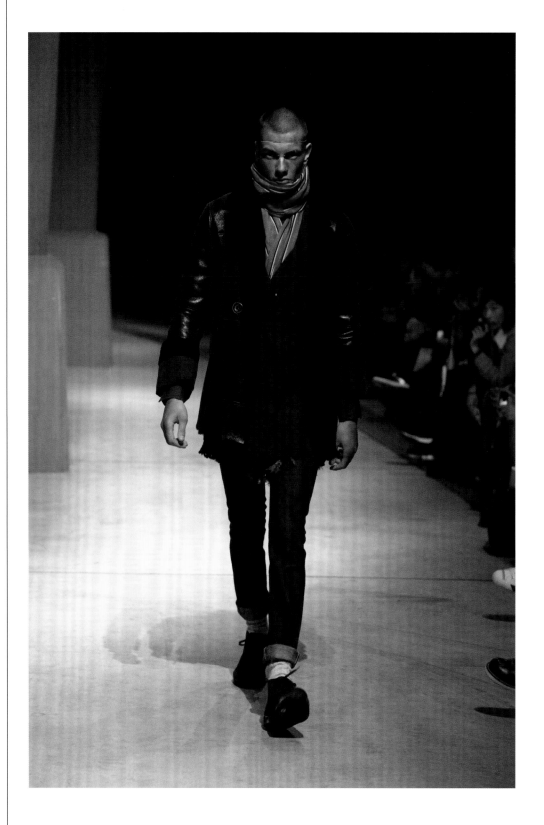

ABOVE:
White Mountaineering, man's ensemble,
Autumn/Winter 2010–11,
photo: Hiroyuki Kamo,
courtesy White Mountaineering

RIGHT:
Factotum, man's ensemble,
Autumn/Winter 2010–11,
photo courtesy Factotum

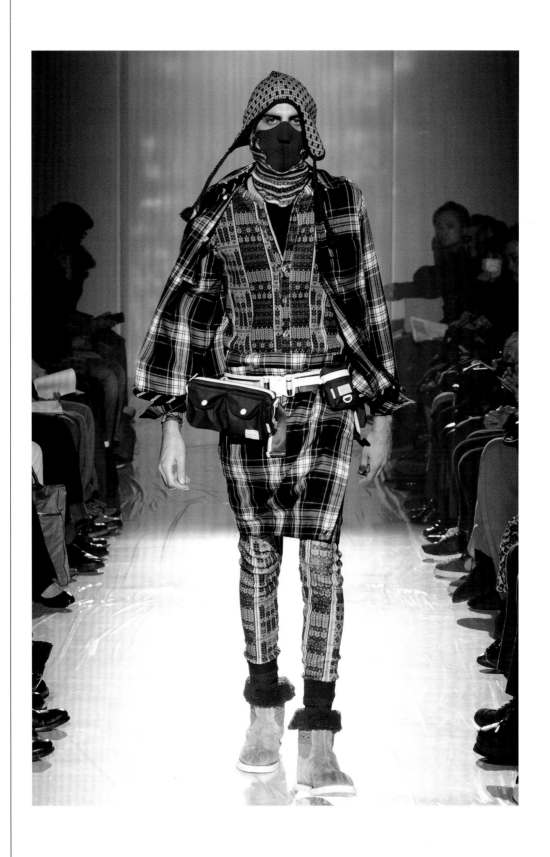

White Mountaineering, man's ensemble,
Autumn/Winter 2010–11,
photo: Hiroyuki Kamo,
courtesy White Mountaineering

advanced fabrics but going beyond active sportswear. For Autumn/
Winter 2010–11, White Mountaineering emphasized layering and
skirt-like effects, with, for example, a kilt over trousers. "I know men
won't wear a feminine skirt," Aizawae says, "so I make it masculine
and comfortable, like a kilt or the apron that a waiter wears, which
looks cool and masculine."[125]

But the highlight of my experience of Japan Fashion Week came
with the first runway presentation by Phenomenon. The designer
for Phenomenon, Takeshi Osumi, is a larger-than-life figure, who
never studied fashion and is always inspired by music. His Autumn/
Winter 2010 collection, held on a cold night at the National
Stadium, began with the sound of classical music, which suddenly
segued into pounding garage rock. The classical music, Osumi ex-
plained later, represented school, and in his scenario, when the boy
leaves for his secret life after school, his own style of music kicks
in. The boy goes to his secret place, an abandoned factory building,
full of cobwebs and insects, but also interesting old objects, such as
lengths of rope, old playing cards, and pieces of samurai practice ar-
mor. These objects, as well as memories from childhood, inspire the
garments in the collection.

The collection was filled with highly desirable garments – such as a
trench coat with a long skirt worn over an ankle-length shirt and a
spiky jacket that evokes both military armor and the outer carapace of
an insect. Several jackets are entwined with rope. One configuration
of rope is based on the way Japanese prisoners were traditionally tied
up (in the era before handcuffs), but another style alludes to sexual
bondage. "You can wear it on the street," says Osumi, but there's also
"a secret theme . . . how the boy ties up his girlfriend in the factory."
One garment has pattern of tanks "like the boy used when he was a
child playing soldiers." Another jacket unzips in such a way that it
conjures up the way a cockroach unfolds its wings.[126]

Nevertheless, some Japanese are willing to pay high prices for exactly
the right clothes – not necessarily European high fashion, but perhaps
the perfect pair of vintage Levi 501s from the 1950s. Blue jeans are

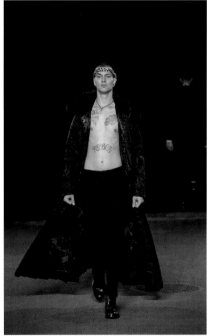

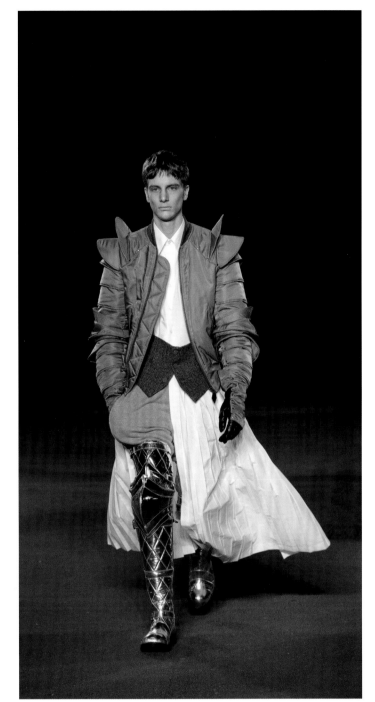

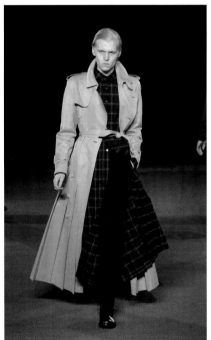

CLOCKWISE FROM TOP LEFT:

SUGAR CANE, EDO-Ai Denim,
photo courtesy Toyo Enterprise Company Ltd

BUZZ RICKSON'S William Gibson Collection,
black MA-1 jacket, photo courtesy Toyo
Enterprise Company Ltd.
BUZZ RICKSON'S, Black Buffalo Jacket,
photo courtesy Toyo Enterprise Company Ltd

BUZZ RICKSON'S William Gibson Collection,
Black N3-B jacket, photo courtesy Toyo
Enterprise Company Ltd.

SUGAR CANE, Okinawa Denim, photo
courtesy Toyo Enterprise Company Ltd

probably America's greatest contribution to fashion, but jeans have reached their peak of perfection in contemporary Japan. Because so many Japanese are obsessive about authentic vintage denim, their price skyrocketed, and a number of companies began investigating how they could replicate the look and feel of vintage denim.

Experts agree that "Japan is the source of the most sought-after denim in the world."[127] Leading Japanese denim brands include Flat Head, Iron Heart, Dry Bones, SUGAR CANE, and Real Japan Blues. "They've perfected the art of reproducing garments the way they made them 50 to 100 years ago," says Kiya Babzani. The first American to focus on importing premium Japanese denim, Babzani was sued by Levis on the grounds of copyright violation. In response, he urged the Japanese brands he imported to remove the tell-tale red tab and alter the characteristic Levis arcuates, while retaining the "robust quality" and "attention to detail" that makes Japanese denim special.[128]

Contemporary Japanese fashion also focuses on work wear or military "products" made by companies that focus obsessively on the perfection of classic garments, sometimes with a pop element. mastermind JAPAN is a very expensive cult label that produces items such as denim jeans and camouflage jackets. Another, rather obscure

yet quite wonderful Japanese company, BUZZ RICKSON's, replicates vintage military jackets and workwear, and has created the William Gibson collection, named after the writer whose cyberpunk novels portray a weird, wired Tokyo-of-the-future. Atsushi Yasui's Free-wheelers and Company also makes beautifully crafted, vintage-style clothes. Bringing American classics back home, Daiki Suzuki's company, Design Engineered Garments, is an American-based brand with a rigorous aesthetic. Suzuki is also responsible for the revival of another classic American company, Woolrich Woolen Mills.

TOP LEFT:
Hiroki Nakamura of visvim,
photo: Adrian Gaut,
courtesy visvim

TOP RIGHT:
visvim, inspiration image, Lapland, Norway,
June 2008,
photo: Hiroki Nakamura,
courtesy visvim

BOTTOM:
visvim, Inspiration image,
Highland, Scottland, Summer 2009,
photo: Hiroki Nakamura,
courtesy of visvim

CLOCKWISE FROM TOP LEFT:

visvim, blue cotton shirt,
Autumn/Winter 2009–10,
photo courtesy visvim

visvim, olive green Gortex jacket,
Autumn/Winter 2009–10,
photo courtesy visvim

visvim, suede Virgil boot, non-seasonal
special item,
photo courtesy visvim

visvim, denim jeans,
Autumn/Winter 2009–10,
photo courtesy visvim

Extreme, even fanatical, attention to detail is characteristic of much of the best Japanese fashion. visvim is one of the most significant brands in Japan that focuses on menswear. Hiroki Nakamura moved to Alaska as a student but later traveled around the United States, collecting and re-selling old Levis, which he regarded as more "authentic" than new ones. "I was buying denim in US warehouses and skateboarding." He began his career working for a snowboarding company, first in sales, then in design. Today, his company – visvim – is based on the concept of updating archetypal designs and fashionable clothing as a "utility product."

visvim got its start in 2000 as a footwear brand, expanding into apparel four years later. It is still perhaps best known for making comfortable, lightweight, high-performance shoes. One model is based on Vietnam War-era military boots, but it is made of Italian "vachetta" leather, "breathable leather, so you can wear the boots without socks." Nakamura works with special leather manufacturers in Italy who use natural vegetable tanning without chemicals.

Known for its use of high-quality materials, visvim is sold at Colette in Paris, Dover Market in London and F.I.L. stores in Japan. Nakamura recently began a collaboration with Moncler. Nakamura begins with intensive research into traditional materials and work clothes. In order to make denim jeans that looked and felt like old denim, for example, he acquired vintage machines and explored traditional dying technology. His goal, he says, is to make "good products that last a long time," because "the consumer culture has to be changed."[129]

Yet the Japanese are equally drawn to novelty. "I love Japan. I just think they're the craziest fashion eaters in the world. They just eat it up and spit it out," said menswear designer Neil Barrett in 2009. "I think they're more critical than anyone in the world," he added. "If you don't create that newness, then they're not interested."[130] Veteran Japanologist Donald Richie agrees. Image change – *imeji cheinji* – is a phrase "often on the lips of young Japanese," he reports, when they notice "some difference in the appearance of their friends: hair dyed a novel shade, something odd in the way of sunglasses, a new cellphone with . . . a Tweetie-Bird strap instead of a Hello-Kitty."[131] Or

as Yo Shitara, the president of the Beams, puts it: "The people on the streets curate culture. That's how we Japanese have contributed to world fashion."[132]

Japan continues to be on the cutting edge, maybe even the bleeding edge, of fashion. However, Japanese fashion today embraces not only the cerebral, avant-garde looks associated with the first wave of Japanese design in the 1980s, but also a range of youth-oriented street styles, such as the popular Gothic Lolita look. Indeed, contemporary Japanese fashion remains significant globally precisely because it mixes elements of the avant-garde (pushing the aesthetic envelope at the level of "high" art) with aspects of subcultural and street style. Equally significant, however, is the Japanese obsession with perfecting classic utilitarian garments, such as jeans, sneakers, and leather jackets. Is Japan still the future? Maybe; it definitely still looks like the future.

notes

1 Barbara Vinken, *Fashion Zeitgeist: Trends and Cycles in the Fashion System,* Oxford and New York: Berg, 2005.

2 Fran Lloyd, ed., *Consuming Bodies: Sex and Contemporary Japanese Art,* London: Reaktion Books, 2005.

3 Antonio Finanne, *Changing Clothes in China: Fashion, History, Nation,* New York: Columbia University Press, 2007.

4 Ivan Morris, *The World of the Shining Prince: Court Life in Ancient Japan*, New York: Knopf, 1964.

5 Liza Crihfield Dalby, *Kimono: Fashioning Culture*, New Haven and London: Yale University Press, 1993.

6 Roger J. Davies and Osamu Ikeno, eds., *The Japanese Mind: Understanding Contemporary Japanese Culture*, Tokyo, Rutland, Vermont, and Singapore: Tuttle Publishing, 2002.

7 Kishino Haga, "The Wabi Aesthetic through the Ages," in Nancy G. Hume, ed., *Japanese Aesthetics and Culture,* Albany: State University of New York Press, 1995.

8 Harold Koda, "Rei Kawakubo and the Aesthetic of Poverty," *Dress: Journal of the Costume Society of America*, no. 11, 1985, p. 8.

9 Dalby, *Kimono*, 1993.

10 Ibid.

11 Shuzo Kuki, *Reflections on Japanese Taste: The Structure of Iki,* trans. John Clark, Sydney: Power Publications, 1997.

12 Peter N. Dale, *The Myth of Japanese Uniqueness,* New York: St. Martin's Press, 1986.

13 Toby Slade, *Japanese Fashion: A Cultural History*, Oxford and New York: Berg, 2009.

14 Ibid., p. 19.

15 Ibid., p. 42.

16 Ibid., p. 154.

17 Donald Roden, *Schooldays in Imperial Japan: A Study in the Culture of an Elite,* Berkeley: University of California Press, 1980.

18 Ibid., p. 151.

19 Brian J. McVeigh, *Wearing Ideology: State, Schooling and Self-Presentation in Japan,* Oxford and New York: Berg, 2000.

20 Ibid., p. 3.

21 Masao Miyamoto, *Straightjacket Society: An Insider's Irreverent View of Bureaucratic Japan,* Tokyo, New York, London: Kodansha International, 1994.

22 Kendall H. Brown and Sharon Minichiello, *Taisho Chic: Japanese Modernity, Nostalgia and Deco*, Honolulu: Honolulu Academy of Arts, 2002.

23 Jackie Menzies, ed., *Modern Boy, Modern Girl: Modernity in Japanese Art, 1910–1935,* Sydney: Art Gallery of New South Wales, 1998.

24 Junichiro Tanizaki, *Naomi: A Novel,* Oxford and New York: Berg, 2001.

25 Miriam Silverberg, *Erotic Grotesque Nonsense: The Mass Culture of Japanese Modern Times*, Berkeley and Los Angeles: University of California Press, 2006.

26 Leonard Koren, *New Fashion Japan*, Tokyo: Kodansha International, 1984.

27 Marc Schilling, *The Encyclopedia of Japanese Pop Culture,* New York: Weatherhill, 1997.

28 Ibid., p. 317.

29 Yuniya Kawamura, *The Japanese Revolution in Paris Fashion*, Oxford: Berg, 2004.

30 Bernadine Morris, "Designer Does What He Likes – And It's Liked," *New York*

Times, July 12, 1972.

31 Judith Thurman, "The Misfit," *New Yorker*, July 4, 2005.

32 Ibid.

33 Patricia Mears, "Fraying the Edges: Fashion and Deconstruction," in Brooke Hodge, Patricia Mears and Susan Sidlauskas, *Skin + Bones: Parallel Practices in Fashion and Architecture*, London: Thames & Hudson, 2006.

34 Quoted in Akiko Fukai, "A New Design Aesthetic," in Louise Mitchell, ed., *The Cutting Edge: Fashion from Japan*, Sydney: Powerhouse Publishing, 2005.

35 Mary L. Long, "Yohji Yamamoto," *People*, November 1, 1982.

36 Holly Brubach, "The Truth in Fiction," *The Atlantic*, May 1984.

37 Suzy Menkes, "Feminist versus Sexist," *The Times*, March 22, 1983.

38 Koren, *New Fashion Japan*.

39 "The Next Dimension – The New Wave of Fashion from Japan," *Vogue*, April 1, 1983.

40 "The Contrast," *Vogue*, July 1983.

41 Skov, Lisa, "Fashion, Trends, *Japonisme* and Postmodernism, or What is so Japanese about *Comme des Garçons?*" *Theory, Culture & Society*, XIII, no. iii, August 1996, pp. 129–51.

42 Alex Kerr, *Lost Japan,* Hawthorne, Australia: Lonely Planet, 1996.

43 Fondation Cartier pour l'art contemporain, *Issey Miyake: Making Things,* Zurich, Berlin, and New York: Scalo, 1998.

44 Ibid., p. 52.

45 Haga, "The Wabi Aesthetic through the Ages."

46 Schilling, *The Encyclopedia of Japanese Pop Culture.*

47 Patrick Macias and Izumi Evers, *Japanese Schoolgirl Inferno*: Tokyo Teen Fashion Subculture Handbook, San Francisco: Chronicle, 2007.

48 Schilling, *The Encyclopedia of Japanese Pop Culture.*

49 Ikyua Sato, *Kamikaze Biker: Parody and Anomy in Affluent Japan*, Chicago and London: The University of Chicago Press, 1991.

50 Ibid., pp. 53–58.

51 Ibid., pp. 107–08.

52 Laura Miller, "Youth Fashion and Changing Beautification Practices," in *Japan's Changing Generations: Are Young People Creating a New Society?* London and New York: Routledge Curzon, 2004, p. 88.

53 Laura Miller, *Beauty Up: Exploring Contemporary Japanese Body Aesthetics*, Berkeley, Los Angeles, and London: University of California Press, 2006.

54 Isaac Gagné, "Urban Princesses: Performance and 'Women's Laguage' in Japan's Gothic/Lolita Subculture," in *Journal of Linguistic Anthropology*, XVIII:i, pp. 130–50.

55 Tiffany Godoy, *Style Deficit Disorder: Harajuku Street Fashion Tokyo*, San Francisco: Chronicle Books, 2007.

56 Ibid., p. 144.

57 Kumiko Uehara and Akinore Isobe, interview with Valerie Steele, March 2010.

58 Hiroko Honda, Asüka, and Maki, interview with Valerie Steele, March 2010.

59 Philomena Keet, *The Tokyo Look Book*, Tokyo: Kodansha International, 2007.

60 Theresa Winge, "Undressing and Dressing Loli: A Search for the Identity of the Japanese Lolita," in Frenchy Lunning, ed., *Mechademia 3: Limits of the Human*, Minneapolis and London: University of Minnesota Press, 2008.

61 Ibid., pp. 57–58.

62 Laura Miller and Jan Bardsley, eds., *Bad Girls of Japan*, New York: Palgrave Macmillan, 2005.

63 Mary Roach, "Cute Inc.," *Wired*, December 1999.

64 Sharon Kinsella, "Cuties in Japan," in Lisa Skov and Brian Moeran, eds., *Women, Media, and Consumption in Japan*, Honolulu: University of Hawaii Press, 1995.

65 Ibid., p. 229.

66 Godoy, *Style Deficit Disorder*.

67 Kinsella, "Cuties in Japan," in Skov and Moeran, eds., *Women, Media, and Consumption in Japan*.

68 McVeigh, *Wearing Ideology*.

69 Ibid., pp. 135–36, 138, 162.

70 Ibid., p. 157.

71 Ibid., pp. 161–65.

72 Ibid., p. 179.

73 Gagné, "Urban Princesses: Performance and 'Women's Laguage' in Japan's Gothic/Lolita Subculture."

74 Kaori Shoji, "Cult of the Living Doll in Tokyo," *New York Times*, February 8, 2010.

75 Shinichi Kashihara, interview with Valerie Steele, February 2010.

76 Hitomi Nomura, Naoki Tobe, and anonymous Mori girl, inteview with Valerie Steele, March 2010

77 *Mori Girl* magazine.

78 Misako Aoki, interview with Valerie Steele, February 18, 2010.

79 Margreit Brehm, ed., *The Japanese Experience – Inevitable*, Kraichtal: Ursula Blickle Foundation and Hatje Cantz Verlag, 2002.

80 Douglas McGray, "Japan's Gross National Cool," *Foreign Policy*, May/June 2002.

81 "Manga X Mode Special," Japanese *Vogue*, July 2009; "Manga Takes the Catwalk," Japanese *Vogue*, July 2009.

82 "Costume Play!" and "Manga", Japanese *Vogue*, July 2009.

83 Kyojiro Hata, *Louis Vuitton Japon: L'Invention du Luxe*, Paris: Assouline, 2004.

84 Suzy Menkes, "Undercover: Strange, 'But Beautiful'," *International Herald Tribune*, May 31, 2006.

85 "Kurai Kawaii: Interview with Jun Takahashi," *Metropolis*, http://archive.metropolis.co.jp/tokyo/454/fashion.asp.

86 Sarah Mower, "Fight Club," *Vogue*, September 2006.

87 Menkes, "Undercover: Strange, 'But Beautiful'."

88 Mower, "Fight Club."

89 Katsuhide Morimoto, *Grace*, 2008.

90 Jun Takahashi, interview with Valerie Steele, Tokyo, Japan, March 2010; and text for Avakareta Life, catalogue for Autumn/Winter 2010–11 Undercover collection.

91 Mower, "Fight Club."

92 Mower, "Fight Club."

93 Tao Kurihara, interview with Valerie Steele, June 2008.

94 *Women's Wear Daily*, October 10, 1996.

95 Cathy Horyn, "Gang of Four," *New York*

Times Style Magazine, Spring 2008.

96 *Women's Wear Daily*, March 7, 1994.

97 Ibid., March 13, 1996.

98 Mower, "Fight Club."

99 Mitsuko Watanabe, Japanese *Vogue*, December 2009.

100 Mitsuko Watanabe, interview with Valerie Steele, June 2008.

101 "Junya Watanabe and Tao Kurihara – What is Their Idea of the Spirit of Commes des Garçons?" interview with Mitsuko Watanabe, *Vogue Nippon*, December 2009.

102 Mitsuko Watanabe, interview with Valerie Steele, June 2008.

103 Ibid.

104 Mower, "Fight Club."

105 Susannah Frankel, "An Un-bride-led classic," *Independent*, April 2, 2007.

106 Maya Nago, "Tokyo Designers Talking: Daisuke Obana, N.Hoolywood," *High Fashion*, August 2007.

107 Ibid.

108 H. Naoto, interview with Valerie Steele, June 2008.

109 Ibid.

110 Indivisual.tv, "h.Naoto Designer Exclusive Interview," December 10, 2009, online video for Youtube.com.

111 Ibid.

112 H. Naoto, interview with Valerie Steele, June 2008.

113 Ibid.

114 "Story of Two Brands: sacai + TOGA," *High Fashion*, February 2009.

115 Ibid.

116 Lau, Vanessa, "Turning Japanese," *W,* March 2010.

117 Hiroyuki Horihata and Makiko Sekiguchi of Matohu, interview with Valerie Steele, March 2010.

118 Lau, "Turning Japanese," p. 166.

119 H. Naoto, interview with Valerie Steele, June 2008.

120 Iwaya, interview with Valerie Steele, June 2008.

121 David Colman, "The All-American Back from Japan," *New York Times*, June 17, 2000.

122 Nago, "Tokyo Designers Talking: Daisuke Obana, N.Hoolywood."

123 H. Naoto, interview with Valerie Steele, June 2008

124 Ibid.

125 Yosuke Aizawa, interview with Valerie Steele, March 2010.

126 Takeshi Osumi, interview with Valerie Steele, March 2010.

127 Jahnvi Dameron, Nandan, *Tokyo Style File*, Tokyo: Kodansha International, 2007.

128 Ibid.

129 Hiroki Nakamura, interview with Valerie Steele, June 2008.

130 Amanda Kaiser, "Neil Barrett Mulls Selling Stake," *Women's Wear Daily*, August 7, 2009, p. 11.

131 Donald Richie, *The Image Factory: Fads and Fashions in Japan*, London: Reaktion Books, 2003.

132 Yo Shitara, interview with Valerie Steele, March 2010.

patricia mears

FORMALISM AND REVOLUTION:
rei kawakubo and yohji yamamoto

The Fashions that have swept in from the East represent a totally different attitude toward how clothes should look from that long established here. They aim to conceal, not reveal the body. They do not try to seduce through color or texture. They cannot be described in conventional terms because their shape is fluid, just as their proportions are overscale [*sic*]. Where the hemline is placed, or where the waistline is marked is immaterial . . .

Bernadine Morris, *New York Times*, 1982

Contemporary Japanese high fashion, especially as exemplified by designers Rei Kawakubo and Yohji Yamamoto, had a seismic, course-altering impact on women's clothing during the late twentieth century. The work of Kawakubo and Yamamoto proved revolutionary soon after its international debut in the early 1980s, and they have rightfully been credited with instigating profound aesthetic changes that have since permeated all levels of fashion – such as deconstruction and the dominance of the color black – and especially those changes now incorporated by fashion creators at the most exclusive clothing companies in the world. Further, more than any other Japanese designers, Kawakubo and Yamamoto have remained viable leaders on the international fashion scene for nearly thirty years.

1 Yohji Yamamoto, dress, cotton, Spring/Summer 2002. Collection of the Museum at FIT. This dress was inspired by the collection of muslins and garment prototypes by Charles James, originally donated to The Brooklyn Museum, photo: William Palmer

The early impact and ongoing relevance of Kawakubo and Yamamoto in the notoriously fickle field of fashion are testaments to their collective and individual artistic visions. While they have been recognized and acknowledged for their combined contributions, the elements that separate and distinguish their work have been less frequently analyzed. They are often discussed in tandem, as a pair with a singular, perhaps indistinguishable, shared aesthetic vision. There are a number of overriding reasons for this assumption: they have the same cultural and national heritage, having grown up in post-war Tokyo; they are of the same generation (she was born in 1942 and he in 1943); they had an intimate relationship; they presented their collections in Paris together in 1981; they successfully managed the long-term growth of their privately owned companies (anathema to the mega-brands that dominate contemporary fashion); and even as their careers took off in different directions, they experienced parallel rises, falls, and resurrections of their careers. Yet it may be said that their similarities have often served to obscure their differences.

The similarities in the work of Kawakubo and Yamamoto gain even more emphasis because modern Japanese fashion has often been viewed less as the result of individual designers' efforts than as a form of collective national expression. The phenomenon of modern Japanese fashion arose as part of Japan's economic ascent in the post-World War II era. It is widely recognized that Japan's technical and industrial prowess paralleled the rise of its creative impact on cultural media, such as film and architecture. For the fashion world, this artistic wave from Japan was a tsunami that brought with it the most meaningful non-western source of change that contemporary fashion has ever experienced.

In order to demonstrate the profound and often underrated impact of Rei Kawakubo and Yohji Yamamoto on fashion over the past three decades, it is worth examining some of the rarely addressed formal elements that define the powerful aesthetic convergences, as well as the divergences, that have made them the preeminent exponents of Japan's artistic contributions to the world of fashion design. Such an analysis reveals that these designers differ, to what may be a surprising degree, both in their working methodologies and their creative output.

Having circumvented the pitfalls of relying on cultural assumptions associated with referring to Kawakubo and Yamamoto (and other designers) as "Japanese," it is possible to assess Kawakubo and Yamamoto in more depth, looking at how they address gender and deconstruction, and the use of the color black. Sources ranging from fashion reviews, modern Japanese texts, and art and fashion history publications reveal how Kawakubo and Yamamoto have evolved, and identify how they have become so influential during their spectacular careers. Looking to the future, it is possible to see this influence in the work of Junya Watanabe, the heir apparent of artistic, global fashion created in Japan.

JAPANESE AESTHETICS AND FASHION: SHIFTING PARADIGMS

> People talk about the Japanese as if they're together in some kind of designers' mafia. In Japan, maybe they're popular somewhere at the far edge of things, but it's got nothing to do with ordinary people."
>
> Yohji Yamamoto, 1984[1]

This claim, made by Yohji Yamamoto only three years after he and Rei Kawakubo presented their work to an international audience, addressed a prevalent sentiment of the time – that all Japanese fashion designers were members of the avant-garde and that they shared nearly identical aesthetic visions. When Issey Miyake in the 1970s, then Rei Kawakubo and Yohji Yamamoto in the 1980s, presented their first fashion collections to the international audience, they were defined as "Japanese" designers. Virtually every article about them and the critical reviews of their biannual collections began the descriptions of Miyake, Kawakubo, and Yamamoto as creators inseparable from and encapsulated in their Asian heritage. Incredibly, many journalists inaccurately assumed that they produced clothing that all Japanese people wore. The reality was that those loose, dark, and seemingly tattered garments were as equally startling to the average Japanese citizen as they were to the western audience.

Today, they are still frequently referred to, first, as "Japanese designers." And it does seem logical to identify them as such – they are, after all, Japanese by birth, by culture, and by race. In contrast, however, leading European and American designers have not experienced national labeling as frequently nor as consistently.

The designers from Japan have long been frustrated with the "Japanese" label. Yamamoto noted, when he and Kawakubo presented their work in the west, that "it was upsetting as both Rei and I thought that we were doing something so international, yet the international press labeled us as Japanese. Issey [Miyake] was particularly upset about it because he didn't even arrive in Paris at the same time as us – he'd already pioneered the way."[2]

The widespread dissemination, the prevalence, and the duration of this designation in the western press leads to several questions. Is there something inherently Japanese about their designs? If so, what are the aesthetic elements that constitute such an identity? On the other hand, are writers and journalists (the vast majority of whom are western) instinctively categorizing these seemingly indefinable creators because of cultural preconceptions?

The ways in which the west categorizes and understands contemporary Japanese fashion designers and their work presents those designers with a frustrating paradox. Before embarking on a discussion of the paradox, however, it is worth remembering that although the influence of this Asian nation on western fashion is not a new phenomenon, Japan's long-term impact on fashion is all but unknown. In fact, it is commonly, and erroneously, believed that designers in the post-World War II era, such as Miyake, Kawakubo, and Yamamoto – along with Hanae Mori and Kenzo Takeda (known simply as Kenzo) – were the first to bring Japanese design influences to western fashion.

In 1994, Akiko Fukai, Chief Curator of the Kyoto Costume Institute, presented the first large-scale exhibition and accompanying publication of material illustrating the impact of *Japonisme* – or the assimilation of Japanese aesthetic principles – on fashion. While many scholars agree that Japanese art was a major influence on European

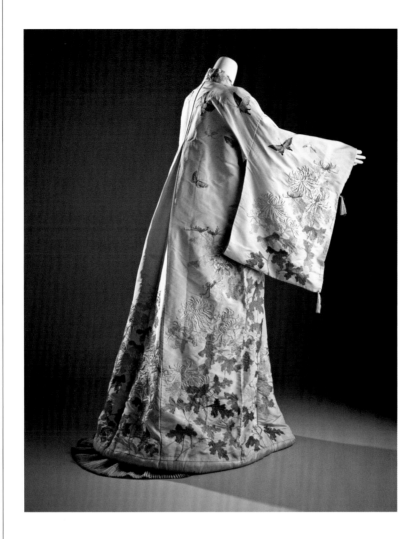

painting and decorative arts in the second half of the nineteenth century, few published sources address its influence on western dress. This is despite the fact that fashion, a concept that differs from traditional dress in that it stresses constant change, urbanity, and secularism, was an ideal medium to absorb the principals of Japonisme.

Fukai noted that it was in the second half of the nineteenth century that we began seeing European and American women's dress ornamented with Japanese-style motifs, or made of fabrics exported from Japan while still conforming to the fashionable western silhouettes of their time. Along with other scholars, such as Betty Kirke, author of *Madeleine Vionnet* (one of the most important fashion monographs

2 Dressing Gown,
silk, embroidery, c.1900,
collection of the Brooklyn Museum,
made in Japan for the western market,
photo: William Palmer

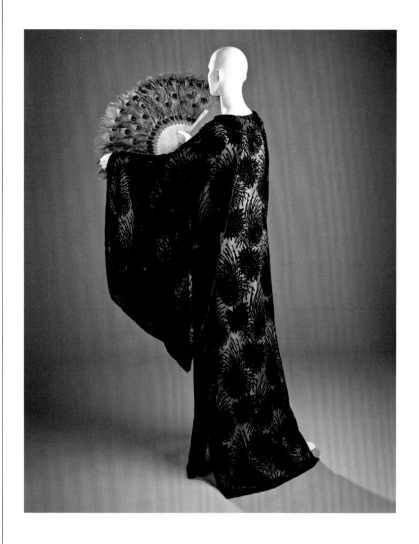

to date), Fukai clearly documented that by the early twentieth century, the influence of Japanese design was no longer confined to ornamenting the surface of Belle Époque gowns, and was becoming much more profound and integral to the very craft of haute couture. The construction of garments such as tea gowns and opera coats was revolutionized in the early twentieth century by a small group of groundbreaking couturiers like Madame Marie Callot Gerber of Callot Soeurs and her disciple, Madeleine Vionnet. Culling inspiration from the kimonos specifically made for the western market (fig. 2) and their reliance on uncut lengths of fabric, the silhouettes of many fashion items echoed Japanese components. In the early 1910s, for example, the full sleeves and crossed bodices of kimonos were incor-

3 Tea gown, devore velvet,
United States, c.1912,
collection of the Brooklyn Museum,
photo: William Palmer

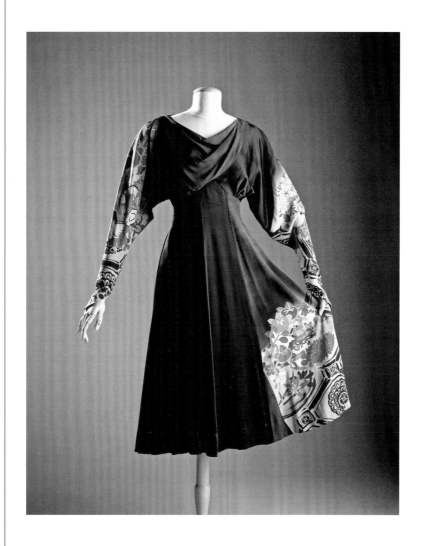

porated into loose-sleeved, v-necked evening dresses, the broad and unstructured body of kimono-inspired dramatic opera coats swathed women in batwing-shaped cocoons, and teagowns were made with long, *furisode*-like sleeves (fig. 3).

Although Japonisme (and exoticism in general) did not evaporate entirely in western fashion, the influence of non-western cultures began to diminish in the late 1920s and early 1930s. Rare examples of Japanese-inspired garments from that era include those by the American couturier Elizabeth Hawes, who used actual kimono fabrics (fig. 4). Due to the instability of the world's economy and the rise of fascist regimes in both Europe and Asia, designers began

to create modern versions of historic nineteenth-century dress that harked back to what many perceived as a golden age in European culture. It was a trend that would dominate high fashion from the late 1930s through the 1950s. By the late 1960s, with the rise of youth-driven social activism and street styles, the influence of "exotic" fashion was reawakened and began to flourish.

It was around that time, 1970, that the western fashion world witnessed the Parisian debuts of two of Japan's newest designers – Issey Miyake and Kenzo. They have been called the "first wave" of Japanese designers to capitalize on the great social changes of the late 1960s and the growing influence of ready-to-wear clothing. They were able to infuse a diverse spectrum of original elements into fashion design. While their separate pilgrimages to Paris began to subtly influence western fashion, neither of them was the first Japanese fashion creator to enter the international fashion arena. That distinction belongs to the trailblazer in the field of international fashion design, at one time a once powerful force in the industry, Madame Hanae Mori.

Madame Mori first went to Paris in 1961, presented her first overseas collection to a New York audience in 1965, and became, in 1977, the first Asian to be admitted to the most exclusive fashion organization in the world, the Chambre Syndicale de la Haute Couture. While elements of Japanese culture are readily evident in some of her creations (the use of butterfly and lacquered box motifs, for example, as well as her kimono-inspired coats), she was nonetheless a classicist who closely followed the conventions of western dress in silhouette and construction.

For some historians, the designs shown in Paris by Kenzo in 1970 marked the first true point of departure from more fitted and figure-revealing looks. By creating garments made from yards of billowing cotton fabric that were smocked across the shoulders and breastbone and then fell in full folds around the wearer, Kenzo is credited with being the first designer to appropriate the less obvious elements of Japanese dress (such as obfuscation of the body), to reinterpret them, and ultimately to restructure the silhouette of modern fashion. By going on to use a plethora of folkloric styles, bright floral fabrics, and

variations on Japanese peasant clothes such as the *happi*, Kenzo presaged the 1970s and 1980s trends for oversized sweaters and boxy silhouettes, which came to be worn by millions. Even his smocks served as sources of inspiration for couturiers such as Yves Saint Laurent.

Issey Miyake began to produce and show his designs around the same time as Kenzo. Rather than incorporating the same bright color palette or breezy prints, however, Miyake pioneered the use of what were then less fashionable, ethnographic materials, such as Asian ikats. Part of what made Miyake unique was his interest in fabrics that had a rough-hewn look akin to those handmade by rural peoples. Whether he used actual indigenous materials or versions woven to evoke traditional cloth, Miyake initiated the trend toward abandoning the less predictable, manufactured, and stylized forms of "exoticism" in favour of seeking out and embracing those deemed more authentic.

Miyake was also one of the first globally influential designers to find creative uses for the latest, technologically advanced synthetics that were being produced in Japan. The use of such fabrics, such as permanently pleated polyester, combined with innovative construction techniques, allowed Miyake to make some of the most extraordinary garments ever seen. Often described as one of the most optimistic and forward-looking designers of his generation, Miyake's fantastic pleated creations that morph from flat pieces of cloth into three-dimensional geodesic forms were revelations when they first appeared in the late 1980s.

Miyake made simpler versions of these innovatively constructed, permanent-pleat garments accessible to a larger pool of customers when he launched his Pleats Please line in 1993. Although the garments were linear in cut, their surfaces in some collections were daringly innovative. For example, from 1996 to 1998, Miyake invited four artists to collaborate with him on the creation of prints to ornament the fronts of his new dresses. Miyake chose artists who in their own works often used the body as a conceptual entity: Yasumasa Morimura, Nobuyoshi Araki, Tim Hawkinson and Cai Guo Qiang (figs 5 and 6).

5/6 Issey Miyake, Pleats Please dresses,
part of Miyake's Guest Artist Series,
(top: by Cai Guo; bottom: by Tim Hawkins)
permanent pleated polyester, 1998 ,
collection of Liz Larson,
photos: William Palmer

More recently, Miyake introduced his A-POC line, A-POC being his acronym for "a piece of cloth." Seemingly endless numbers of identically laser-seamed dresses arrived at stores attached to one another and rolled into bales of tubular jersey knit, allowing each customer to customize her garment as it was cut away from the others (fig. 7).

When Kawakubo and Yamamoto brought their work to Paris in 1981, they were following the path paved by Miyake and Kenzo. Although they garnered almost no attention at first (they were unaware of how to position themselves in the Parisian fashion show calendar and had not hired public relations specialists), they quickly began to embody what came to be viewed as "Japanese fashion." Yet, with one hundred and fifty years of cultural exchange, and more than a century since Japanese design had begun to influence European fashion, that delimitation inspires the question previously touched upon: What exactly is "Japanese" about the work of Rei Kawakubo and Yohji Yamamoto?

Yamamoto addressed one of the important differences between Japanese and western cultures – classicism – when he noted:

7 Gotscho, "Totem" installation for the
Musée des arts asiatiques,
Nice, France, 2003,
featuring APOC garment by Issey Miyake,
black synthetic, 1999,
photo: the author

The biggest difference between our Japanese taste and European peoples' taste is in the concept of perfection. When I traveled in Greece and Italy and saw the classical architecture, I saw things that were made in a static image of perfection. I'm not interested in that kind of perfection – I'm tired of it. When I make something I don't want to recreate my own mind exactly. So I always make seventy to eighty percent of what I think and then I throw it in front of the consumers to complete and say, wear it the way *you* like.[3]

Beyond Apollonian ideals of the formulaic and balanced attributes of classicism and strong-armed dominance over the natural world, there exists another important difference between Europeans and East Asians: in the west, the fine arts (primarily painting but also sculpture), are assumed to reign supreme over the minor or decorative arts. In turn, there is a similar hierarchy in which furniture, ceramics, and metalwork outrank other applied arts such as textiles, and, finally, fashion. The Japanese, like many other non-western civilizations, have traditionally understood that seemingly insignificant objects can be imbued with high levels of intellectual and spiritual importance. Ceramics, textiles, and paper, for example, are objects that are still viewed as craftworks worthy of respect. Even food packaging can become a work of art in Japanese hands, as is vibrantly illustrated in Hideyuki Oka's publication, *How to Wrap Five More Eggs* (fig. 8).

The third element that separates "Japanese" avant-garde fashion from western dress is its reliance on cloth as a starting point for creation. This is especially true for the fabrics used by Miyake, Kawakubo, Yamamoto, and now, Watanabe. Japanese fabrics are either in-house designs, specially commissioned, artisanally produced, or startlingly new synthetics that are made by the most technologically advanced mills in the world. This practice, no longer viable in the realm of haute couture, continues today in Japan.

Beyond these cultural differences centering on aesthetics and craft, there is also the issue of perceived racial identity. It is important to address race because it has had an impact on how Japanese fashion

has been perceived. Not only have some been critical of Japanese fashion and, by extension, the Japanese themselves (this will be addressed later), some Japanese have been conversely critical of westerners who have attempted to document them.

In an example of the latter, Dr. Dorinne Kondo, a Japanese-American scholar, analyzed Wim Wenders's 1989 film *Notebooks on Cities and Clothes*, an "essay" or "diary" film about Yohji Yamamoto. She is critical of the director's portrait and states that the juxtaposition of the inanimate object and the couturier "makes equivalence between the feminized Yamamoto and the feminized camera, re-circulating Orientalist tropes of Asia and Asian men as passive, feminized, 'waiting'."[4] Wenders, she contends, maintains his position as Master Subject; Yamamoto is almost, but not quite, an equal.

Kondo's analysis overlooks the fact that Wenders, while ignorant about fashion, did know quite a lot about modern Japanese culture and has long been an admirer of it. In fact, one of Wenders's great influences was Yasujiro Ozu (1903–63), arguably Japan's most distinguished and certainly most prolific filmmaker. (Wenders's ode to Ozu in *Tokyo-Ga*, another of his diary films, was released in 1985, four years before *Notebook on Cities and Clothes*.) Furthermore, the imagery of Japan's capital city in *Tokyo-Ga* allowed Wenders to capture the shared experience of being colonized by the American military and the cultural omnipresence of the United States that both he in Germany and Yamamoto in Japan experienced during the mid-twentieth century.

This link between Wenders, Ozu, and Yamamoto, as well as their creative media – film and fashion – are overlooked in Kondo's examination. In fact, Wenders elevated the designer to a status equal to that of great creators in other media – quite a promotion for someone who, as an artist in the realm of fashion, was routinely placed on the lowest level in the western hierarchy of the arts. And not incidentally, he is Japanese. In the west, the Japanese have long and often been condescended to as mere "adaptors" of other cultural memes rather than lauded as originators in their own right.

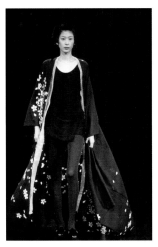

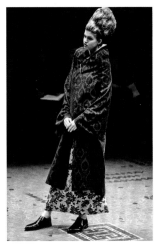

Kondo's external assessment of race does raise the question of how the Japanese assess their own cultural identity and incorporate "Japanesque" elements, especially those already so familiar to the global community. Issey Miyake, on the one hand, incorporated a sense of humor and daring when he designed his tongue-in-cheek body stockings covered with Yakuza tattoos, and more reverence when he was using indigo-dyed cotton ikat textiles based on hand-woven versions made by rural peoples. In the 1980s, Kansai Yamamoto (no relation to Yohji Yamamoto) designed bold, highly graphic sweaters emblazoned with oversized images inspired by *uioke* block prints. His work contradicted the more commonly recognized minimalism of Japanese aesthetics.

Rei Kawakubo and Yohji Yamamoto have rarely embraced obvious Japanese clothing elements in their work. Yet ever atypical, they both presented their respective takes on the kimono in the mid-1990s.

Yamamoto designed what at first appeared to be literal examples of kimono for his Spring/Summer 1995 collection: a brilliant violet robe decorated with *shibori* (a kind of resist dye process wherein tiny knots are embroidered into a fabric, the fabric dyed, and the knots removed to reveal tiny, undyed peaks) and an azure blue kimono covered with falling cherry blossoms (fig. 9). The Yamamoto kimonos, however, had none of the weight of traditional versions. Their lightness, and the fact that they were worn open, with clear views of a bodystocking-sheathed form beneath, alluded to the way a European might historically have worn it as a dressing gown or robe.

Kawakubo presented her ode to the kimono for her Fall/Winter 1996 collection (fig. 10). Inspired by the kimono shape, with its straight cut, loose sleeves, padded hems and collars, Kawakubo obliterated any literal connection to the garment by choosing velvets with pale grounds and piles woven with undulating botanical motifs in the style of the European high Renaissance and Baroque eras in rich brown, royal blue, and scarlet hues. The models, their hair coifed into huge domed styles covered in white powder, further enhanced the baroque sensibility. The looks were modernized with black leather brogues.

While Kawakubo and Yamamoto grappled with Japanese forms, so too did some fashion journalists. Articles concerning a resurgence of interest in the designers appeared frequently in major fashion magazines in the mid-1990s, more than a decade after the designers' debuts. Surprisingly, some journalists were still confounded, or even blatantly ignorant, about this ground-breaking work. Marina Rust, for example, in her piece "Something Japanese" for *Vogue*, set out to understand the appeal of clothes designed by Kawakubo and Yamamoto.[5] In an ongoing dialogue with a friend (who played the role of avant-garde educator), during a visit to the Comme des Garçons boutique (then located on Wooster Street in Soho neighborhood of New York City), she stated:

> We enter the store. The first rack holds sleeveless dresses in black, taupe, and incongruous plaid. I've seen this stuff. Last week I was on the fourth floor of Barney's, a scary area into which I rarely venture. The mannequin wore a stretch tube dress with one large lump on the shoulder, another at the hip. . .

When asked if the lumps could be removed at the Comme boutique later, the salesperson noted they could be and that the "lumps are more of an intellectual thing. It's about glorifying the dress, not the body." Rust noted to her friend, "call me callow, but I'd prefer to look good." Similar banter continued as Rust and friend moved on to the Yamamoto and Miyake boutiques. The outing ended with the friend replying to Rust's question about who looks good in such clothes – "The Japanese."

Thus, to define the designers exclusively as "Japanese" is both uninformed and inaccurate. But it is not so much a product of overt racism as it is a desire to categorize these designers by those unwilling or unable to comprehend the challenging complexity of cutting-edge design.

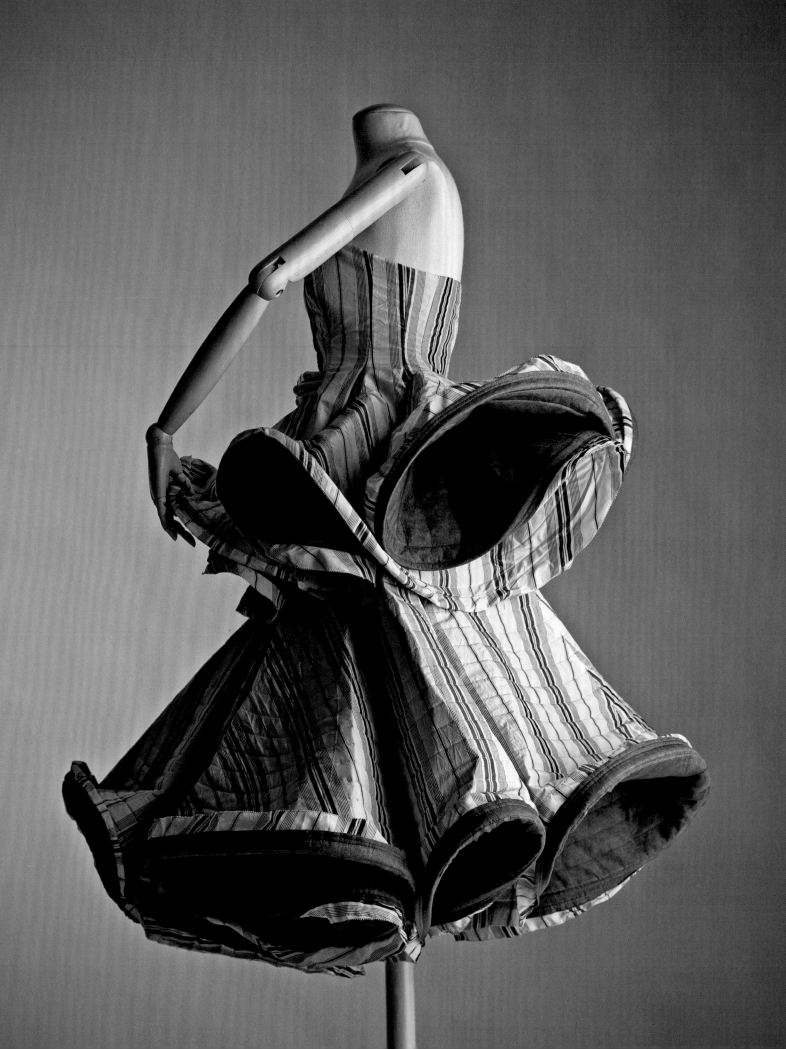

CONVERGENCE AND DIVERGENCE

As noted earlier, Kawakubo and Yamamoto are often discussed as a single entity. This assessment is understandable. Their powerful and persistent collections of the past three decades have made them the preeminent exponents of Japanese fashion design. But for most of this time, they shaped fashion from opposite ends of the creative spectrum. Kawakubo is a conceptual designer who begins with an idea, often a very abstract one, then has her team of expert craftspeople build upon her elusive aesthetic vision. Yamamoto, conversely, is a highly skilled draper and tailor who often works out his ideas technically, the process of dressmaking being his tool-of-choice throughout the entire act of creation. Most of the observations and research herein specifically address the high-end, biannual collections for women by Kawakubo and Yamamoto since their 1981 Paris debut.

It is well known in the realm of fashion that from the onset of Rei Kawakubo's career in the late 1960s, "intellectualism" has been the first word used to define both the designer and her work, which is produced under the label Comme des Garçons. In her overriding desire to create fashions that defy conventional beauty – while at the same time redefining what we see as fashionable – Kawakubo is the quintessential postmodern designer. Despite being known for indefinable items of clothing, Kawakubo does respect tradition and beauty, and creates a kind of style that stands as a reaction to the uniformity of today's fashions. Fashion journalist Bernadine Morris noted:

> Rei Kawakubo of Comme des Garçons is widely recognized as having the purest vision and the most powerful approach to fashion . . . There is hardly a glimpse of the body as arms were thrust through openings in cape-like tops, and clothes were layered in the prevailing Japanese manner.[6]

By contrast, Yohji Yamamoto's revisions of historical western dress, especially his collections designed since the mid-1990s, place him in the more "lyrical" or "romantic" faction of today's avant-garde, and at the same time, the contingent that rebels against convention. He often combines recognizable western silhouettes, such as bustled

11 Yohji Yamamoto, crinolated dress from the "Wedding" Collection, Spring/Summer 1999, collection of Allen Sui.
photo: William Palmer

coats and crinolated dresses, with unorthodox materials, such as the felt that covers billiard tables or those that resemble mattress ticking (fig. 11) to create the most beautiful of today's avant-garde fashions.

This divergence went all but undetected when Kawakubo and Yamamoto presented their first collections in 1981 and 1982. The overall critical assessment of Kawakubo and Yamamoto by the French (the first western journalists to view their work) did not clearly distinguish the designers. The comments about one could have just as easily described the other, and the journalists often considered them in tandem. Despite the inflammatory titles of articles such as "L'Àpres troisième guerre du feu" ("After World War III"); "Le Bonze et la kamikaze" ("The monk and the Kamikaze"); "Les Japonais jouent 'Les Misérables'" ("The Japanese do *Les Misérables*"); "L'Offensive japonais" (The Japanese Offensive"); "Fripe nippone," (Japanese secondhand"); and "Yohji Yamamoto: Brut et sophistication" (Yohji Yamamoto: Brutal Sophistication"), many in France understood that Kawakubo and Yamamoto were presenting a new kind of fashion that, while not conventional, was nonetheless worthy of commentary.

Also, Issey Miyake, who presaged Kawakubo and Yamamoto in the west, was designing in the early 1980s with a sensibility that illustrated a shared vision (although, by the end of the decade, Miyake's work was clearly different from theirs). On some occasions, their aesthetics were so new that each designer's work was hardly distinguishable from the others', as seen in a pair of editorial spreads that appeared in American *Vogue* in April and July of 1983. In the April publication, work by these three designers appeared separately in photographs by Irving Penn, but the clothes, in a predominantly dark palette with loose, unconstructed silhouettes, were somewhat indistinguishable. That July, the portrayal of the Japanese triumvirate was even more daring and evocative than in the previous editorial spread. In contrast to those taken in Penn's sterile studio, the photographs by Hans Feurer were taken outdoors and featured models, solo and in groups, as well as details of the clothing. The models' odd eye makeup (ombréd masks made from a gradation of

blue shadow, or a solid horizontal line across closed eyes and continuing across the face), and their wind-blown, swirling manes evoked a sense of boundless freedom as they moved briskly past the camera (see page 21). So similar do the garments seem that, without a caption for each picture, it would be difficult to correctly identify the individual creators of each item.

After a lull in their careers that lasted from the late 1980s to the mid-1990s, Kawakubo and Yamamoto witnessed a renewed interest in their work. At the same time, Miyake's influence waned and he was supplanted on the international fashion stage by Kawakubo's protégé, Junya Watanabe. It was also during this revival that their work became more individually distinctive. Kawakubo became increasingly experimental, while Yamamoto became one of the grew figures to reinterpret and recontextualize vintage and historic fashions.

One of the best descriptions of how aesthetically divergent Kawakubo and Yamamoto had become from one another was written by the philosopher Kiyokazu Washida. In an essay entitled "The Past, the Feminine, the Vain," he stated:

> Rei Kawakubo, in many ways a comrade of Yohji Yamamoto's, confronts the logic of Fashion head on, by constantly renewing the 'now': in other words, by accelerating the change of Fashion, or by producing 'now' before 'now' is usurped. She moves faster than Fashion, manufacturing her 'now' before 'now' ceases to be. Renewing herself so quickly that no one can keep up, she does not allow herself to become entrenched in a fixed image, or to imitate herself.

> Yamamoto, on the other hand, turns his gaze backwards. Picture someone standing at a bridge [*sic*]. Fashion involves that person gazing at the water approaching from upstream, fixing their attention on what will be next. Now, the reversal of that gaze, in other words, turning to look in the direction in which the water disappears, will mean an approach where attention is not focused on that which is about to become 'now,' but on the phase of time when 'now' ceases to be 'now.' Yohji

Yamamoto often says that 'now' is transient. Perhaps because he is able to look at things this way, he can touch the fleeting 'now' and capture the very moment when things are destroyed and disappear.[7]

Kawakubo and Yamamoto began by running their businesses like others in Japan. They were the sole proprietors and did not seek support from leading fashion conglomerates. Also, in a very unique practice, they produced and made available every high-end item they presented on the runway, no matter how ornate or complex the object. Major western firms often create elaborate ensembles exclusively for the runway only, never intending such designs to go into production.

However, as time went on, their businesses began to develop structures quite distinct from each other. Kawakubo, with her husband Adrian Joffe, had been expanding her Comme des Garçons empire of free-standing stores, making collaborative agreements with companies ranging from ballet shoe maker Repetto to swimwear giant Speedo, and a "universe" of young designers, "one superstar at a time."[8] This universe included Watanabe, Jun Takahashi (for his label, Undercover), and Tao Kurihara. For years, Yamamoto flourished with the support of licensing partnerships (Adidas, Mandarina Duck, and Mikimoto). He also backed his daughter Limi's entrée into fashion and acted as her business advisor. Sadly, Yamamoto faced the bankruptcy of his company in 2009. Although he quickly found a new backer, the global economic crisis of 2008–9 led to the closing of his New York press office as well as his free-standing stores in the city.

Their individual visions and fortunes aside, however, Kawakubo and Yamamoto have shared throughout their careers key design elements for which they both have become famous. The following is a discussion of those elements and a look at how these designers have come to shape one of the most radical and enduring influences in contemporary fashion.

> I don't agree with the normal notion of sexuality. I don't feel sexuality in the normal meaning. A fantasy of mine, for example, is a woman, forty or fifty years old. She is very skinny, with gray hair and smoking a cigarette. She is neither woman nor man but she is very attractive. She is sexy for me. She is walking away from me and as I walk after her she calls out, 'do not follow.'

> Yohji Yamamoto, 1984[9]

The complexity of gender issues is as poignant as it is relevant to a discussion of contemporary fashion arts. It should be not surprising, then, that both Rei Kawakubo and Yohji Yamamoto are creators who embrace strong feminist ideals in their work. It is worth addressing some of the elements through which Kawakubo and Yamamoto have expanded perceptions of gender identity in their clothes for women, and considering the roles the designers themselves have played in defining and embracing modern feminist ideals within the fashion world over the past three decades.

Kawakubo and Yamamoto self-consciously removed their work from stereotypes of sexually charged dress by originally producing garments that were almost exclusively unfitted or oversized. This "one size fits all" look flew in the face of a taste in the 1980s for the kind of aggressive and highly sexualized silhouettes that are normally associated with that decade. Although their clothes have changed a great deal over the past thirty years, Kawakubo and Yamamoto are still more likely to create versions of fashion that obfuscate the western view of gender. Both of them embrace distinct versions of feminism (specifically within Japan, as experienced by them independently), yet Kawakubo's intellectual approach inverts our notions of the highly sexualized body while Yamamoto embraces a dual mix of historic modes and the transplantation of men's garments into the feminine vernacular. Underlying both of these visions of gender presentation is

the west's misunderstanding that dress in Japan is universally asexual or unisexual.

Born in 1942, Rei Kawakubo, the daughter of an administrator at Keio University, studied literature and philosophy at Keio before becoming a fashion stylist in 1967. Dissatisfied with the kinds of clothing available, she decided in 1969 to design her own. She formed her limited company in 1973, calling it "Comme des Garçons." Meaning "like the boys" in French, Kawakubo chose the name because the sonorous quality appealed to her – but of course, it immediately brings to mind a myriad of gender-related references that have provided fodder for fashion theorists. Not only was Kawakubo a pioneer in forming her own company, she later acquired young male talents like Junya Watanabe and, more recently, Jun Takahashi, founder of the fashion label Undercover. Unlike other partnerships within fashion conglomerates, Watanabe and Takahashi work with Kawakubo and receive what would appear to be competing privileges: autonomy and protection. It should be noted that Kawakubo is a designer who has no formal fashion training. This fact is important because, like another great female couturier, Elsa Schiaparelli, her skills lay not in her fingertips but in her ability to engage in theoretical discourse.

Of all the Japanese designers who showed their collections in Paris in the early 1980s – at the height of the feminist movement – Kawakubo received especially harsh criticism from female fashion journalists and editors. Holly Brubach, in an article on Yves Saint Laurent, expressed the sentiments felt by many:

> The dread and hopelessness that pervade so many of the recent clothes by Japanese designers, notably Rei Kawakubo, are nowhere to be found in Saint Laurent's collections. Japanese fashion in its more extreme forms prefigures a world that no one is looking forward to. The woman who wears Comme des Garçons (Kawakubo's label) is well off but not proud of it, unwilling to dress herself up so that other people have something pleasing to look at, and over-burdened by the news she reads everyday in the paper.[10]

As Harold Koda noted in his 1984 article on Kawakubo, the designer herself would likely be surprised by such conclusions because she understood that her main client was someone who was financially independent and who chose to wear Comme des Garçons designs precisely because of her sense of independence and self-assuredness. Of equal surprise is the fact that time has quelled neither Kawakubo's intense devotion to her ideas nor the mixed reviews of her work.

Two more recent collections stand as leitmotifs of her compelling vision of female sexuality and beauty. The first was her Spring/Summer collection of 1997 entitled "Dress Meets Body, Body Meets Dress" (and referred to by some detractors as "Quasimodo").[11] Kawakubo created dresses made of stretchy, synthetic fabrics printed in pink or blue gingham that had "pockets" into which she had placed down-filled pillows (figs 12). Rather than pad the breasts as an enhancement of the female form, for example, she put the pockets and pillows on the necks, upper backs, hips and bottoms. The result, according to journalist Sarah Mower, was "utter shock and outrage. Few journalists could understand clothes that were so far away from conventional ideas of flattering fashion."[12]

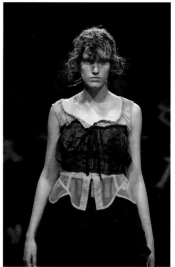

These journalists were probably unaware that similar padded pillows were once used during the 1820s and 1830s to transform the sleeves of the upper arms into an exaggerated shape called the "gigot," or "leg-o-mutton." When asked by Mower about her Spring/Summer 1997 collection, Kawakubo replied:

> I used three different approaches, mixing three types of techniques, or ways of thinking. Firstly, the wanting to do something really strong that didn't resemble anything else. (I usually have this wish, it is true.) The second thing was the anger I felt at the time about how boring all normal clothes were then and how marketing seemed to be taking over. This led to me deciding to design bodies this time, instead of clothes. The third thing that followed on from the first and second, was the decision to use incredibly stretchable fabrics, because otherwise how would people move in the clothes?"[13]

TOP:
12 Rei Kawakubo, bump dress,
Spring/Summer 1997,
photo: Maria Chandoha Valentino

BOTTOM:
13 Rei Kawakubo,
lingerie-inspired ensemble,
Spring/Summer 2001,
photo: Maria Chandoha Valentino

For her Spring/Summer 2001 collection, Kawakubo produced what Mower described as clothes that:

> . . . caused major shock yet again, but in a very different way. The last thing her followers would ever expect of Rei Kawakubo was a Comme des Garçons show about sex . . . unmistakably derived from slippery nylon baby dolls, fifties corsets and bras [fig. 3], and peek-a-boo sex-shop merchandise . . . the sex reference was full on, not abstracted and unmissable. The reaction in the room was sheer delight. As soon as the audience realized what Kawakubo was doing, women began grinning. Clearly, what she was saying was from the woman's point of view, sexy but powerful, sexy but funny, sexy without apology . . . When a girl walked around the room wearing a pinstripe boiler suit, almost a business suit, but with a split in the crotch, women were finally laughing out loud . . . Kawakubo had astonished again, going against everyone's expectation of her, and yet producing something that was totally true to her own character.[14]

Yohji Yamamoto approaches the creation of women's fashions from a point of view that is very different from that of Kawakubo. Born in 1942, he never met his father, and was raised by his war-widow mother, Yumi. A dressmaker by trade, she suffered what Yamamoto recalls were the indignities of a highly skilled worker whose gender and station in life afforded her little opportunity to make a comfortable living or to attain recognition for her talents. It was she who encouraged her son to become an attorney. He graduated with a law degree from Keio University but never practiced, the lure of becoming a designer pulling him into fashion instead. Like his mother, he began as an anonymous creator before forming his company in 1977.

Yamamoto, who has been married, divorced, and has fathered several children by more than one partner, has a professed love of and respect for women that has not been evident to everyone. Having admitted an aversion to the overtly sexualized female, Yamamoto has said that his preferred female type is rather asexual, an older or middle-aged woman, slender, and with an elusive personality. The late dancer and choreographer, Pina Bausch, was a long-time muse.

Yamamoto's preference for a more androgynous look may also stem from a frightening childhood image of "threatening" femininity – high heels, seamed stockings, and a body-hugging dress, then topped by a face painted with deep red lips – that alluded to prostitution. In addition, Yamamoto has often, consciously or otherwise, dressed women in designs inspired by menswear. Such cross-gender role-playing has long been a part of Japanese culture and a persistent theme among performers and artists for centuries. The fact that Yamamoto has on more than one occasion chosen women as models for his menswear fashion shows is another small piece of the sexual identity puzzle.

Even when his work in recent years embraced the sweeping romanticism of post-war Parisian haute couture, Yamamoto's historical re-contextualizations contrasted sharply with the work of other marquee designers like Azzedine Alaia, Tom Ford, Vivienne Westwood, John Galliano, and Alexander McQueen. Deliberately absent from Yamamoto's runway presentations were the supposed requisites of a contemporary high-fashion wardrobe: high heels, rising hemlines, plunging necklines, and sheer fabrics. While he incorporated corset-enhanced silhouettes that delineated the curves of the female form (figs 14 and 15), he rarely elevated feet to distend the posture and inhibit a full range of movement (instead opting for boots that resembled Doc Martens); he also relegated sheer and transparent material to ornamental flourishes rather than, like most other designers, using it as a veil to allow large swaths of flesh to be glimpsed beneath (fig. 15).

These characteristics might be the reason that Yamamoto's dark, masculine suits and coats (fig. 16), sometimes paired with white shirts (for both men and women), have long been some of his most enduring and compelling products. In a 1999 interview, Barbara Weiser, the New York-based retailer and former owner of the Chiarivari boutique, told this author that the earliest Yamamoto white shirts sold in her boutique in the early 1980s were wonders of construction and that in them, "the inner workings of Yamamoto's very personal vision could be seen."[15] Others have noted the same qualities in his simple suit jackets and trousers for both men and women.

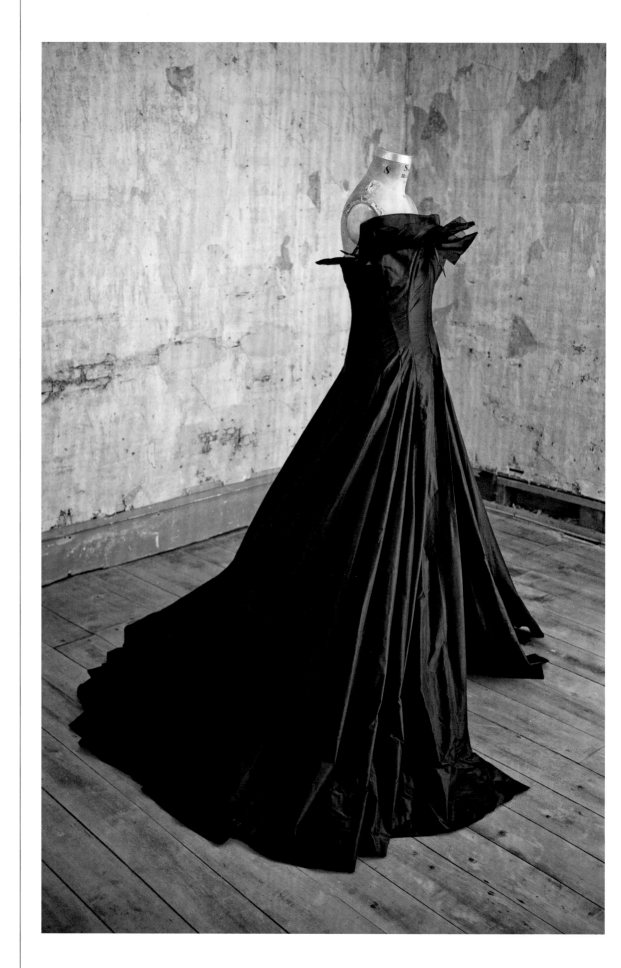

14/15 Yohji Yamamoto,
black layered gown (left) and detail (right),
silk and lace, Spring/Summer 1999,
collection of the Museum at FIT,
(one of the original three layers is not
illustrated)
photo: William Palmer

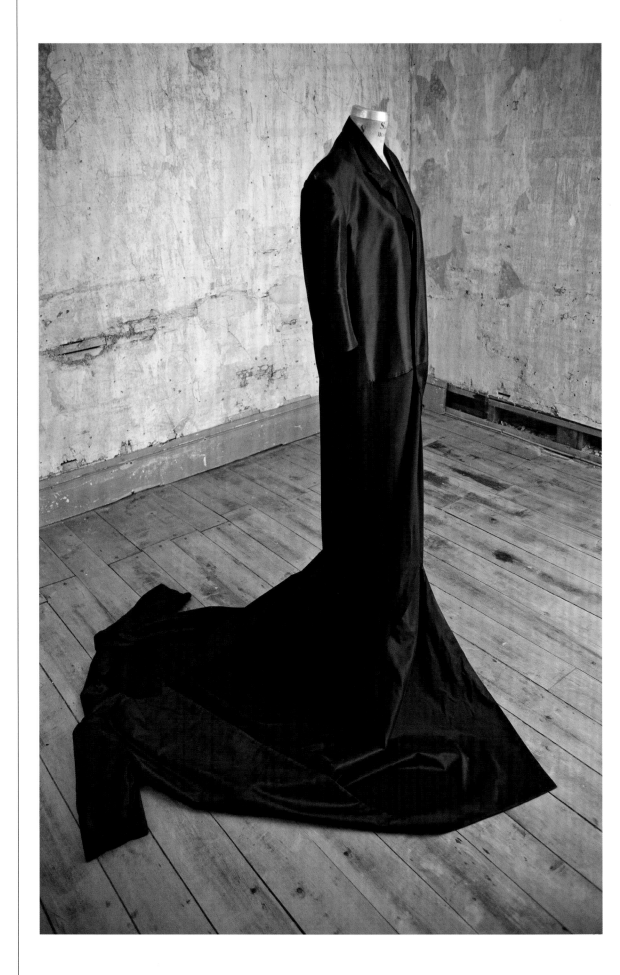

16 Yohji Yamamoto,
black two-layered and oversized coat,
Spring/Summer 2001,
collection of the Museum at FIT,
photo: William Palmer

The birth of the modern suit came about during the latter part of the eighteenth century and the first two decades of the nineteenth. Inspired by the unadorned, neutral-colored hunting costumes that were tailored to closely fit the bodies of sporty English gentlemen, the suit quickly became the ubiquitous choice of dress for newly wealthy industrialists and a ruling class enamored with the enlightenment. Art Historian Anne Hollander noted in her 1994 publication *Sex and Suits* that dark wool jackets and pants were "suggesting the force and clarity of Greek democracy and Roman technology. Both of these became erotically as well as politically appealing; basic Greek or Roman seemed the right form in which to cast the various new social and emotional aspirations of the moment."[16]

Worn by men of all classes depending on occasion, the dark suit, complete with white shirt, has earned at least part of its "erotic charge," as Hollander notes, from its polar relationship to female fashions that keep the sartorial past alive. No doubt this difference between masculine and feminine has been the crucial element in the suit's sexual potency. Its ability to convey both power and conformity also gives the suit its truly modern aesthetic. This blend of erotic appeal and strength may likely have been a perfect template for Yamamoto to express his postwar version of male and female sexuality.

Like mirror images of one another, Kawakubo and Yamamoto continue to address the ambiguities of gender, not only through their work but also in the ways that they work. Kawakubo, for her male protégés Watanabe and Takahashi, plays the role of mentor in the male-dominated world of fashion creation. Yamamoto's mother and his daughter, both vital contributors to the creative and business sides of his company, hold him in a generational embrace. Despite the overblown and obvious kind of feminine sexuality that now dominates contemporary fashion, Kawakubo and Yamamoto continue to counter the ceaseless recycling of those traditional gendered images in their work and in their lives.

17 Yohji Yamamoto,
black crinolated jacket,
Spring/Summer 1999,
photo: William Palmer

> I've always felt very comfortable with the color black. I
> don't know why. But my feeling for black is stronger than
> ever these last ten years.
>
> Rei Kawakubo[17]

> I can't use bright, light, cheery colors. For a moment I'm
> very happy with them but after three minutes I get bored.
> I'm waiting for the time when the fashion movement turns
> to cheerful and bright colors. Then I'll be able to make my
> things quiet and not exciting.
>
> Yohji Yamamoto[18]

No color in the fashion vocabulary has been more important in
the work of Rei Kawakubo and Yohji Yamamoto than black. Their
early, unrelenting black-on-black aesthetic earned devotees of
Kawakubo and Yamamoto the nickname Karasuzoku (members
of the Crow tribe). In the United States, particularly in New York
City, Kawakubo's and Yamamoto's reliance on the color black was
adopted by the Soho-based arts community as the hip, downtown
"uniform." Journalist Jeff Weinstein of the *Village Voice* argued that
for Kawakubo particularly, "'black' becomes a full spectrum, an ex-
amination of the relationship between fiber and dye."[19]

But with the enthusiastic embrace by some came an equally strong
level of disdain by others. The ubiquitous presence of this inky hue in
the fashions of Kawakubo and Yamamoto carried the weighty sym-
bolism of centuries of black garb for the journalists viewing their
work for the first time. For them, black related to the color's western
historical associations, which had been processed through a kalei-
doscope of self-conscious modernism and post-modernist theory
and assumption. As a result of such a historical re-contextualiza-
tion, black, by the last quarter of the twentieth century, had become
loaded with a plethora of meanings, implying poverty and devasta-

tion to some, sobriety, intellectualism, chic, self-restraint, and nobility in dress to others.

Black has been the power color for many centuries in Europe. For example, during the 1600s it was worn by members of the Spanish nobility and their Catholic hierarchy, as well as the burgomasters and Protestant extremists of the Northern Lowlands. Black, especially when combined with a billowing silhouette, moved among academics and monks, and widows and nuns, to signal scholarship, piety, and sexual inaccessibility. Black robes, academic or clerical, all but erased the corporeal body. (Note the similar effect the chador has on women in some Islamic countries.) By the nineteenth century, it shrouded those in the arena of anti-establishment intellectuals. Black clothes, especially if they were tattered, were not the uniform of the immaculately groomed dandy but rather that of romantic artists, the bohemians, and, a century later, the beatniks, and the punks.

Most potent of all, black developed an association with ritual mourning and death in the nineteenth century. Yet by the end of that century, the black dress had also begun to migrate away from the conscripted ritual of mourning into the realm of hedonistic eveningwear. From the grand bourgeois portraits of *Madame X* by John Singer Sargent, and *Lady Meux* by James McNeil Whistler, to the "little black dress" by Gabrielle "Coco" Chanel in the late 1920s, black in fashion signaled a new vision of chic, perhaps even sexual *savoir faire* – that is, chic informed by experience.

Contrary to the western connotations that were assigned to these clothes by critics and historians in the 1980s, the modern, anti-establishment appeal and the popularization of black fashions by Kawakubo and Yamamoto over the past twenty years owe as much to the subtlety of traditional Japanese aesthetics as they do to any western historical connotations. While some scholars, such as the American curator Harold Koda, have made connections between contemporary fashion and Japanese philosophical traditions, such as *wabi-sabi*, a more viable assessment of the appeal of darkness comes from the recognition of the mundane and the everyday in Japanese culture. When expressly asked by Japanese-American scholar Dorinne Kondo

about the foreign press and its perceived connection between contemporary Japanese fashion and wabi-sabi, Rei Kawakubo replied:

> Do you feel sabi/wabi? [*sic*] About Japan? . . . So, I don't especially . . . feel it. It's not important. For me . . . I've seen so-called 'traditional' culture maybe once in school, when I had to. Things like Kabuki, one time only, for a class in elementary school.[20]

Wabi-sabi is a philosophical, intellectual, and cultural term with deep and profound meaning. Although complex, in the west it has recently become a catch-all phrase that allows some to conveniently label the Japanese approach to aesthetics. Commonly quoted elements of wabi-sabi are: the appreciation of things that show their age or have an inherent patina and character; objects that are seemingly imperfect (and very much the opposite of the kind of classicism Yamomoto described earlier), although beautifully and painstakingly crafted; and the reality of the impermanent or the ephemeral.

With this basic definition in mind, Kawakubo's rejection of wabi-sabi seems somewhat contradictory, though in her quote she connects the originally raucous form of entertainment Kabuki with the sublime philosophy wabi-sabi to drive home her denial of the influence of traditional culture on her work. But since there is no concrete evidence that Kawakubo and Yamamoto drew solely from this source, and since most design styles are derivative, it could be speculated that they received far more inspiration from their contemporary environment than from the ideas of antiquity. Their black, oversized, asymmetrical garments are contemporary hybrids: distillations of select traditional aesthetics.

One of the most important expressions of such values and the role of darkness in the contemporary realm come from writer Junichiro Tanizaki's seminal work *In Praise of Shadows*, originally published in a literary journal in late 1933 and early 1934. While it easily could be described as an essay on aesthetics by an eminent novelist, Tanizaki (1886–1965) had a deep, even scholarly, interest in the traditional culture of Japan. The author described how many traditional elements pervade everyday life in contemporary Japan – from architecture, to toilets, to food.

Tanizaki wrote this work at a crucial time in modern Japanese history. Although the nation had been officially opened to the west only eighty years earlier, it had already undergone a dramatic transformation. By this time, during the late Taisho and early Showa periods, Japan was the most westernized nation in Asia, at least in terms of adapting new technologies. But Tanizaki seemed less concerned about the influx of technology in its purely secular applications than he did about the loss of aesthetic meaning in daily life. For example, he noted:

> Westerners are amazed at the simplicity of Japanese rooms, perceiving in them no more than ashen wall bereft of ornament. Their reaction is understandable, but it betrays a failure to comprehend the mystery of shadows . . . the sitting room, which the rays of the sun at best but barely reach . . . the light from the garden steals in but dimly through paper-paneled doors . . . walls in neutral colors so that the sad, fragile, dying rays can sink into absolute repose.[21]

Such darkness not only captured the essence of the ephemeral but also shielded the viewer from the harsh and gaudy. This is made poignantly clear when he writes:

> Darkness is an indispensable element of the beauty of lacquerware . . . decorated in gold [lacquerware] is not something to be seen in a brilliant light to be taken in at a single glance; it should be left in the dark, a part here and a part there picked up by a faint light.[22]

Whatever distinction can be made about the influence of the old versus the new, one thing rings true in the words of Tanizaki when he muses about how the darkness also affects the way in which a woman's body is seen, or not seen. Despite the fact that the writer published his essay before Kawakubo and Yamamoto were born, there is an arguably viable similarity between his assessment of women in their kimonos and those who don avant-garde fashion. He states:

> The body, legs, and feet are concealed within a long kimono . . . to me this is the very epitome of reality, as a woman of the past did indeed exist only from the collar up and from the sleeves out; the rest of her remained hidden in darkness. A woman of

the middle or upper ranks of society seldom left her house, and when she did she shielded herself from the gaze of the public in the dark recess of her palanquin. Most of her life was spent in the twilight of a single house, her body shrouded day and night in gloom, her face the only sign of her existence . . . women dressed more somberly . . . daughters and wives of the merchant class wore astonishingly severe dress. Their clothing was in effect no more than a part of the darkness, the transition between darkness and face.[23]

Published images of such women from this era are rare. In *Women of the Showa Era*, photographer Koyo Kageyama documents public life in Japan before, during, and after World War II. In keeping with Tanizaki's assessment, most of the elevated married women are less visible than their younger (and perhaps lower-ranking) counterparts, who are often seen wearing western fashions.

In Tanizaki's mind, the woman is shielded from the world as much as she is from light. Certainly this does not parallel the presentation of modern fashion. The aesthetic attributes of traditional Japan and contemporary culture and the role that black fashions play can be seen in black's association with "poverty." For some it is an illusion – or perhaps an allusion – to rusticity, simplicity, and un-self-conscious restraint. In Japan, black dyes may have rural as well as noble warrior connotations. Yohji Yamamoto noted in Leonard Koren's 1984 publication:

> 300 years ago, black was the color of the farmer and the lower-class samurai. It wasn't exactly black but an indigo blue dyed so many times it's close to black. The Samurai spirit is black. The Samurai must be able to throw his body into nothingness, the color and image of which is black. But the farmers liked black or dark, dark indigo, because the indigo plant was easy to grow, and the dye was good for the body and kept insects away.[24]

A key connection between black and the symbolic association of old Europe, traditional Japan, and the modern urban landscape may also have derived from the couture atelier. As mentioned earlier, Balenciaga and Dior, the two most important figures in the post-war world of couture, often created day suits and coats, ball gowns, and

opera coats devoid of any ornament. While it is widely believed that Dior especially opted for soft, muted tones and remarkably complex yet delicate embroideries, many museum collections dispel this predilection. The vast majority of the garments preserved from the late 1940s are dark colored. Charcoal gray, navy blue, and, of course, black woolens were often molded and manipulated into pure sculptural forms that accented the wearer's silhouette while displaying marvelous engineering and tailoring techniques as well as a love of dramatic form.

While Paris suffered under the Nazi occupation during World War II, the immediate post-war effects of rationing and continued shortages of food, fuel, and fabric, combined with two especially brutal winters, gave the city a look of destitution it had not seen in decades. Against that harsh backdrop and the subsequent years of reaffirmation were the severely beautiful couture creations with oversized collars cut like enormous wings, ample melon-shaped sleeves, and full, swinging skirts, billowing away from corseted waists and resting upon padded hips.

Kawakubo and particularly Yamamoto appropriated many elements of historical western fashions, especially from the New Look period (1947–49), which is itself a historical revival of the Belle Époque (1895–1914). Yet they never merely mimicked vintage clothing, as so many other designers have done since the 1970s. The polish of French 1940s and 1950s couture was deliberately tarnished in their hands. Their impact was only moderate until around the mid-1990s, when they came out with a fresh approach that distinguished them even from the designers by whom they had been inspired.

Yamamoto, for example, integrated highly sculptural and architectonic elements similar to those used by Dior and Balenciaga. They, like Yamamoto, understood that monochromatic or tone-on-tone use of black (or other neutrals) is often most effective in expressing the dynamic, three-dimensional possibilities of rending dramatic form through garment construction. Yamamoto's New Look versions were often made without the requisite padding and beautiful silk linings. He chose to make ball gowns out of black and white wool felt, the

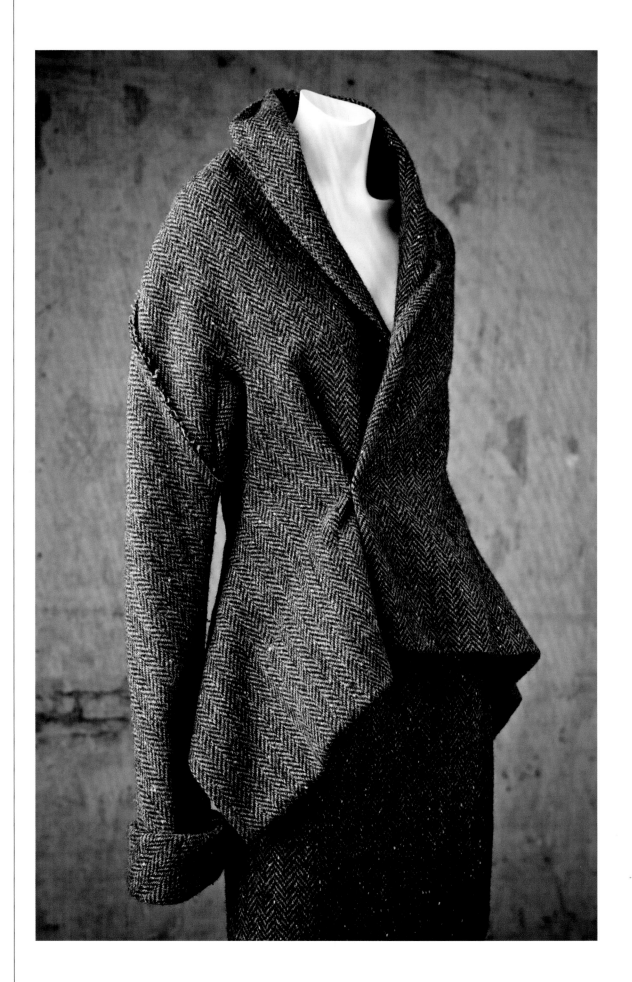

18 Yohji Yamamoto, gray wool tweed suit,
Fall/Winter 1997,
private collection,
photo: William Palmer

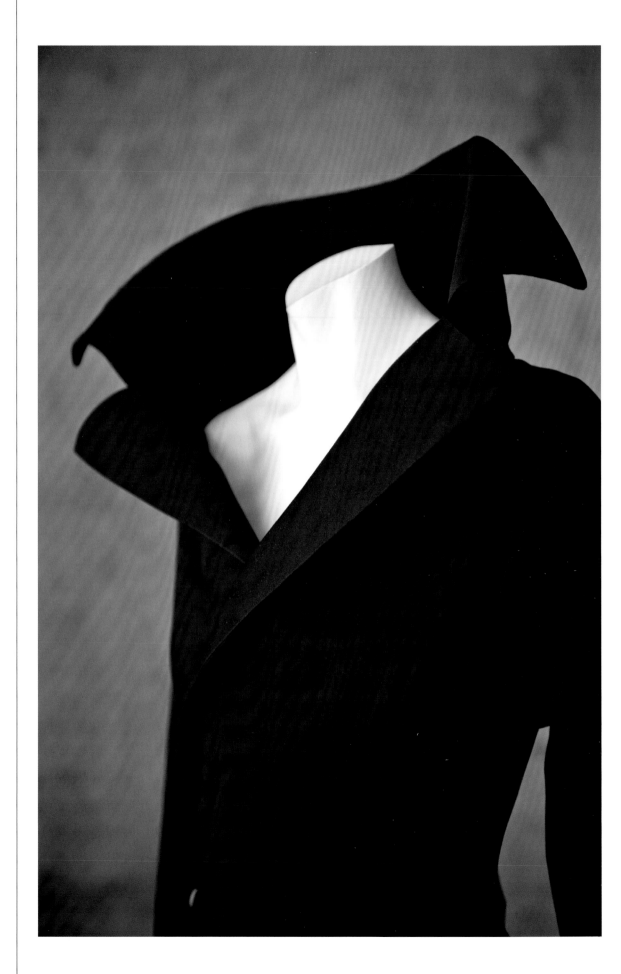

19 Yohji Yamamoto,
blue wool tweed and feathered suit,
Fall/Winter 1997,
private collection
photo: William Palmer

same fabric used to cover billiard tables. His coats were sometimes made from wool batting sandwiched between two layers of black netting, with the sleeves hinged using synthetic webbing. Yamamoto draped tweed as if he were creating an Art Moderne-era gown using silk charmeuse rather than a dense, inflexible woolen used to make a New Look-era day suit (fig. 18). When reinterpreting the oversized, sharply tipped lapels of a black silk Dior evening dress from 1950, Yamamoto made his version in cotton, in a shirtwaist style for day, and included long sleeves (fig. 19).

Such appropriations of mid-twentieth-century couture can be linked to post-World War II Japanese urbanism when assessing the role of black in Kawakubo's and Yamamoto's clothing. Tokyo suffered not from a severe cold as Paris did but, rather, the devastating effects of war, as well as earthquakes and fires in the preceding decades. Tokyo and many other cities throughout Japan were forced to fracture their connections to traditional design. The modern and rapidly rebuilt environment, with its reliance on tarmac and concrete, was not dissimilar from what philosopher Walter Benjamin observed as the roots of modernity in the "Haussmannization" of Paris in the mid-nineteenth century. Benjamin posited that the demolition of medieval Paris and the disenfranchisement of many of its citizens led to the rise of anonymity in a disconnected habitat, encouraging some to become "performers in costume," poised on a stage that was the city. And, just as in Paris in the nineteenth century (when no other color played so important a role), black became the emblematic hue of the 1980s avant-garde Tokyo-based designers Rei Kawakubo and Yohji Yamamoto.

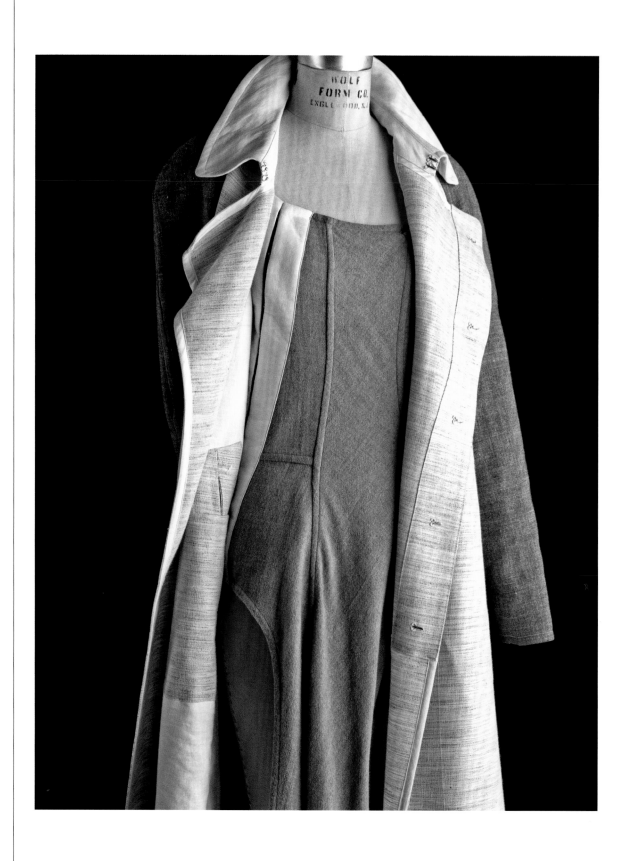

20 Rei Kawakubo for Comme des Garçons,
ensemble made from cashmere and tailoring
interfacings, Fall/Winter 1998,
private collection,
photo: William Palmer

> Rarely has a critical theory attracted the sort of dread and hysteria that deconstruction has incited since its inception in 1967.
>
> *Dictionary of Critical Theory*, 1991[25]

The term "deconstruction" has been applied within a wide range of artistic disciplines – including art, architecture, design, and music – for more than three decades. In fashion, it shook the very foundations of clothing creation; the aesthetic of deconstruction differed dramatically from the polished and finely finished garments that were dominant during the 1970s and 1980s. "Deconstructed" garments are often unfinished-looking, with loose, frayed hems and edges, and they sometimes appear to be coming apart, or look as if they were recycled or made from composite parts (fig. 20). The fashions are frequently dark in color, suggesting poverty, devastation, and/or degradation, while their silhouettes tend to obscure the body and lack a clear frontality.

Deconstruction was originally a French philosophical movement of the 1960s based on the writings of Jacques Derrida; its relationship to contemporary fashion design has yet to be fully explored by fashion theorists, critics, and curators. However, there is no reason to believe that Derrida's ideas were the motivating force behind the pioneering designs of Rei Kawakubo and Yohji Yamamoto.

It is more likely that deconstruction arose in their work as a freeform fix, the combined result of a mélange of influences: the devastation of Japan in World War II, and then its rapid rebuilding in the post-war era; the revolt against bourgeois tastes; an affiliation with European street styles, and a desire (like the early proponents of abstraction in fine art) to find a universal expression of design by erasing those elements that position people into specific socio-economic and gender roles. Aesthetically, the dressmaking techniques that gave Kawakubo and Yamamoto the look they desired also finds connection to traditional non-western methods of clothing construction and a modified

reinterpretation of the Japanese concept (wabi-sabi) that natural, organic, and imperfect objects can also be beautiful.

It should be noted that although deconstruction in fashion is relatively new, numerous historical precedents exist, including the opulent silks deliberately woven with slits and slashes that were the rage in fashion during the sixteenth-century German Renaissance. Considered one of the strangest fashion phenomena of the Renaissance, "slashing" supposedly originated in 1477, when Charles the Bold was slain in battle and Swiss and German mercenaries patched their torn garments with rich textile scraps looted from the wealthy Burgundians. True or not, by the early 1500s aristocratic men throughout many western European courts quickly adopted this flashy new style. Their deliberately slashed sleeves and hose revealed under-layers of cloth, thus displaying several splendid fabrics simultaneously.

Another precedent for the degraded appearance of deconstructed fashion emerged through those who made their living selling discarded clothing and textiles. In the nineteenth and twentieth centuries respectively, writers Charles Baudelaire and Walter Benjamin were fascinated by these "ragpickers" who, as Caroline Evans explained, scavenged cloth for recycling, thereby "recuperating cultural detritus cast aside by capitalist societies."[26] The ragpicker utilized the waste that was created by the frivolity of fashion at its most extreme.

It can be argued that the first contemporary manifestations of deconstruction in fashion appeared in the clothing worn by punks, beginning in 1976. The youth of Great Britain, long-time leaders in counterculture fashion, had come to dominate the creation of street styles during the post-World War II era. Even among youth groups, such as the mods and the teddy boys, the clothes worn by the punks stand out as particularly aggressive and menacing. The self-crafted punk aesthetic often involved day-glo colored hair coifed into spiked mohawks; used or vintage clothing that obviously had been ripped, torn, and reassembled; spike-studded leather; black Dr. Martens boots, and jewelry made from safety pins, which pierced both cloth and skin. Punk fashion also contained elements of fetishism, particularly

in the work of the punk movement's "official" designers, London-based Malcolm McLaren and Vivienne Westwood, whose fashions were often inspired by bondage gear.

In 1977, Zandra Rhodes, another London designer (of both textiles and clothing), created her Conceptual Chic collection. Although she is credited with designing the first high-fashion punk collection, Rhodes was no anarchist – instead she was inspired by a decidedly non-punk source, the late 1930s Surrealist designs of Italian-born couturier Elsa Schiaparelli. Specifically, Rhodes was inspired by Schiaparelli's meticulously executed "Tear" dress from 1938, itself a wearable version of a garment depicted in Salvador Dali's 1936 painting *Three Young Surrealist Women Holding in Their Arms the Skins of an Orchestra* (1936). The dress's visual potency comes from the fact that this most formal of evening costumes is presented in a "deteriorated" state, its fabric printed with *trompe l'oeil* rips of garment and flesh. Rhodes did her own "tear" prints on chiffon that were ornamented with safety pins and silver chains, and she designed jersey dresses that were actually torn, also decorated with safety pins.

Kawakubo and Yamamoto were clearly not the first designers to appropriate elements of deconstruction in their work. But they were the first to formalize and appropriate it so completely that French journalists referred to the Kawakubo/Yamamoto look as "Le Destroy." Thus, it can be argued that the official "birth" of deconstruction in fashion occurred in 1981, with the Paris debuts of Comme de Garçons and Yohji Yamamoto. Nearly all of their garments in the early 1980s had ragged edges, irregular hemlines, crinkled fabrics, and loose-fitting layers that fell aimlessly over the body (fig. 21). For some, the clothes resembled the garb of homeless people or survivors of an apocalypse. The press was virulent in its condemnation of this aesthetic, calling it everything from "ragged chic" to "Hiroshima bag lady." In many ways, Kawakubo and Yamamoto had simultaneously rebelled against the rigid social and cultural codes of Japan, severing connection with the country's sartorial history, and thus were leading the way into the future. As Kawakubo declared, "We must break away from conven-

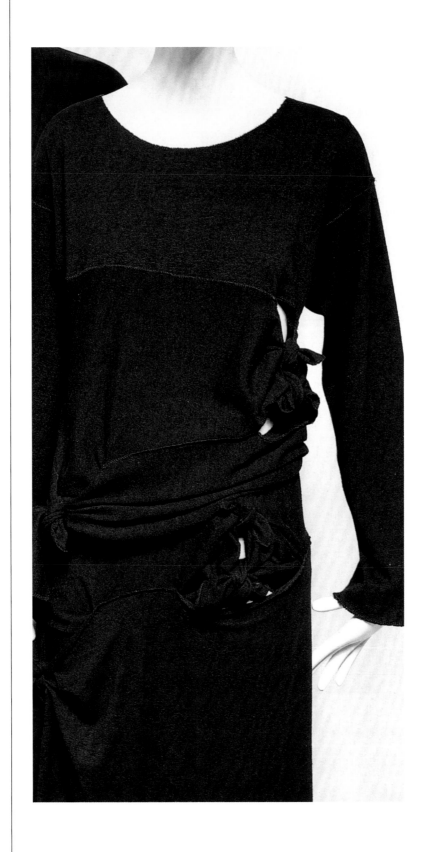

21 Rei Kawakubo for Comme des Garçons,
"Slash and Tie" top and skirt,
Fall/Winter 1983,
collection of the Museum at FIT,
photo: Irving Solero

tional forms of dress for the new woman of today. We need a new strong image, not a revisit to the past."[27]

Following the success of earlier Japanese designers who presented their collections in France, according to Yamamoto, it was Kawakubo who first suggested that they go to Paris. He noted "she was coming up against resistance in Tokyo to some of her more experimental ideas."[28] He agreed that they should take the financial and critical risk of taking their ideas abroad. At the Intercontinental Hotel in Paris in early April 1981, they presented their collections to a small audience of about one hundred people, who witnessed "a new style characterized by monochromatic, asymmetrical, and baggy looks":

> They set the stage for the beginning of the postmodern interpretation on the part of those who design clothes breaking the boundary between the West and the East, fashion and anti-fashion, and modern and anti-modern. . . these designers placed great significance on clothing inherited from the past, including Japanese farmers' clothes designed through necessity and adapted textile and quilting from ancient Japan, which Japanese would not consider fashionable."[29]

That first showing was not particularly well attended and historical fact contradicts the widely held notion that Kawakubo and Yamamoto were immediately recognized as revolutionaries. The designers themselves confirmed the assertion that few journalists and even fewer retailers were at this auspicious debut. But by the next fall, with the help of a French publicist, Kawakubo and Yamamoto had made in-roads, and they were officially added to the roster of La Fédération Française de la Couture, du Prêt-a-Porter des Couturiers de des Createurs de Mode, the reigning body of the French fashion system. Although the importance of the Fédération was waning and it was no longer the august entity of its heyday, it was still a necessary vehicle for Kawakubo and Yamomoto.

With the exception of a very few journalists, such as Claire Mises of *Libération*, they were all but ignored by the press for the entire year of 1981. In October, Mises wrote:

They derive their inspiration from the same source: the Middle Ages in a Mizogushi film, I believe. There may be more severity in the work of Comme des Garçons, which gives a sense of timelessness to their clothes. Yohji Yamamoto comes with about the same level of refinement, a bit more in evidence . . . these two designers push the limits completely through deconstructed garments, flexibility of materials, and simplicity of forms.[30]

No reports of the Kawakubo and Yamamoto 1981 collections were published in either the *New York Times* or *Women's Wear Daily*. The only Japanese designers who received media coverage that year were Kenzo and Miyake. The reviews were most often complimentary, though some journalists admitted uncertainty about the flowing nature and oversized scale of the clothes.

Other journalists, such as Michel Cressole and Serge Daney of *Libération*, increased their coverage of Kawakubo's and Yamamoto's subsequent collections, setting a trend for other French publications, including *Le Nouvel Observateur*, *Le Figaro*, and *Dépêche Mode*, to do likewise. Although Paris has long been the world's fashion capital, it has also traditionally relied on the influx of foreign talent to infuse its own culture with new artistic influences and to foster radical change. It can be argued that the deconstructed aesthetic of Kawakubo and Yamamoto would never have become an international phenomenon had they not decided to show their collections in Paris.

With few exceptions, most serious journalists in the United States and Europe were perplexed, and occasionally angered, by clothes that were viewed as anti-establishment and anti-female. Ironically, some of the more reactionary journalists betrayed a certain sexism when writing about the clothes: "Japanese fashion star Yohji Yamamoto is correct in his assessment of his own work. His designs are definitely 'for the woman who stands alone.' Who would want to be seen with her? Yamamoto's clothes would be most appropriate for someone perched on a broom."[31]

Interestingly, as early as 1982, fashion trade journals like *Women's Wear Daily* began to mention, albeit briefly and tepidly, the fact that a hand

ful of American buyers were in fact taken by the new Japanese looks. The first article devoted exclusively to the Comme des Garçons and Yamamoto collections, appearing in the 15 October 1982 issue, noted that the collections possessed a kind of poignant beauty. Journalist Patrick McCarthy noted that Yamamoto's pants were original, with "paper-bag gather and loop fastenings" and plain and rough-hewn fabrics that were made to look rich and daring.[32] But the aggressive nature of Kawakubo's presentations and the "Flintstone Age" primitivism of the footwear were also described in equal measure.

American retailers were among the first to bring deconstruction fashion from Japan to the west. While touring Tokyo in 1979, Alan Bilzerian – Boston-based owner of the eponymous boutique – came across a pair of "extraordinary trousers" made by Yamamoto. After much effort, Bilzerian made contact with the designer and imported his garments to the United States prior to Yamamoto's Paris debut.[33] Likewise, Barbara Weiser, then still a co-owner of the New York boutique Charivari (which reigned as the spot for cutting-edge fashion during the 1970s and 1980s), serendipitously discovered Yamamoto while in Paris on a buying trip in 1981. She remarked how the allure of his garments came from both their austerity and their complexity. At first sight unable to understand how they were meant to be worn, she found herself mesmerized by their mysterious folds and sweeping volume.[34]

The earliest clients of Kawakubo and Yamamoto understood that the two designers were not actually "deconstructing" fashion but carefully "constructing" clothes using specially made textiles and design techniques, as opposed to making very precious objects look worn or used. Rather than following the punks – who chose to cut and slash inexpensive, readily available clothing to achieve aesthetic pauperism – Kawakubo and Yamamoto maintained a healthy respect for craft. Referring to one of her best-known designs, the infamous Lace sweater of 1982, a black knitted top deliberately woven with holes (see page vi), Kawakubo noted: "The machines that make fabric are more and more making uniform, flawless textures. I like it when something is *off* – not perfect. Hand weaving is the best way to achieve this. Since

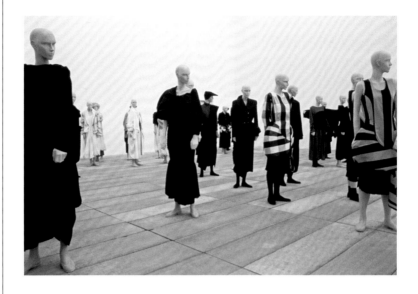

this isn't always possible, we loosen a screw of the machines here and there so they can't do exactly what they're supposed to do."[35]

Their garments were as carefully made and beautifully executed as any high-end ready-to-wear object in the west. Kawakubo and Yamamoto demonstrated a basic respect for textiles by minimizing cutting and sewing – emphasizing the inherent quality of the materials rather than cleaving fabric closely to the body. This totemic draping makes their work unique, imparting something previously unseen in the modern fashion lexicon.

During the mid- to late 1980s, Kawakubo and Yamamoto remained the preeminent figures in the world of avant-garde fashion, and their influence began to permeate the hallowed halls of culture. In 1987, for example, Comme des Garçons was prominently featured in an important exhibition highlighting the work of three of the twentieth century's most important female fashion talents. Curators Richard Martin and Harold Koda organized *Three Women: Madeleine Vionnet, Claire McCardell, and Rei Kawakubo* for the Museum at the Fashion Institute of Technology, New York. They argued that Vionnet, the greatest couturier of the golden age of modern fashion, McCardell, the leading innovator of mid-century design, and Kawakubo, the postmodern visionary, were equally important figures. The exhibi-

tion not only illustrated the regard these curators had for Kawakubo's work but also her lofty ascent while only at the midpoint of her career (fig. 22).

By the end of the 1980s, however, the novelty of Kawakubo's and Yamamoto's aesthetic began to wane, usurped by new talent from Antwerp, Belgium. A contingent of young designers that included Ann Demeulemeester, Dries Van Noten, and, in particular, Martin Margiela, created a new and more western kind of deconstructed fashion that had been built upon the Japanese foundation. Margiela, for example, began by creating a typical western high-fashion garment and then pulled apart and inverted certain components such as sleeves and pockets. The garment was then reconstructed with the interfacings and raw edges deliberately on view. Athough Margiela's clothes were new, they reflected his appreciation for reclamation. He stated: "I love the idea of recuperation. I believe that it is beautiful to make new things out of rejected or worn things."[36]

The work of the Belgian-born Margiela was first seen by an international audience in 1989, several years after his graduation from the Royal Academy of Fine Arts in Antwerp. His garments – as refined as those of any tailor on Savile Row – suggested tailoring while appropriating the vocabulary and exacting standards of couture. But his inversion of traditional construction elements displayed the integrity and honesty of the dressmaker's craft. Interior elements that are normally carefully hidden, such as linings, shoulder pads, interfacings, and padding, became both structure and ornament for Margiela. Even small details, like snap closures sewn on with raw basting stitches, became a form of applied ornament. He even took to coating his designs, first for a museum in Holland and later for an installation in Brooklyn, New York, with molds and bacteria as an experiment to see how these organisms would degrade objects from his archives (fig. 23 and 24).

While Margiela's particular brand of deconstruction was new and unique, it was built upon a language that had already been already established by Kawakubo and Yamamoto. However, Margiela himself is credited with bringing the term "deconstruction" into the fashion

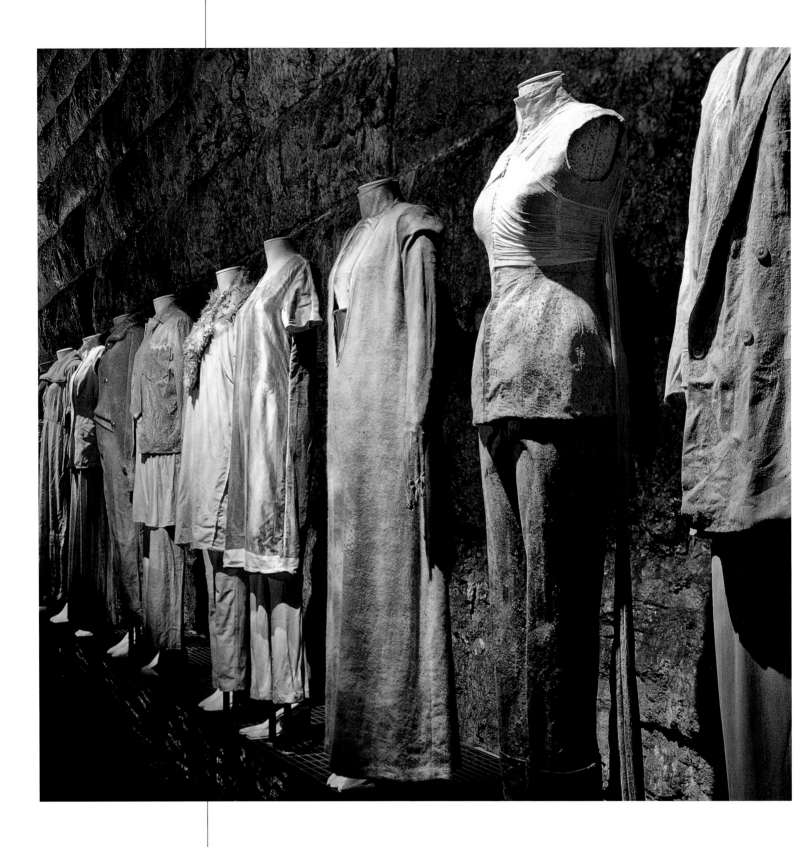

23 Martin Margiela, "9/4/1615" installation
at Brooklyn Anchorage, New York, 1999,
photo: William Palmer

lexicon. More specifically, Bill Cunningham, photographer for the *New York Times* and one the world's foremost commentators on and archivists of fashion trends, noted that Margiela's designs "realized a brash new spirit exploding out of rap music and deconstructivist architectural impulses . . . those present were witness to an event unique in the annals of fashion history . . . the deconstructivist impulse of the clothes and the manner in which they were shown – tops of dresses falling down over the hips, intriguing undergarments revealed, plastic

24 Martin Margiela, garment covered in mold, made for the "9/4/1615" installation at Brooklyn Anchorage, New York, 1999, originally created for Museum Boijmans Van Beuningen, Rotterdam, 1997, photo: William Palmer

dry-cleaning bags serving as tops. Jackets were hardly recognizable, the sleeves tied about the waist like a schoolchild's sweater."[31] Margiela and his Belgian contemporaries, known collectively as the Antwerp Six, made biannual pilgrimages to Paris and were apparently familiar with the work of the older Japanese designers: "Antwerp's fledgling designers would scurry to Paris during runway seasons, begging, borrowing and copying invitations to get into the shows and see what the future held for them. They witnessed the rise . . . of Rei Kawakubo and Yohji Yamamoto."[37]

While Kawakubo, Yamamoto, and later Margiela, brought deconstruction to the realm of high fashion, those who attempted to move it into the mainstream were less successful. One of the best known examples was the Grunge collection of November 1992 by Marc Jacobs for Perry Ellis. His last for that company, the collection sought to draw a connection between contemporary youth culture (in this case grunge, the punk-influenced rock-music style that emerged in Seattle, noted for its loud and discordant phrasings), and high fashion, but it was not well received. Models donned expensive silk dresses made from patterned fabrics that were deliberately mismatched and loosely constructed. However, some were more offended by the models' twisted and matted hair, which was tucked under knitted stocking caps, and by accessories such as combat boots and Birkenstock sandals, and the presence of nose rings.

Kawakubo and Yamamoto reinvigorated the use of deconstruction in the mid-1990s. This design element, that defined so much of their early careers in the west, was fused with the growing revival of both Belle Époque and mid-twentieth century couture. Kawakubo, for example, in 1997 designed brocaded coats and cocktail dresses with sheer insets that revealed swaths of flesh and demonstrated a lack of support materials (fig. 25). She enhanced the interplay of sheer and opaque pieces of fabric by using asymmetry. Although not black, her cocktail dresses and evening gowns took on the appearance of partial garments that looked as if they had been taken apart and reassembled backwards in a deliberately askew manner. In a later collection, Spring/Summer 2001, she also made dresses from what

25 Rei Kawakubo for Comme des Garçons,
detail of a brocaded coat, Fall/Winter 1997,
collection of the Museum at FIT,
photo: William Palmer

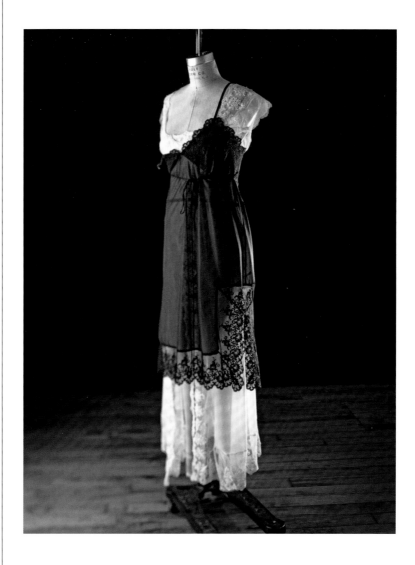

appeared to be silk slips dating to the 1950s, cut in half and then attached to other slips before being wrapped and tied around the body (fig. 26).

Yamamoto presented collections from 1996 to 1997 that were odes to postwar Chanel, Dior, and even Hollywood in the 1950s. He appropriated that era's cardigan-like jackets and pencil skirts and silhouettes with whittled waists and sweeping skirts, but cut fabrics like felt and tweed as if they were silk and left their raw, unhemmed edges exposed.

Both approaches – Yamamoto's inverted couture techniques and Kawakubo's deranged socialite imagery – led to a resurgence of interest in deconstruction. Kawakubo and Yamamoto created some of the most beautiful and intellectually moving fashions seen in the late 1990s. Their popularity returned once again, along with an interest in ladylike fashions, and their new, poetic creations paved the way for subsequent generations of creators.

Although the runways were largely bereft of deconstructed elements for much of the 1990s, many designers would come to incorporate them so fluidly that deconstruction became a hallmark of their work. The incorporation of deconstruction by the world's leading purveyors of high-end ready-to-wear and haute couture lines relied not on the original style of deconstruction pioneered by Kawakubo and Yamamoto, but their later, more aesthetically subtle and refined version. A cadre of younger designers who became the creative heads of venerated Parisian firms (such as Olivier Theyskens at Rochas and Alber Elbaz at Lanvin) are so versed in the elements of deconstruction that the finest and most coveted examples of their work consistently utilize this poetic form of deconstruction envisioned by Kawakubo and Yamamoto. It remains one of the most important design elements in fashion today.

JUNYA WATANABE: MASTER CRAFTSMAN

> It's very simple. I work hard to make the clothes I want to make and those who sympathize with my creation wear it. The people who buy my clothes take fashion seriously. They get a kick out of the challenge to wearing something new. Those are the people I design for. I am not interested in the mainstream.
>
> Junya Watanabe, *Dazed and Confused*[38]

Perhaps the only fashion designer in Japan who has been able to follow in the footsteps of Kawakubo and Yamamoto is Junya Watanabe.

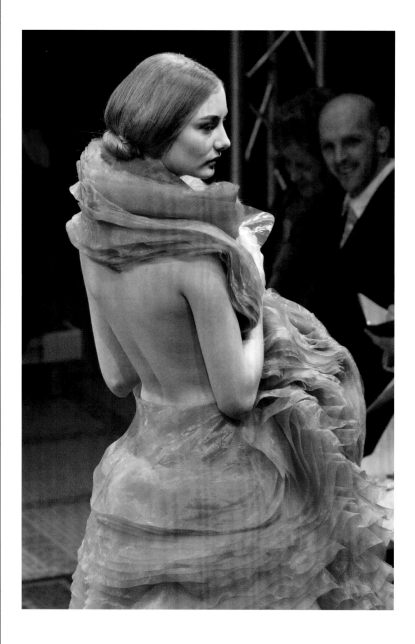

Watanabe has been able to combine the very best aspects of Japanese design (such as emphases on beautiful execution and high aesthetics) with creativity and innovation on a par with Rei Kawakubo, and he has done so to international acclaim.

The importance of Watanabe has been recognized by leading western critics. In a 2002 article, Amy Spindler convincingly argued that

Tokyo is now the international center of fashion, not Paris or New York. She wrote:

> Being the capital of fashion isn't about who has the boutiques or the runway shows or the fashion magazines, although Tokyo has plenty of those. To be the true capital of fashion, fashion must dominate everything. It must be the passion of the masses and the connoisseurs. It must be the primary mode of expression beyond art, film, music. It must be a place where fashion is treated like a necessity, not a luxury. . . . It's the only city in the world where creating fashion is treated as an intellectual pastime. Ask who is the greatest living artist in Tokyo and a surprising number of people won't name a writer or painter; they'll name Rei Kawakubo. Or Junya Watanabe.[39]

While Watanabe is acknowledged as a master of his craft in Japan (as well as by many abroad), very little is known about his private life and professional forays. Indeed, he has been labeled "the shyest man in fashion." The few facts about him read like a simple dictionary entry: he was born in Tokyo in 1961. Inspired by the success and respect garnered by Issey Miyake, he opted to study fashion design at the most celebrated school of its kind in Japan, the Bunka Fashion Institute. He graduated in 1984, and went straight from school to the design department of Comme des Garçons. Three years later he was given the Comme des Garçons Tricots label to design, a responsibility that continues to this day. In 1992, Kawakubo allowed Watanabe to design under his own name with the support of her company. The only bit of personal information the designer revealed in a recent interview published in *Arena Homme* magazine concerned his first marriage and divorce. "My wife left me," he noted. When this occurred, he would not say.

As he chooses to remain isolated from the mainstream fashion world, Watanabe's only visible moments in the spotlight occur when he sends his clothes down the Paris runway four times a year – twice each for his women's and men's high end ready-to-wear lines. It is through those garments that Watanabe's reputation as the greatest technical master working in contemporary fashion was born.

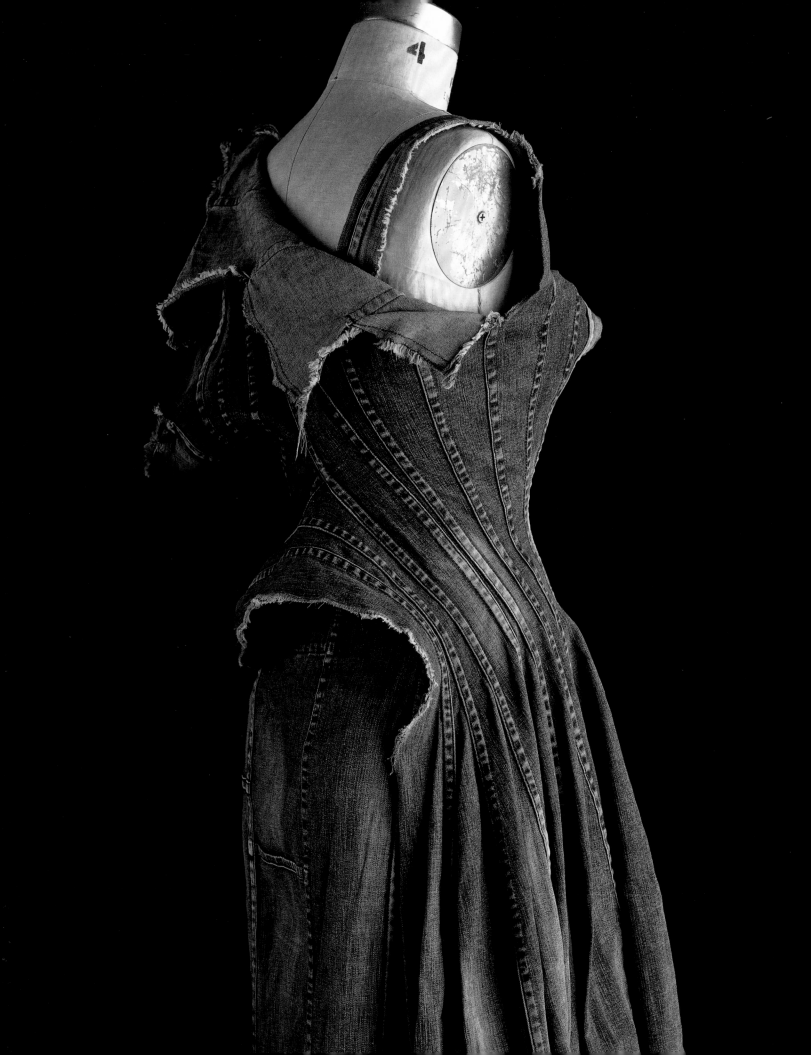

Watanabe readily concedes that Rei Kawakubo has been instrumental in his success and in the evolution of his style. Both by being his financier and by giving him complete autonomy to create, Kawakubo has inverted traditional gender roles – she is his sponsor and protector, he her disciple. But the Comme des Garçons company is continuing the long-held practice of nurturing talent, not unlike the guild systems of medieval Europe that allowed apprentices to perfect their skills under the tutelage of acknowledged masters.

Each Watanabe garment is both a technical and aesthetic achievement. His garments often possess the kind of impact evident in the work of other great couturiers/craftspeople, such as Cristobal Balenciaga. In the best examples of his work, Watanabe's technical brilliance and virtuosity are readily on display, from the corseted bodice of a denim dress, to the pleating of an organza dress shaped like a paper lantern (fig. 30), to a wool purse that unfolds to become a fitted jacket (figs 28 and 29).

Augmenting photographs of a few pieces from Watanabe's vast oeuvre with flat patterns allows the planar disposition of the pattern to reveal the full extent of Watanabe's conceptual achievement and his contribution to contemporary fashion design.

The patterns shown here have been modified and simplified by couturier Pamela Ptak in order to more clearly communicate the configuration of the whole design. With patterns as complex as these, many details have been eliminated. The patterns are executed to illustrate and clarify the manner in which they come together. In most instances, artistic license has been taken so that an angled side seam or a shoulder gusset can be more clearly observed. The patterns and diagrams can be thought of as a simplified map, leading not to a line-for-line copy, but to further understanding of the idiosyncratic accomplishment of the designer.

The first object is Watanabe's corseted denim dress made for his Spring/Summer 2002 collection (fig. 30). This garment is one of several stellar examples that dispel the contrived conclusion by many that Watanabe has a propensity only for synthetic, high-tech

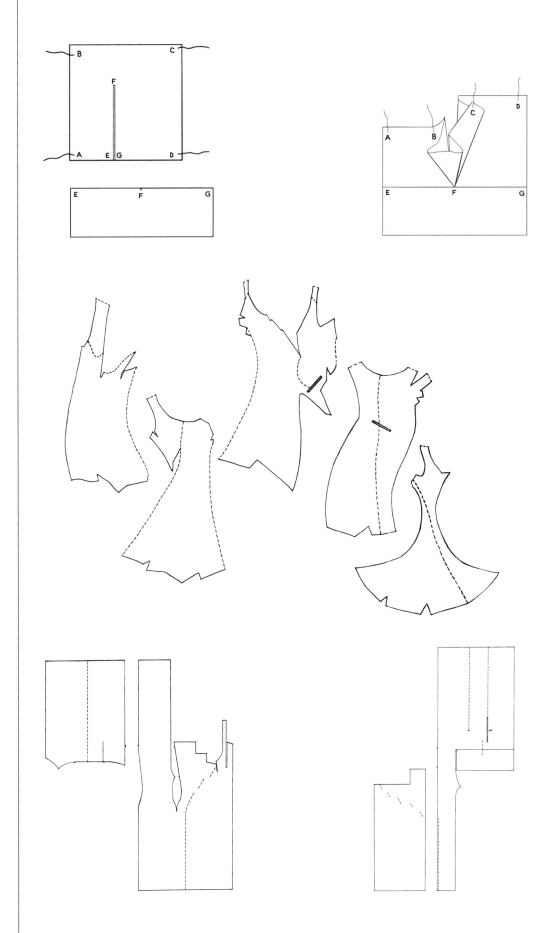

fabrics. Despite its seemingly sweet homeliness and evocation of an Americana "prairie look" in the style of Ralph Lauren, the dress is in fact a highly complex creation.

Although this is a single garment, it is composed of two distinctly different parts. The most obvious and readily visible part of the dress is the amplitude of form that emerges from the top of the bodice and the flare of skirt in front. The amplitude in front is crafted from long bands of fabric (none more than five inches wide), cut on the straight grain and then connected into vertical strips that incrementally narrow at the waist. A few of these vertical strips start at the hem, extend over the shoulder, and then return to form another edge of the skirt. Other bands that begin at the hem curl back into the bodice or wrap around the torso and then either return to another part of the skirt's rim or attach to the other component of the dress (fig. 31).

This second component is a partial skirt that is visible only from the back. Rather than forming a series of ever widening or narrowing bands, the skirt is a patchwork of irregularly sized rectangular panels laid on their sides. The visual effect is more horizontal than vertical and, collectively, these small pieces of material give the illusion of a wall made from bricks or stones.

This dress and the following example are made of cotton blended with a small amount of Lycra. Each was over-dyed to give it a coppery cast after the deliberate raw edges were frayed and then stitched to avoid stretching and further degradation.

A pieced denim dress from the same collection provides another example of Watanabe's technical bravura (fig. 34). The pieced look of the dress evokes the homespun quality of a quilt, a cornerstone of the American folk-art canon. Like the quilted bedcovers or pieced garments made for both men and women in the nineteenth century, the dress is crafted from small fragments of cloth. Watanabe maintains the look of such humble clothing with what appear to be scraps of recycled of cotton denim.

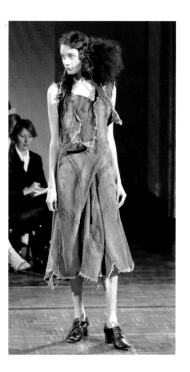

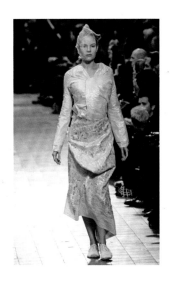

But the garment parts company with historic Americana when the construction of the dress is more closely examined. Rather than constructing a whole textile from small pieces of fabric sewn together, Watanabe first pieced together one set of small, diamond-shaped patches to create a large vertical panel. He repeated the process to make a total of five panels (fig. 32), all of which were sewn to each other to make a vertically seamed dress. Watanabe's dress bears no resemblance to the more typically constructed, vertically seamed sheath, which is made from four linear pattern pieces (two in front and two in back). The use of five panels, and their arced s-shape, destroys such symmetry. In pattern form, each of the five large panels undulates like an amoeba. On the wearer, the dress is a multi-strapped contraption with a haltered inner bodice that is enveloped by an asymmetrical over-bodice slit open in front.

Like its sister garment, this dress has an obvious deconstructed look. While the careful fraying is a deliberate design element, it also reconnects the dress to its primitive American roots. Both dresses bear similarities to those worn by female pioneers that settled and farmed the United States' heartland throughout the nineteenth century.

A third example by Watanabe is his wrap skirt from the Spring/Summer collection of 1999 (figs 35 and 36). When worn, the deceptively simple construction of this sarong-style skirt is not evident. A part of the skirt's complex visual interplay comes from the tension between its fluidity and rigidity, the latter voiding any connection to the uncut wrapped sarongs worn throughout southern Asia. The bell shape of the skirt holds its form, as does the pouch-like drape of the large flap in front.

The skirt is made from two pieces of fabric cut with only right angles (fig. 33). One of them is a simple, elongated rectangular panel that forms the hem of the garment; the other is an L-shaped swath that is as wide as the lower panel to which it is attached. This L-shaped swath was formed when it was cut vertically down the middle, dividing the top part of the swath in two. The divided halves form an asymmetrical, two-part waistband, held in place with twill tape ribbons that can be tied into any position the wearer chooses.

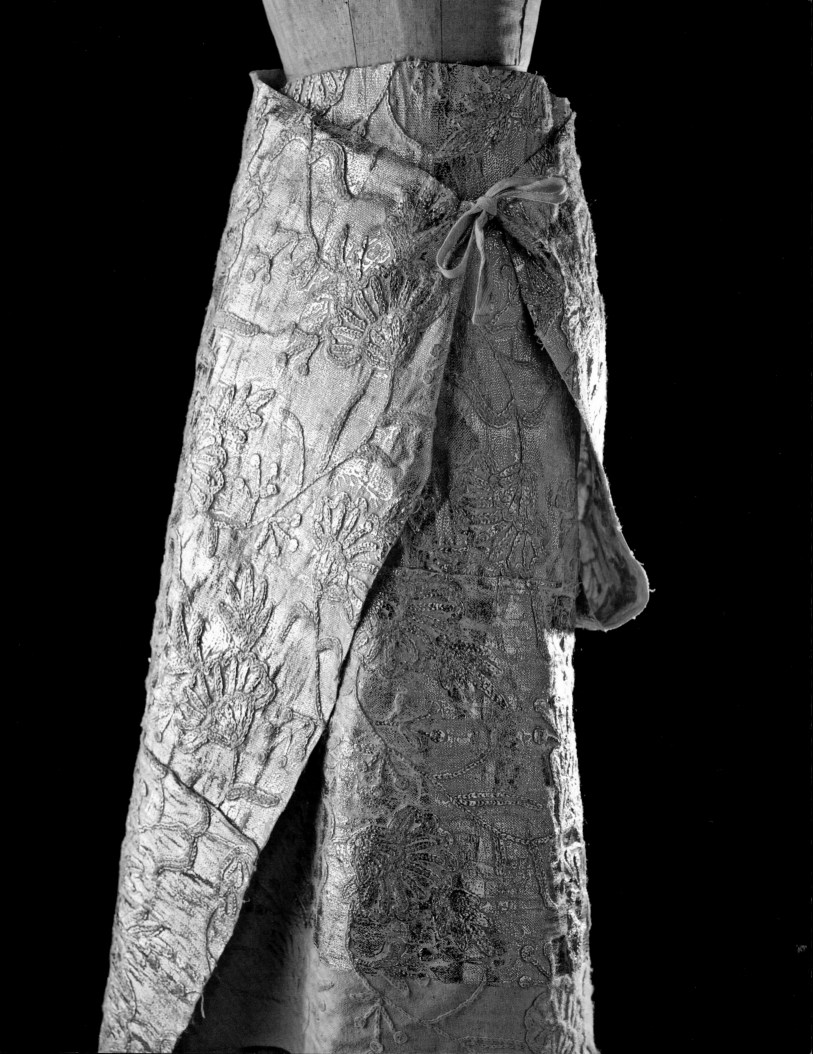

The fabric choice is a surprise. Watanabe chose an un-dyed, off-white wool fabric, similar to the types of domestic material used in eighteenth- and nineteenth-century homes in Great Britain and its colonies. The historic quality is further enhanced by the crewel work of meandering floral motifs executed in the tambour, or chain-stitch, embroidery the English adopted from India and spread throughout the world. Its connection to the past is severed as the outer surface of the skirt is painted silver.

CONCLUSION

Japanese fashion, particularly by Rei Kawakubo and Yohji Yamamoto, has been integral to the development of contemporary fashion worldwide. As stylistic revolutionaries and then establishment leaders, they have created a force so potent that the most revered clothing designers in the world incorporate their most important contributions.

While many fashion specialists may never embrace their work, the most respected ones understand their contributions and value what they have produced. Such reverence is not confined to the plethora of cutting-edge publications like *Purple* or *i-D* magazine. One of the world's leading stylists, Grace Coddington, for example, has regularly incorporated Comme des Garçons and Yohji Yamamoto garments into her spectacular editorial spreads for American *Vogue*. Another *Vogue* editor, André Leon Talley recognized the cerebral beauty of a particularly challenging Comme des Garçons collection when he paraphrased Bill Cunningham of the *New York Times*. The garments from the Spring/Summer 2000 collection were made from layers and layers of pink, red, and white ruffles that completely covered Kawakubo's dresses and coats. The designer obscured the silhouettes of these three-dimensional garments by shoving parts of their hems into panty-hose-like underpants. And yet, for all the seemingly unsavory runway theatrics, Cunningham and Talley saw and understood their beauty. Talley wrote:

> Bill Cunningham, one of the most respected individuals in fashion, known for his integrity and humor, told me right after

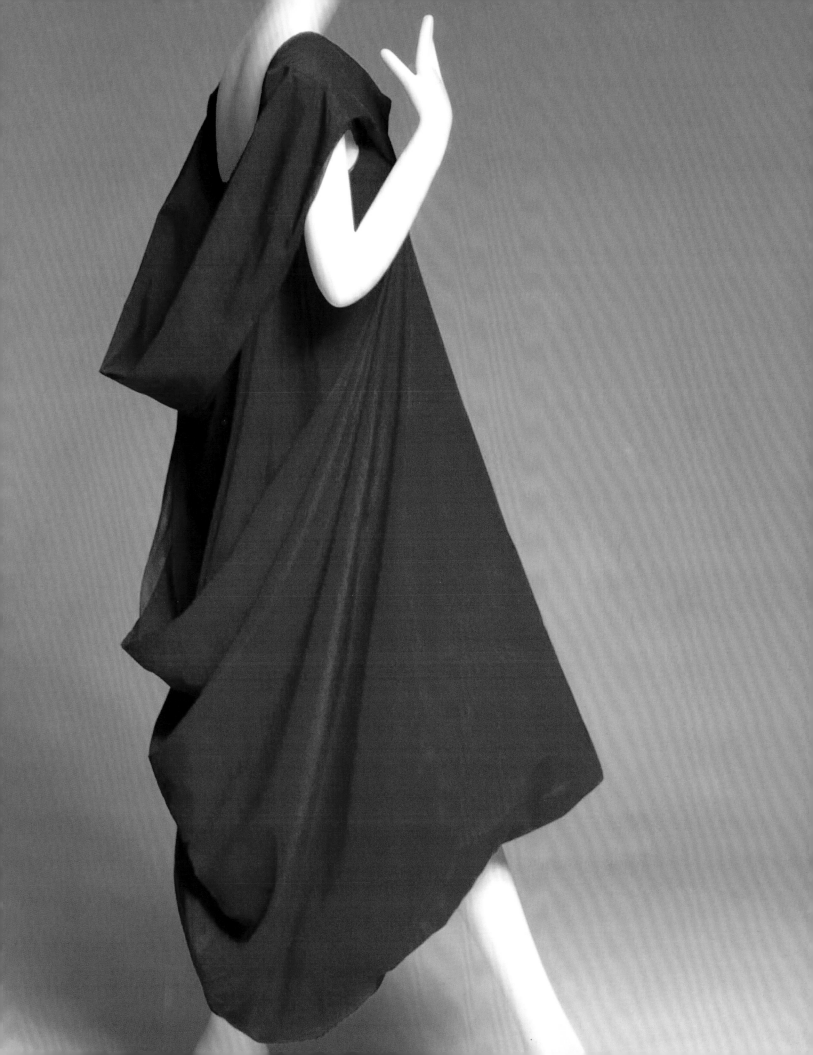

the show, "I felt I was at [Cristobal] Balenciaga, but in a modern way." And he (Cunningham) can truly judge, since he saw his first Balenciaga couture show in 1952 . . . Thank God he was there to see this colorful and unique fashion moment – a fashion orgasm, full charge.[40]

Nearly every scholar and curator of contemporary fashion actively observes and procures the work of the leading Japanese designers for her or his institution's collections. While many of us still refer to these designers *en masse*, there is an awareness that they are individuals whose work has propelled and continues to compel contemporary fashion. The Museum at FIT is one of many institutions that collects their work and displays it regularly. Singularly unique and profoundly compelling, the visions of Rei Kawakubo and Yohji Yamamoto set them apart from nearly all other designers, including those who create work in homage to their style.

notes

1 Leonard Koren, *New Fashion Japan*, Tokyo: Konansha International, 1984, p. 89.

2 Lisa Armstrong, "Deconstructing Yohji," British *Vogue*, August 1998, p. 136.

3 Koren, *New Fashion Japan*, p. 95.

4 Dorinne Kondo, *About Face: Performing Race in Fashion and Theater*, New York: Routledge, 1997, p. 75.

5 *Vogue*, May 1997, pp. 146, 148.

6 Bernardine Morris, "From Japan, New Faces, New Shapes," *New York Times*, December 14, 1982, p. C10.

7 Kiyokazu Washida, "The Past, the Feminine, the Vain," in Carla Sozzani and Yohji Yamamoto, eds., *Yohji Yamamoto: Talking to Myself,* Milan and Tokyo, Carla Sozzani Editore and Yohji Yamamoto Inc., 2002, n.p.

8 Lee Carter, "Connect the Dots: Rei Kawakubo Maps Out Her Universe, One Superstar at a Time," *New York Times*, August 28, 2005, p. 94.

9 Koren, *New Fashion Japan*, p. 96.

10 Holly Brubach, "The Truth in Fiction," *Atlantic Monthly*, May 1984, p. 96.

11 Judith Thurman, "The Misfit," *New Yorker*, July 4, 2005, p. 62.

12 Sarah Mower, "Talking with Rei," *Vogue Nippon*, September 2001, p. 157.

13 Ibid., p. 158.

14 Ibid., p. 159.

15 Barbara Weiser, phone interview with Patricia Mears, Brooklyn, New York, September 20, 1999.

16 Anne Hollander, *Sex and Suits*, New York and Tokyo: Kondansa International, 1994, p. 5.

17 Koren, *New Fashion Japan*, p. 114.

18 Ibid., p. 92.

19 Jeff Weinstein, "The Man in the Gray Flannel Kimono," *Village Voice*, April 19, 1983, p. 23.

20 Kondo, *About Face*, p. 67.

21 Junichiro Tanizaki, *In Praise of Shadows*, trans. Thomas J. Harper and Edward Seidensticker, New Haven, Conn.: Leete's Island Books, 1977, p. 18.

22 Ibid., pp. 13, 14.

23 Ibid., p. 28.

24 Koren, *New Fashion Japan*, p. 57.

25 Leonard Orr, *A Dictionary of Critical Theory*, Santa Barbara, Calif.: Greenwood Press, 1991.

26 Caroline Evans, *Fashion at the Edge: Spectacle, Modernity and Deathliness*, New Haven and London: Yale University Press, 2003, p. 36.

27 Bernadine Morris, "Loose Translators: The New Wave," *New York Times*, January 30, 1983, p. 40.

28 Armstrong, "Deconstructing Yohji," p. 136.

29 Yuniya Kawamura, *The Japanese Revolution in Paris Fashion*, Oxford and New York: Berg, 2004, pp. 125–26.

30 Claire Mises, "Pret-à-porter 1982: du sectarisme grâce au forme adoucies," *Libération,* October 17–18, 1981, p. 8.

31 Mary L. Long, "Yohji Yamamoto," *People*, November 1, 1982, p. 7.

32 McCarthy, Patrick, and Jane F. Lane, "Paris: The Japanese Show Staying Power," *Women's Wear Daily*, October 15, 1982, p. 5.

33 Alan Bilzarian, phone interview with Patricia Mears, Brooklyn, New York, August 8, 1999.

34 Barbara Weiser, phone interview with Patricia Mears, Brooklyn, New York, September 20, 1999.

35 Koren, *New Fashion Japan*, p. 117.

36 Luc Derycke and Sandra van de Veire, eds., *Belgian Fashion Designers*, Antwerp: Ludion, 1999, p. 292.

37 Amy M. Spindler, "Coming Apart," *New York Times*, Style Section, July 25, 1993, p. 9.

38 2003, p. 116.

39 Amy M. Spindler, "Do You Otaku?" *New York Times Magazine*, Spring 2002, part 2, p. 134.

40 André Leon Talley, "Style Fax: Paris P.C.," *Vogue*, December 1999, p. 94.

yuniya kawamura

JAPANESE FASHION SUBCULTURES

An analysis of Japanese youth subcultures focusing on the outward appearance of their members offers the best way to understand their worldview and how their values, norms, attitudes, and beliefs have changed dramatically over the past few decades.[1] The way they dress and their taste in clothes are exhibitionistic in nature and serve as a marker of social background, specific territorial space, and subcultural allegiance. Fashion always reflects the prevailing ideology of a society, and the Japanese youth of today is no exception, since its various styles play a vital role in creating a subcultural community. How young people dress or with which styles they experiment is a reflection of their internal selves that many of them find difficult to express verbally. Japanese youth subcultures are often led by fun-loving high-school or middle-school girls who greatly influence fashion trends within their own community. A different type of fashion is being dictated directly and indirectly by these appearance-conscious youngsters. They are the agents of fashion who take part in its production and dissemination, and, as a result, their subcultural communities are sustained.

Japanese fashion has been an inspiration to many fashion professionals and fashion-conscious individuals both in and outside Japan, starting

with Kenzo Takada's appearance in Paris in 1970 and followed by Issey Miyake in 1973, Hanae Mori in 1977, and Yohji Yamamoto, and Rei Kawakubo of Comme des Garçons in 1981. However, today's Japanese youth fashion offers another contribution with regard to the aesthetic aspect of fashion and is receiving a great deal of attention from the west. Styles created by Japanese subcultures emerge from the social networks among different institutions of fashion as well as from various street subcultures, each of which is identified with a unique look as well as by a particular district. The young people rely on a distinctive appearance to proclaim their symbolic and subcultural identity, which is not consciously political or ideological: it is simply an entertainment for them, and the styles determine their group affiliation. Their appearance gives them a strong group identity and a sense of belonging. Being a member of the subculture is more important than simply wearing what is required in order to be part of the group. These young people are not interested in the mainstream or becoming part of mainstream society; they enjoy their marginal status as a member of their confined subcultural community. When the Japanese media began to pay attention to youth subcultures in the mid-1990s, there were only two or three groups, and they were easily recognizable because of their distinctive outfits. These subcultures have branched out intricately into many smaller sub-subcultures; their social networks are becoming complex, and their territorial space occasionally overlaps.

JAPAN'S ECONOMIC DOWNTURN AND STRUCTURAL CHANGES

Japanese society was famously cohesive and conformist, and groups and individuals were not polarized but integrated. However, that began to change under the strain of economic stagnation in the 1990s, when Japan's unique system of lifetime employment collapsed. The increase in the suicide rate among middle-aged men is indicative of how devastating this social change was. The total number of suicides has exceeded 30,000 every year since 1998, and in 2009, according to the National Police Agency, it increased to 32,753 from 32,240 in the

previous year, with men accounting for 23,406 of the total and women, 9,347. As the suicides among middle-aged men increased, Japanese male dominance began to break down. Fathers could no longer be the sole breadwinners of the household, so mothers who used to be full-time homemakers had to work part-time to supplement their household income. The recent White Paper on Youths published by the Japanese government estimated that in 2008 the number of so-called NEETs (not in employment, education, or training) reached 640,000. The social and economic situation is likely to become even more unstable and insecure, since, according to a survey carried out by a major research company, Teikoku Data Bank, of the 10,624 companies questioned, 47.5% indicated that they did not intend to hire any full-time employees for fiscal year 2010. One of the boys I interviewed in the course of my research told me, "I don't know of anyone in my circle of friends who has a full-time job. Not having a full-time job has become the norm. We all work as part-timers or freelancers, and we are always worried that our employers may tell us tomorrow that we are fired."

Today's young people are the children of the adults who went through restructuring processes at work and experienced major changes in the economic system and the labor market. These children may have seen their fathers being laid off for the first time; they no longer have the concept of a secure, full-time job. Juvenile delinquency increased from 69, 211 cases in 2006 to 88,104 in 2007 and had almost doubled to 134,992 by 2008. These statistics reflect the fact that young people see no cause for optism in the Japan of the future. Widespread feelings of disillusionment, alienation, uncertainty, and anger have spread throughout society from adults to children. Clearly, a gradual breaking-down of traditional family, social, and economic systems is taking place.

The value system of the whole society, especially that of teenagers, has changed and is still in the process of changing. The previous generation's traditional Japanese beliefs, such as selfless devotion to their employers, respect for seniors, and perseverance, no longer exist. An intentional shift from old ideology and ways of life is evident in

today's Japan. Young people see the assertion of individual identity as being more important and meaningful than that of family or corporate identity, formerly the key concepts in Japanese culture. These attitudes are reflected in the norm-breaking, outrageous, and yet commercially successful styles that they adopt and that attract attention.

While it may seem ironical, it is under these changing social and economic conditions that Japanese street fashion and subcultures have become increasingly creative and innovative. They go against the grain of normative ideas about how one should dress in the public sphere or assume a persona. The youngsters are in search of an identity and a community where they feel comfortable and are accepted.

GEOGRAPHICALLY DEFINED SUBCULTURES

Today's Japanese youth subcultures are geographically defined by various districts in Tokyo, such as Shibuya, Harajuku, Akihabara and Ikebukuro. At the same time, they are stylistically defined. The young know exactly where they are going and how they are supposed to dress. One of the girls I interviewed used to hang out in Shibuya and explained, "You would never go to Harajuku dressed in a Shibuya style or vice versa. You would be totally out of place. We know where we belong or where we want to belong." Tokyo is a very small city, but each district creates its own unique characteristics and subcultures and provides a space for the young to interact and communicate with each other face-to-face. This space gives them a sense of belonging, and thus they keep coming back to be with those with similar values and interests. The districts are helped by various related industries and by the media (for example, print magazines and websites) to produce, disseminate, reproduce, and perpetuate the subcultural phenomenon. There are complex networks within each tightly knit community, and at the weekends the districts are packed with young people who help sustain the huge subculture industries that produce or create video games, songs, figurines, coffee shops, etc.

A landmark in the district of Shibuya is Shibuya 109, a major shopping center/building with eight upper-level and two basement floors. It has been run since 1979 by Tokyu Malls Development (TMD). Originally, the stores in the center sold conventional women's wear, but in 1996 the retail emphasis of the entire building changed to capture the younger market. As of March 2010, there are 116 tenants/stores in the building, all of which target women in their teens and early twenties, and at weekends the center is full of young girls. For the past thirteen years, Shibuya 109 has been growing its annual sales every year, according to Kunio Soma, Managing Director of TMD. This upward trend has resulted from the *kogyaru* ("high-school gal") phenomenon – which began to appear in Shibuya in the mid-1990s – and the multiple youth subcultures that came out of it: the girls in the area became known for wearing short, plaid skirts, which looked like their school uniforms, and knee-high, white socks, occasionally with a lot of make-up and artificial suntan to make their complexion darker. The effect and influence exercised by these girls extended far beyond the confines of one particular group of teenagers.

The main concept of Shibuya fashion is *ero kawaii* (erotic and cute) – or *ero kawa* in abbreviation – which represents various Shibuya subcultures. As its name indicates, the style has both erotic and cute elements which are often treated as polar opposites. One of the most prominent subcultures that first emerged in Shibuya was called Ganguro (literally, "face-black"), which led to and branched out into other smaller, local subcultural groups. The social life of the majority of the teenagers in this district revolved around Shibuya Station, and they subconsciously and unintentionally created a subculture. A common sight on the streets of Shibuya in the 1990s was groups of young girls between the ages of fifteen and eighteen with long dyed-brown or bleached-blond hair, tanned skin, heavy make-up, bright-colored mini-skirts or short pants that flare out at the bottom, and high, platform boots. A designer who used to be Ganguro said, "I was a hardcore Ganguro when I was in high school. I had to be. Otherwise, I wouldn't be accepted by other kids. I would be totally

out of place if I looked normal. We all want to fit in when we are teenagers."

Ganguro led to Amazoness which was more extreme in terms of make-up and fashion, but, according to some industry professionals, Amazoness was probably so extreme that it did not last long. Instead, toward the end of the 1990s and in the early years of the new century, Yamamba ("mountain witch") emerged as another fashion trend and subculture and appeared to replace the Ganguro look. More recently, Yamamba has evolved into Mamba and Bamba.

There are multiple interactions occurring simultaneously on the streets of Shibuya, and the subculture groups with specific appearances have diffused into so many different sub-subcultures that it is almost impossible to track down all the existing groups. Each subculture is also associated with a particular brand. One Shibuya subculture group is called Lomamba – that is, Mamba with a Lolita touch – and the label worn by its members must be LizLisa, which is sold at Shibuya 109. Similarly, Cocomba is Mamba wearing the brand Cocolulu, also sold at Shibuya 109. One girl I interviewed said, "There are so many girls who are only partially Mamba, and they are not authentic Mambas. Authentic Mamba is not tied to one brand."

HARAJUKU

Harajuku is well known for having produced subcultures even before the 1990s. In the early 1980s, a subculture called the Bamboo Tribe appeared in Harajuku at weekends and danced to music wearing bright-colored, silky costumes. It was only in the late 1990s that a new subculture called Lolita began to emerge in the district. Harajuku is the place for Lolita girls. One of the girls I interviewed said, "I love Harajuku. I go there almost every day. I like to watch people walking down the streets of Harajuku. I love the atmosphere." At the weekend, the famous Takeshita Street, a pedestrianized street filled with stores and boutiques that sell Harajuku fashion, is, like Shibuya 109, packed with teenage girls.

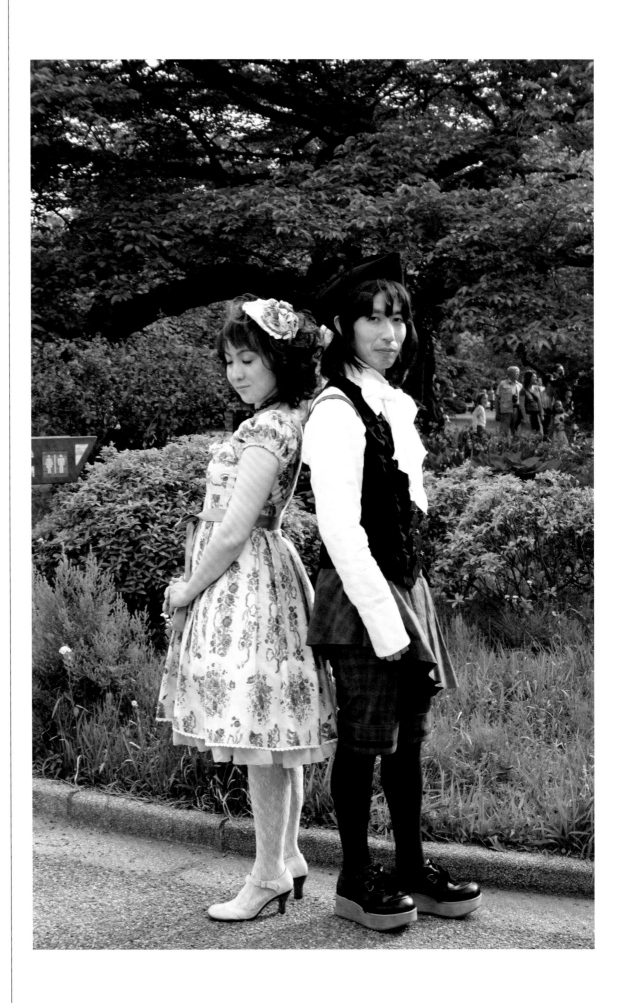

Lolita, one of the most popular subcultural styles found in the Harajuku area, can be seen as a counter-reaction to *kogyaru* style and others that evolved out it. It is a fashion style popular among those who think Shibuya style is too sexy or erotic and not feminine. It is usually worn by girls, and the predominant image is that of a Victorian doll; it presents an exaggerated form of femininity, with pale skin, neat hair, knee- or mid-thigh-length Victorian dresses, pinafores, bloomers, stockings, and shoes or boots.

Its substyles include Gothic Lolita (sometimes called Elegant Gothic Lolita), with a monochromatic palette; Classical or Country Gothic Lolita, with pastel colors; and Punk Gothic Lolita, with punk elements such as leather, studs, safety pins, zippers, and chains. Other Lolitas include Ama-Loli, with a basic Lolita look using mostly white; if pink is used, it is called Pink-Loli. When two girls wear exactly the same Lolita style, it is called Futago-Loli, which means Twin Lolitas. Wa-Loli is a combination of Wa – Japanese elements – and Lolita. The Lolita members are bound together by their stylistic expression and have created a subcultural community. They communicate face-to-face or online, they talk about different Lolita brands and discuss how to put together a particular Lolita look or how to make handmade Lolita items. They get together at weekends, take photos of each other and post them online, go to events and attend tea parties organized by Lolita fashion labels. They have created their own language and slang that is incomprehensible to outsiders, for example "LoliBra," which refers to a Lolita brand, or "Cardi," which is a cardigan.

An industry observer explained, "This is a style that has been developing out of the cosplay phenomenon on the streets of Japan for the last ten years or so. The look has evolved and is slowly beginning to take roots in other countries around the world." Lolita girls are often mistaken as cosplayers who dress like their favorite characters in Japanese cartoons, but they insist that they are not. The Lolita girls and cosplayers often congregate in the same physical space – Jingu Bridge near Harajuku Station – and outsiders have no clue as to who is a cosplayer and who is not.

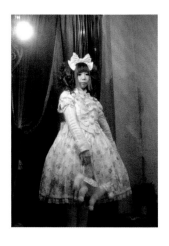

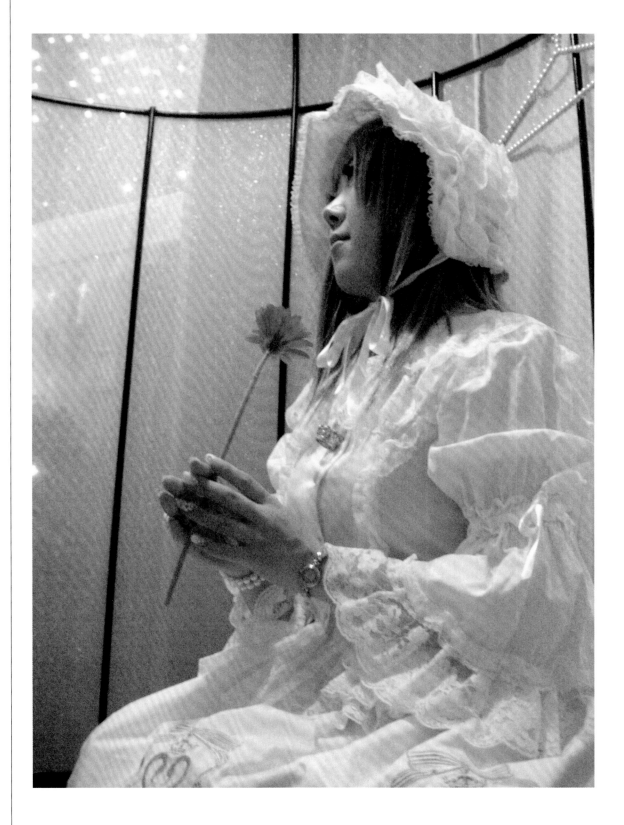

ABOVE:
haru wearing Sweet Lolita,
photo: Momo Matsuura

RIGHT:
shii wearing White Lolita, photo:
Momo Matsuura

Akihabara, the largest electronics town in Japan, is the place for manga and anime fans or fanatics called *otaku*, which refers to those with obsessive interests. The term (meaning "house") implies that they are introverted and spend most of the day at home reading manga and watching anime DVDs. The manga and anime industries are central to Akihabara subculture, and there are many related auxiliary industries producing video games, anime songs, anime and manga figurines, and cosplay costumes among other things, as well as cosplay restaurants and maid cafés.

Cosplay, an abbreviation of "costume play," is a phenomenon in which manga and anime *otaku* dress themselves as their favorite characters. The purpose is merely to have fun and entertain themselves and others. There are cosplay events throughout Japan every weekend, and cosplayers go to show off their handmade costumes. One of the long-time cosplayers I interviewed explained to me, "The fundamental rule among the cosplayers is that they must make and sew their own costume. The closer to the character in anime or manga you get, the higher the respect and status you earn as a cosplayer. Once I know which character I am playing, I watch the DVD hundreds of times and draw sketches to check all the details. To make a two-dimensional character three-dimensional is the biggest challenge, but it's also great fun." A group of cosplayers will decide on a particular anime or manga and negotiate which character each wants to play, and then they set the date to complete their costume. Once everyone has finished, they rent a photography studio, choose an appropriate scene to represent, and take photos. The cosplayer explained, "We are fanatics, so once we find a person who is also *otaku*, we go on and on and talk about our favorite anime and manga for hours. People probably think we are crazy."

In cosplay restaurants, waitresses wear different uniforms/costumes every day, and female customers can choose a cosplay outfit, such as a maid, a high-school girl, or a nurse, and for 1,000 yen (approximately US$11.00) can have photos of herself taken for 5 minutes. Maid cafés also flourish in Akihabara, where waitresses are dressed as maids and

Waitress dressed as high-school girl
at a cosplay restaurant in Akihabara,
photo: Yutaka Toyama

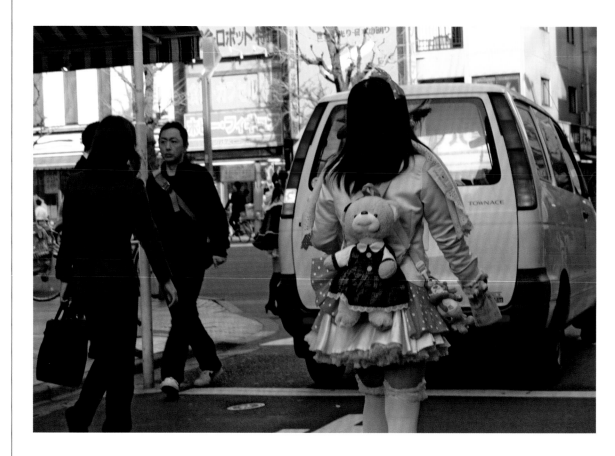

greet their male customers with "Welcome home, Master!" Providing this kind of space for the *otaku* community offers a sort of stability and security for those who are otherwise socially isolated. There are also maid crossings, street crossings where Maids hand out flyers to encourage people to visit their café. The Maid's dress is very similar to that of Gothic Lolita, but the members of the two subcultures insist that they are completely different.

The district of Ikebukuro is smaller than Akihabara. It is known as the female version of Akihabara, and the female version of *otaku* is *fujoshi* (literally translated as "rotten girls"). There is a butler café for women where male waiters are dressed as butlers and greet their female customers by saying, "Welcome home, Princess." Unlike at maid cafés, an appointment is required. *Fujoshi* are obsessive about *doujinshi*, self-published manga or novels by amateur artists and writers. The most popular plot is a love story between two good-

looking boys, a genre called Boys' Love (abbreviated to "BL"). Some *fujoshi* dress as boys and work as waiters at Dansou Café, which caters mainly to girls and women.

In Akihabara and Ikebukuro, the youngsters play around with what they wear and take on other personae; they become actors and actresses simply by changing their outfits, and this in turn temporarily changes their identities, giving them with a great sense of satisfaction.

IN SEARCH OF A SENSE OF BELONGING

As I walked through the different districts in Tokyo where youth subcultures are found, sat in coffee shops, listened to the conversations of young boys and young girls, and interviewed them, what sprang to my mind was the evasion of any serious responsibility and the assertion of pleasure-loving attitudes in a very innocent way. What the future holds for these young people should be society's major concern. But at the same time, it is undeniable that youth subcultures are becoming increasingly innovative and creative as the Japanese economy declines and the young begin to lose a sense of belonging. Japanese fashion subcultures have never been so daring, so radical, or so provocative.

As Emile Durkheim indicated in his famous study *Suicide* (1897), the degree of their social integration is the key to a person's sense of well-being and happiness. In a society where conformity was valued and strongly emphasized in schools and workplaces, social integration was not even questioned, because it was obvious that the society's members would automatically earn the sense of belonging, especially within a company where lifetime employment was guaranteed. Durkheim explained that when the sense of belonging disappears, people feel lost, and, in extreme cases, it can lead to suicide (which is greatly affected by social and environmental factors). This is already evident in the increasing suicide rates in Japan.

In contrast to this, one of the Lolita girls explained to me, "Since I got involved in the Lolita subculture, I made more new friends

who are into Lolita just like me. That is a rewarding experience, and something I did not expect before I became so obsessive about it." But their group identity is not as solid as the family or the company identity that the previous generation experienced, because subcultural membership is voluntary, and members are free to enter or leave at any time. They are confined by the rules as long as they are within the subculture, but once they leave, they can ignore them.

While western youth subcultures, such as British punk or American inner-city hip hop, often convey a strong political or ideological statement, Japanese teenagers claim that they have no message and say that their distinctive styles are purely for enjoyment. Fashion and how they dress are of the utmost importance, because they want to stand out and be noticed, but they have no intention of rebelling against the formal and traditional ways. None of them considers their community as a counter-culture. They enjoy hanging out in small or large groups around train stations, going to events together, and taking photos of each other. Those who belong to the subcultures are connected by a strong bond and spend time with friends who dress in similar fashion. The choice of dress is considered representative of one's inner self as well as of one's group membership. Having no message to convey already conveys a message: there may be a hidden message of helplessness and hopelessness.

One of the Lolita girls I interviewed said, "When I dress Lolita, it means intentionally cutting off all ties with the rest of the world and entering a world that is uniquely mine, and that is the world that is not mundane. Lolitas wear a girl's Victorian dress, and a girl is not a woman, she is a child, and a child is free of any responsibility, and she can do whatever she wants to. She can play and have fun. Many of us are confined by daily social rules and regulations in schools and offices, and on weekends we dress Lolita, and there is a sense of freedom of being a child. Lolita is a child's festival, a festival that can be enjoyed by that child alone." There are elements of infantilization here. Many of the youths I interviewed said, "It may sound evasive, but there is a sense of not wanting to grow up because adults are mean, cruel, and unkind." They want to play, have fun, and remain

Ayumi Saito cosplaying Nanamatsu
Koheita in Nintama Rantaro,
photo: Sorata

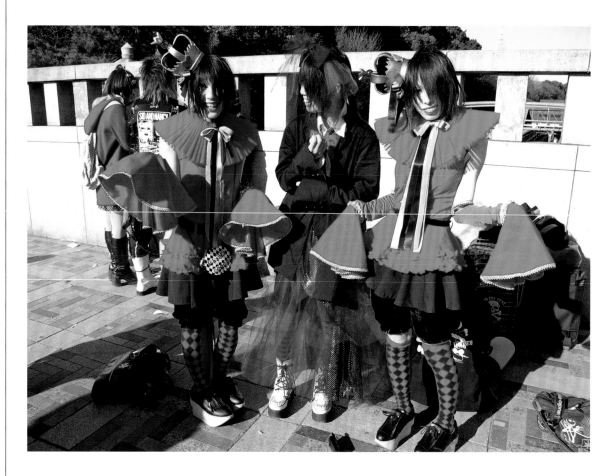

childlike. They dress or cosplay in a way that means they can remain a child. They are enjoying their life in their own way without any of the grand social ambitions that many young people used to have during the 1980s, when the economy was at its peak.

Furthermore, when they put on a unique outfit or costume, they become someone they are not. Erving Goffman explained that human beings play multiple roles with different social functions, and the roles change as we grow up.[2] His famous analysis consists of the front-stage and the back-stage performances. We all put on an act depending on which role we are playing or which mask we are putting on. Today's Japanese youths do it literally and use their everyday life as a stage, acting with appropriate costumes. In that way, they do not face what is in front of them in real life or who they really are.

ABOVE:
Cosplayers in Harajuku,
photo: Yoya Kawamura

RIGHT:
Cosplayers in Harajuku,
photo: Yoya Kawamura

Dick Hebdige has written that girls have been relegated to a position of secondary interest within both sociological accounts of subculture and photographic studies of urban youth.[3] The masculine bias is still there in the subcultures themselves, but it is the girls who are dominant in Japanese subcultures. In all the above-mentioned subcultures, the key players are girls, and they express their gender identity in an extreme manner. They assume a specific female identity, one that projects an intensified feminine image that comes in a different form, shape, and style. For Shibuya girls, it is their sexuality and an erotic sense of self that need to be emphasized, while Harajuku Lolita girls create a cute, innocent, female style. Maid café girls in Akihabara play a stylistically and physically submissive role that primarily serves male customers.

Is Japanese society losing male dominance? One male *otaku* answered my question: "These days, women are becoming so strong and independent that we, the guys, think that they no longer need us. But when we go to a place like maid café, we can interact with a girl who is cute and submissive. She is someone who would need us and depend on us. We like that feeling. I also feel great when a waitress says to me *Welcome home, Master*! It is comforting."

*

Fashion expresses individual identity, and individuals today have multiple identities with different roles to perform, and therefore, they choose their identification from numerous ranges of images and styles. Traditional points of collective identification, such as class, gender, race, and occupation, are less significant and are gradually being replaced by unique, exclusive identities. The members of subcultures demonstrate a fragmented, heterogeneous, individualistic, yet collective, stylistic identification. This manifests itself as an expression of freedom from traditional and rigid structure, control, and restraint. The distinctive looks function as a visible group identity for the youths and become shared symbols of membership affiliation. A symbol is the vehicle by which humans communicate their ideas, intentions, purposes, and thoughts – that is, their mental

lives. The teenagers are almost uniformly aware of their means of communication, which utilizes stylistic symbols that vary in every subculture. Therefore, these styles are functional and meaningful only within the specific territory of Shibuya, Harajuku, Akihabara, and Ikebukuro among particular groups of people.

notes

1 Research on youth subcultures is a timely topic since fashion process can no longer be explained by the trickle-down theory postulated by classical scholars (Georg Simmel, "Fashion," *The American Journal of Sociology*, LXII, no. 6, May [1904] 1957; Thornstein Veblen, *The Theory of Leisure Class*, London: Allen and Unwin [1899], 1957) and needs to be conducted not only theoretically but more empirically, as well as transnationally. According to subcultural theories (Dick Hebdige, *Subculture: The Meaning of Style*, London: Routledge, 1981; Arielle Greenberg, *Youth Subcultures: Exploring Underground America*, Harlow, Essex, UK: Longman, 2006; Chris Jenks, *Subculture: Fragmentation of the Social*, London: Sage Publications, 2004; Riesman 1950), subcultures are often determined by class, gender, and age, and they are expressed in the creation of styles in order to construct their identities. Therefore, fashion becomes crucial in many subcultures, and at the same time, they maintain their autonomy, resist hegemony, exist in opposition to the establishment and construct a cohesive group identity. But the theoretical analysis of subcultures frequently refers to empirical case studies in the west. Cultures and subcultures are increasingly becoming global, and thus, case studies in non-western cultures, such as Japan, should not be neglected. My intention as a researcher is to make an empirical contribution to subcultural studies in the west. Japanese fashion subcultures are beginning to attract a great deal of attention from the media around the world, but there is still a void in scholarly writings, especially in social sciences, on Japanese youth fashion and subcultures which I attempt to fill.

The most appropriate way to study subcultures is by an ethnographical method that is used by many qualitative researchers, since they can get close to the empirical social world and dig deeply into it through direct communication and interaction with research subjects. This essay is based on my current ethnographical fieldwork in Tokyo which I began in 2006 and plan to finish in 2010. I conduct sociological investigation of these subcultures from both micro-interactionist and macro-structural perspectives. I combine direct observation, both participant and non-participant, with structured and semistructured in-depth interviews to attain a close and full familiarity with the world I examine. My qualitative data comes primarily from Shibuya and Harajuku from where the latest street fashion originates, and Akihabara and Ikebukuro where distinct youth subcultures are found.

The term "subculture" is defined as a group of people with cultural values and norms that separate them from the larger society. I use the term "fashion subculture" to indicate that my focus is a subculture that emphasizes or plays around with and manipulates physical appearance, and to whose members how they dress is of utmost importance. In Japanese subcultures, there is a strong connection between the group and the physical space where an identity performance takes place.

2 Emile Durkheim, *Suicide: A Study in Sociology*, trans. John A. Spaulding and George Simpson, New York: The Free Press [1897], 1968.

3 Dick Hebdige, *Hiding in the Light: On Images and Things*, London: Routledge, 1989.

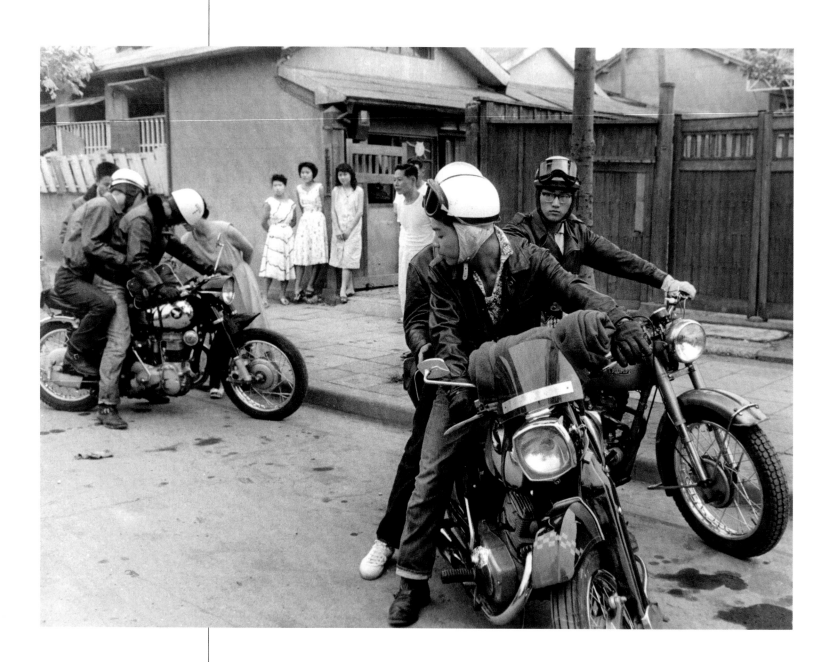

hiroshi narumi

JAPANESE STREET STYLE
its history and identity

Subcultural styles have long been a part of Japanese costume history. In the early seventeenth century, for example, there was a group of young delinquents called the Kabuki-mono. The term is associated with the beginnings of the Japanese classical dance-drama Kabuki; the meanings of the verb *kabuku* include "to wear outrageous clothes." The young men were lower-level samurai who led a dissolute life and broke the hierarchical dress code of the time. A female dancer, Okuni of Izumo, appropriated their style and performed street dances in male attire – an event said to be one of the origins of Kabuki. Her performances were so popular that this transvestite style was widely adopted by women.[1] In the middle of the century, a subculture among young men with the Kabuki-mono attitude emerged on the streets. In spite of the flamboyance of their costumes, they set trends in contemporary kimono design,[2] and in spite of the strict class system, even the empress wanted to have one of their designs. The distance between subculture and fashion has sometimes been very short.

In this essay, I look at the more recent descendants of the Kabuki-mono, and I begin with a brief history of post-war Japanese street style. Modern Japan has been introduced to various styles of western clothing since the Meiji Restoration in 1868, and Japanese street style has also grown up under the influence of western consumer culture.

Kaminarizoku, 1960,
photo: © *The Mainichi Shinbun*

American culture, above all, has always played a major role in Japanese post-war fashion. Since the 1970s, however, the younger generation has been fabricating its own style, mixing elements from western and Japanese culture according to its own notion of what looks good. How and why have the young evolved some unique street styles in this era? In response to this question, I shall examine some significant characteristics of street style, focusing on a specific subculture among girls who hung around the Shibuya district of Tokyo in 1999–2001. While the style adopted by these girls was no less deviant than that of hippies and punks, it seems that the identity they assumed was fairly ambiguous, and not at all indicative of any involvement on their part with either political protestation or social frustration. Rather, it was an expression of urban self-display. By considering these developments, I hope to illuminate the crucial relationship between style and identity among the youth of post-war Japan.

FLIRTING WITH AMERICA: 1945–1960S

After the Second World War, Japanese youth looked toward American culture and was eager to be part of it. In post-war Japan, various subcultural groups called *zoku* (literally, "tribes") emerged.[3] The term was coined in 1956 by the journalist Ohya Soichi, who described a new group of affluent youth as the Taiyozoku (Sun Tribe), a name derived from the title of the bestselling novel *Season of the Sun* by Shintaro Ishihara. Since then, the media have applied the concept of "the tribe" to any new subcultural group or street style associated with young people. Although there is room to discuss to what extent Japanese *zoku* can be identified with western youth subcultures, both groups have shared a great deal in terms of appearance. Most *zoku* are groups of young people who take up deviant styles. The Taiyozoku was the first manifestation of post-war youth pursuing a hedonistic lifestyle in a new age of mass consumption.[4]

Previously, in the late 1940s, the Panpan (street prostitutes) were the first subcultural group to lead fashion trends. Some of them, the Yo-pan (*yo* means "western"), specialized in having only American soldiers as clients. In bombed and ruined cities, young women who had lost

their fathers or homes had no other recourse than to sell themselves to ensure the survival of their families. Since they had to attract customers and had the opportunity to obtain clothes and cosmetics from their American clients, the Panpan decorated themselves with colorful American fashions and gaudy make-up. Society was shocked that Japanese women, who, until this point, had been believed to be decent and moralistic, could change their appearance so abruptly and could flirt with Japan's former enemies. Another subcultural group of the 1940s and 1950s was the Apurezoku (*apure* derives from the French words *après guerre* and means "post-war generation"). These were young people who, as a result of the defeat in the war, despised the older generation and Japanese traditions and admired instead the more material, American way of life. Some were notorious for committing crimes such as bank robbery or fraud in order to obtain good clothes and food, which were otherwise unaffordable.

American youth culture exerted a direct influence through the media. Motorcycle gangs, which appeared in the late 1950s with the newly paved roads, were given the name of Kaminarizoku (Thunder Tribe), referring to the noise and public disturbance they caused. They were the first generation of the biker subculture, to which I shall return

below in the context of the later the Bosozoku. The Rockabilly-zoku of the late 1950s to the early 1960s was a group of fans who adored a new generation of rock 'n roll and country-music singers.

In the early 1960s, fashionable tribes appeared in different areas of Tokyo. Roppongi, Miyuki Street in Ginza, and Harajuku lent their names to the Roppongizoku, the Miyukizoku, and the Harajukuzoku respectively. Owing to the rapid economic growth at this time, the members of these tribes could afford to buy fancy clothes and cars. At weekends, they hung out in restaurants, coffee bars, and boutiques, or went to dance clubs to meet friends and find dates. These subcultures received quasi-official names and media attention because, through their distinctive appearance and behavior, they symbolized emergent consumerism. The styles adopted by them were quite dandified. The most distinctive male attire was either a suit or blazer, worn with a shirt and cotton trousers, or American casual wear such as jeans and a T-shirt. The men's fashions were divided into either American Ivy (from Ivy League) or European Continental. The women's fashions, on the other hand, were not so strongly determined. Girls generally wore fashionable Euro-American dress. While mini-skirts and flower prints were purportedly influenced by the style of "Swinging Sixties" London, the overall ensemble seemed to derive principally from media images of American fashions.

These tribes were criticized on two principal grounds. First, the male style transgressed the traditional notion of Japanese masculinity. Boys were keenly fashion-conscious, going so far as to be meticulous about the precise length in centimeters of their trouser legs. In the 1960s, it was still believed that men should not pay undue attention to their personal appearance, and boys were generally expected to wear their school uniforms outside of school hours. Thus, dandyism was a subversive encroachment on the normal and respectable mode of male dress. Second, the style hinted at the power of consumerism. In the 1960s, the clothing industry was relatively undeveloped. Suits and

American casual wear, including jeans, were so expensive that even adults could not easily afford to buy them. While the style appeared to be somewhat conformist, the young men wearing it provoked a sense of antagonism and jealousy amongst other men.

In the late 1960s, young Japanese aspired to escape from the existing social order. When baby boomers became adolescents, they felt the need to manifest their generation's view as much as their counterparts in Europe and America did. The Futenzoku (Vagabond Tribe), for example, was directly influenced by hippy culture: its members looked untidy and were caricatured by the media as "down and outs." They adopted a style whose explicit aim was one of deviation from the rest of society and rejection of all authority. Their sartorial language echoed that of the American hippies: they wore T-shirts (sometimes tie-dyed) and jeans, ethnic accessories (necklaces, tasseled and beaded vests, thong sandals), carried shoulder bags, and wore their hair long. Long hair and general shabbiness were also a deliberate rejection of the dress code of the parental culture as well as that of previous tribes. Like the hippies, the Futenzoku were fascinated with drugs. However, while the hippies used marijuana and LSD, the principle drugs of this tribe were paint-thinner and sleeping pills, since it was difficult to obtain hallucinogenic drugs in Japan. The experience was entirely different: hallucinogenic drugs were used to explore the user's

mind and inner world; sniffing paint-thinner or taking sleeping pills, on the other hand, caused the members of the Vagabond Tribe to become dim or sleepy, and removed any propensity to activity. In a sense, they used these drugs in order to do nothing.

Street style during this period was often based on the imitation of foreign cultures. Having no opportunity to go abroad, however, the members of tribes reconstructed the imagined west from the images and information they found in magazines, movies, and so on. The difference between Japanese tribe and western subculture may lie in the differences of history. Hippy style was expressed through a "variety of old and second-hand clothes,"[5] and was created by selecting items from previous styles, by accessing their heritage of clothing. However, since the history of western clothing in Japan was relatively short, young people there found that supplies of old and secondhand western clothes were in short supply. Similarly, a lack of hallucinogenic drugs in Japan meant that the Futenzoku resorted to sniffing paint thinner as an alternative. A different historical background meant that Japanese street style developed along a different trajectory, and the tribes did not replicate fully the experiences of their western counterparts.

DANCING IN THE STREET: 1970S—1980S

In the 1970s, the younger generation started developing its own styles rather than merely imitating those of the west. Following the peak of the rapid economic growth in 1970, the Japanese regained their self-confidence and began to look for an identity within their own culture.

During this period, juvenile delinquents involved in fighting, mugging, truancy, and so on established the infamous Yankii (literally, "Yankee") tradition.[6] Although several hypotheses have been offered as to why they were called "Americans," it is certainly the case that they were originally attracted to American fashion of the 1950s which they used in combination with their school uniforms. They sculpted their hair with pomade into the "Regent" style, like

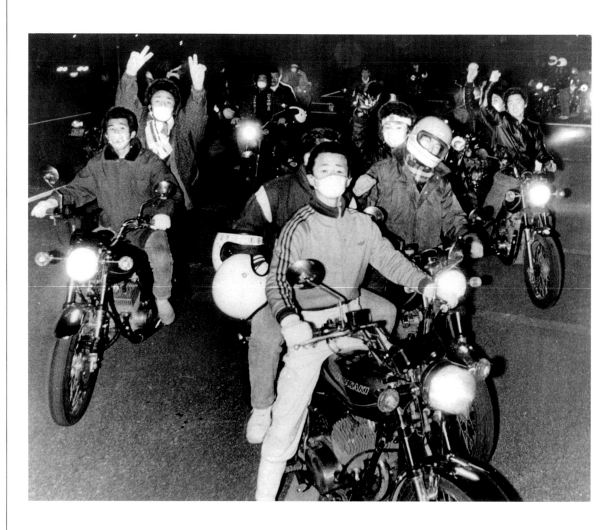

James Dean in the movie *Rebel without a Cause*, or they had their hair "punch permed." School-uniform jackets were often extremely long, and trousers were very wide, while the school bag was crushed as thin as possible. Some of them were fond of listening to rock 'n roll, rhythm & blues, and soul music. It was an eclectic style, combining school uniforms, Japanese *yakuza* (gangster) and American gangster at random. They exaggerated a "normal" style to the extreme.

The Bosozoku (Speed Tribe), the most widespread and notorious deviant youth in the 1970s, were motorcycle gangs that succeeded the Yankii. They caused a nation-wide moral panic. Though similar to the British Rockers and the American Hell's Angels, the members of the

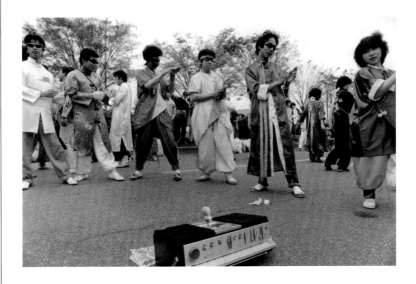

Bosozoku were considerably younger than their western counterparts. Their style was based on the Yankii style and could be distinctive in the way it transformed both vehicles and clothes,[7] all of which were heavily modified according to certain rules. The most famous of their costumes was the group uniform – *tokkofuku* (kamikaze suits) and *sentofuku* (combat suits) – which were dyed in colors – black, purple, red, and so on – that changed the original context entirely. These clothes were further modified with the addition of cloth badges and embroidery which depicted group names, symbols, slogans, and poems. Other aspects of the Bosozoku style were taken from several different sources such as parental culture, working-class culture, or other subcultures like gangsters. *Dokajan* (construction workers' wear), *jimbei* (traditional summer suits), and *china* (Chinese suits) were all appropriated for the style.

Nationalist symbols and slogans were the most typical features of the appearance of the Bosozoku. They often wore headbands and 'flu' masks, which depicted images of the Japanese "Rising Sun" or the imperial chrysanthemum crest. These symbols were usually drawn, printed, or embroidered, and nationalist slogans also featured alongside them. The Bosozoku, however, used them purely for their shock effect. Simply put, they appropriated the icons because they made them appear menacing and conspicuous.

Takenokozoku dancing
in the street in Harajuku, 1980,
photo: © *The Mainichi Shinbun*

In 1979, a new type of delinquent, some of whom were close to Yankii, appeared in Harajuku – one of Tokyo's famous pedestrianized public spaces known as "pedestrian heavens" – wearing pastel-colored, quasi-ethnic costume. They gathered in teams in the pedestrianized public space on Sundays and danced in a seemingly childish and simple manner. Following the name of the boutique that sold them their costumes, they were called the Takenokozoku (Bamboo Shoot Tribe). Their dancing and appearance looked so frivolous and foolish

that those who had believed delinquent youth to be frightening and dangerous were confused.

In the 1980s, the Japanese economy heated up to the infamous "bubble" stage and consumerism reached its peak. Various fashion brands flourished, and the whole youth generation became attached to them. One group that devoted itself to following trends and buying fashionable clothes was the Crystalzoku (Crystal Tribe), named after the prize-winning novel *Somehow Crystal* by Yasuo Tanaka.[8] Tanaka vividly illustrated an affluent youth that was so familiar with consumer culture that it could express itself through the detailed information given by its choice of brands, goods, and restaurants. While the Crystalzoku preferred the goods of foreign high-fashion brands, such as Louis Vuitton or Chanel, domestic brands were more popular because of their affordable prices. The style of this tribe was conservative and respectable rather than deviant and delinquent.

Even avant-garde brands were rapidly involved in the wave of consumerism. Supporters of Comme des Garçons and Y's of Yohji Yamamoto, for example, were distinguished by their dark appearance in the street. From the late 1970s to the early 1980s, the black clothes of these labels were appreciated by small groups of trendsetters and intellectuals. Since black was a color rarely worn by young women at that time, they were stigmatized as the Karasuzoku (Crow Tribe). The tribe was, however, short-lived.

In the middle of the 1980s, the emergent domestic brands enjoyed enormous financial success. Most had been founded in the 1970s by young entrepreneurs and were called the DC brands (standing for "designers and characters"). DC brands were various, ranging from European traditional (e.g., Bigi, Nicole) to cute fashion (e.g., Pink House, Milk) to avant-garde (e.g., Issey Miyake, Comme des Garçons). Since fashion labels renew their collection twice a year, the younger generation consumed huge numbers of clothes, and they looked very conspicuous. The boom reached its peak at the end of 1980s.

The female *zoku* of the late 1980s included the Body-con (body conscious) who tended to wear tight-fitting mini-dresses influenced

TOP:
A couple wearing
DC brands' clothes, 1986,
photo: © www.web-across.com
(Parco Co., Ltd)

BOTTOM:
Body-con, 1987,
photo: © www.web-across.com
(Parco Co., Ltd)

by Azzedine Alaia. After work, female office workers changed from their company uniforms into sexy mini-dresses and danced in huge discotheques to European disco music. The bubble economy had given these young women a vast disposable income and consumer power, and they were, as a result, highly valued by the clothing industry .

The more traditional Shibukaji (Shibuya Casuals) became popular at the end of the 1980s. The style was based on American casual wear, represented mainly by Ralph Lauren, as a reaction to the fancy clothes of DC brands. At first, it was an affluent youth style like the "preppy" style; however, as the style prevailed in the public sphere, delinquent groups called the Teamer adopted it, fought each other, and beat up office workers.

Although the influence of the west was still present, the younger generation had gradually freed itself from its cultural inferiority complex and had taken a new direction, mixing the styles of the west with those of Japan. Furthermore, the rising consumerism of this period implanted a strong drive towards designer brands. Like the various designers of DC brands, street style also sought diversity and originality.

WEARING COSTUME ON THE STAGE: 1990S—2000S

The bubble economy burst abruptly in 1991 and Japan has entered a long period of recession. However, while most of the DC brands fell into decline, an urge to consume clothes remained, or, rather, became even stronger. Instead of domestic DC brands, high-fashion brands such as Louis Vuitton, Dior, and Chanel became the next target of young consumers. Compared with previous decades, youth subculture became fragmented into smaller groups, and young people changed their appearance constantly. The media have had some difficulty in differentiating between each new tribe and the word *kei* (literally, "string" or "genealogy"), hinting at some vague affiliation rather than strong connection, has often been used instead of *zoku*. For instance, Gal-kei is a term loosely covering girls who

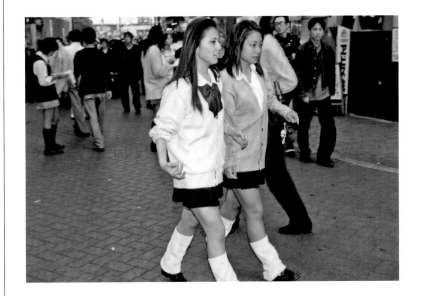

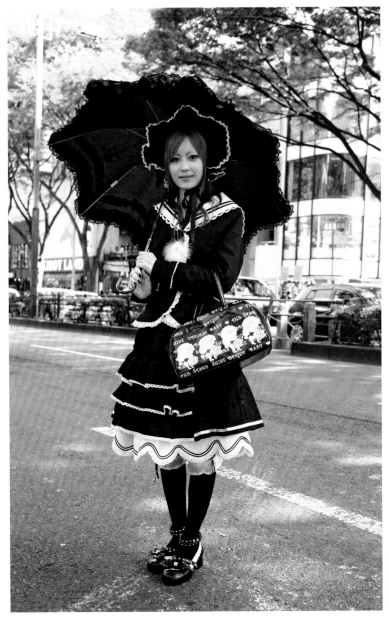

TOP:
Kogal wearing school uniform and
loose socks, 1997,
photo: © www.web-across.com
(Parco Co., Ltd)

BOTTOM:
Goth-Loli, 2009,
photo: © www.web-across.com
(Parco Co., Ltd)

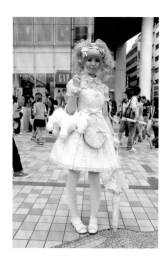

Lolita, 2009,
photo: © www.web-across.com
(Parco Co., Ltd)

wear cute and sexy fashion. Onee-kei (*onee* means "older sister") is a label given to girls who prefer more adult fashion to the younger "gal" fashion. The comradeship of *zoku* has been absent since the 1990s, and youth groups are hardly ever labeled with that term these days. It is interesting to note that in the 1990s some prominent girl subcultures became active on the streets – for example, the Kogal, the Ganguro, the Lolita, or the Goth-Loli (Gothic-Lolita). On the other hand, boy subcultures were not as conspicuous as before.

The Kogal was a major driving force of youth culture in the 1990s. "Ko" implies "immature" or "younger," so Ko-gal referred to a girl who had not become a mature "gal" yet. They were teenage high-school students who had their long hair dyed brown and their skin tanned and who wore mini-skirts, loose socks, and so on. One fashion source for them was African American culture. The girls' influence frequently led to major consumer trends; for example, they started to use pagers and PHS (personal handphone systems) to communicate with friends long before this technology became widely popular.

The Ganguro (literally, "extremely black" or "face-black") or the Yamamba, as I shall discuss below, appeared on the streets of Shibuya from 1999 to 2001, and had a more deviant appearance than the Kogal. The name "Yamamba" derives from a traditional folktale about a female monster who had been abandoned to starve to death by her children, who could not afford to feed her, and who had become a cannibal through living alone deep in the mountains. They looked so strange that the media tried to ridicule their appearance.

Another line of girl subcultures includes Lolita, Goth-Loli and cosplay (costume play). Those who have been attracted to these styles have much in common in terms of their aspiration to identify themselves through fantasy. Thus, they wore their own clothes in order to become "true selves" at weekends or after school or work. Lolita refers to the style of wearing white frilled dresses over panniers or crinolines. Goth-Loli has mingled Lolita and Gothic, girlishness and darkness into a cute but more disturbing style. In one interview, a Lolita said that wearing this fashion in private hours made her relaxed and comfortable.[9]

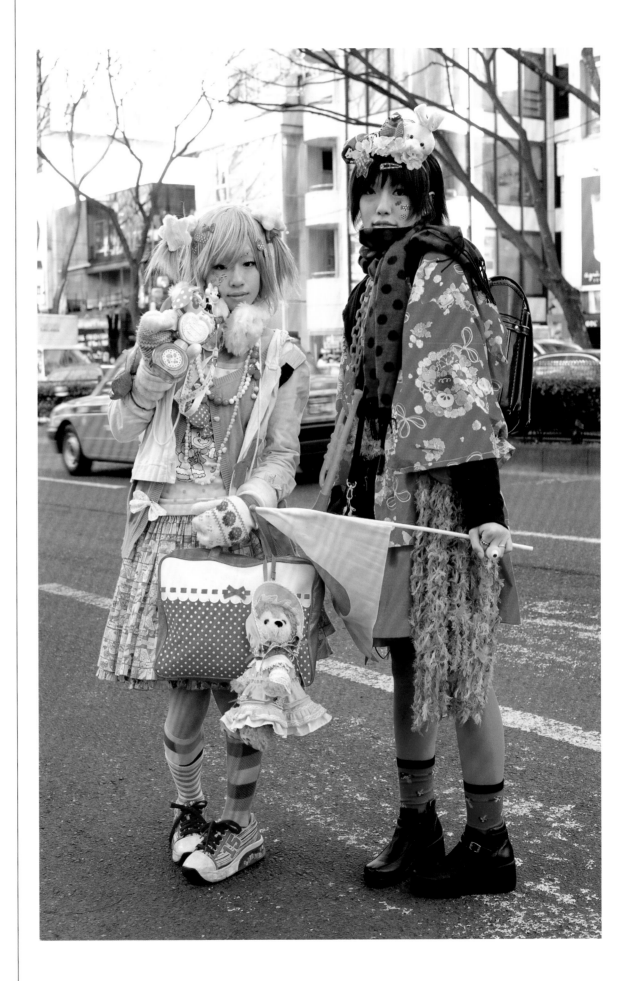

Girls wearing
cosplay-like costume, 2010,
photo: © www.web-across.com
(Parco Co., Ltd)

Cosplay is a fan culture in which participants put on costumes, make-up, wigs, etc. to imitate the imagery of characters related to music, manga, anime, and computer games. The costumes are self-made, and it is difficult to recreate these characters in reality because it involves transforming two-dimensional images into three-dimensional costumes. Those who make these costumes themselves tend to be more respected than those who just buy them in stores. There are two types of cosplay subculture.[10] In one, the members are fans of manga, anime, and computer games. Every weekend, they rent a hall (you have to pay a fee to enter), where they "become" fictional characters with like-minded company and take photos of themselves in their costumes. The other consists of followers of *visual-kei* rock bands. They go to concerts wearing the same styles as the members of their favorite bands. It can be seen as an expression of affection towards the band. Many cosplayers are women, although there are also numerous male cosplayers. Thus, there has been a recent gender inequality in this subcultural style in favor of girls and young women. It is probably in part because of the biggest subculture of the 1990s, the *otaku* (Japanese nerds; the word literally means "house"),[11] who are enthusiasts of anime, game, manga, and figurines. Most of them are men who have preferred to stay at home reading comic books, watching anime, and playing computer games, rather than going out. Their favorite district is Akihabara, in the eastern part of Tokyo, which has many stores specializing in comics, computer games, and figurines. In contrast to Angela McRobbie's observation about the invisibility of girl subculture in the U.K. during the 1970s,[12] Japanese boy subculture was invisible in Tokyo during the 1990s.[13]

It is interesting to note that the girl subcultures in Japan in the 1990s and 2000s have had few connections with western counterparts. It is true that the Lolita and Gothic originally derived from the west and that the Kogal admired African American music. However, they have not been so concerned with *assimilating* western culture. In fact, they prefer Japanese rock and movies to American. They no longer feel inferior to America or to the west in general. In addition, the styles of Lolita, Goth-Loli and cosplay suit immature bodies, enabling Japanese girls to fit into them easily. There they have the advantage over American girls.

Since the bursting of the bubble economy, Japanese youth, liberated from its previous inferiority complex, seems to have lost its faith in American culture. Having absorbed several influences such as black music and gothic fashion, they have since involved themselves in a closed society and developed their own styles. As the media and consumerism transformed urban spaces into "mediascapes," the streets of Shibuya or Harajuku have been reinterpreted as a stage for performance. Young people come to the metropolitan streets in order to play out roles on this stage. Street style has become a stage costume rather than everyday clothes. The core experience of street style is to display oneself in the city. In the next section I examine this development by looking at the specific case of the Ganguro.

GANGURO: BLACK AND FURIOUS

Becoming a member of subculture is a cultural practice that enables young people to consider who they are. Whilst it is commonly believed that younger generations make their own styles to express their personal identity, I am suggesting the style might rather *construct* their identity in Japan. By examining a subculture of the 1990s, I hope to redefine the relationship between style and identity.

The Ganguro emerged on the streets of downtown areas in Tokyo around 1999–2001. The number of girl participants rapidly increased in 2000. However, they had already started to decrease by the end of that year. The boom was over by the end of 2001, but their activity continued for a few years or so. Although they disappeared, their style was copied by other girls a few years later. Its major characteristic was a very dark skin color, which was the result of the girls' using suntanning machines and cosmetics of African American origin. Eye shadow and lipstick were white, and hair was dyed white, blonde, pink, or brown. The girls wore mini-skirts and high-heeled boots or sandals. Some of them were called Yamanba, which, as mentioned above, refers to a female monster in an folktale. They looked so deviant that most adults were shocked and sometimes fiercely criticized their body decoration. It caused a small-scale moral panic at the time.

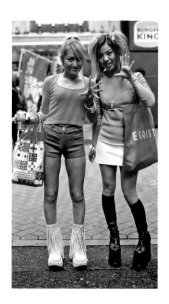

From my own personal perspective, when I first saw images of them I was reminded of past subcultures such as the Bosozoku and the punks in the 1970s. In the course of my research, however, I have gradually realized that they barely had any subversive intention, unlike the latter. According to interviews some of them gave, they even got along well with their family.[14] In spite of their spectacular look, the Ganguro's profile was not so special. Their main activity was just hanging about in the street. Sometimes they gathered to perform a dance called "para-para," and some of them formed dance groups. Primarily they were 15–18-year-old high-school students who lived in the outskirts of Tokyo. So far as I know, they did not behave delinquently (juvenile prostitution, shoplifting, and so on). It has been argued that these girls belonged to the working class, but this claim requires further analysis.

When these girls were asked why they changed their body skin color to black, they replied that this made them looked healthy, thin, smart, and cool.[15] Some of them answered also that it enabled them to attract attention from the public. In addition, they were fascinated with dance music, so their style was also influenced by African American pop stars, like Janet Jackson, and their Japanese counterparts, like Namie Amuro. While the girls' behavior was seen as deviant, they did not themselves think of it as such.

GET WILD & BE SEXY

egg

PRICE
490
YEN

3 MAR.2K
Volume45

©2000;MILLION PUBLISHING INC.

BURITERI STYLE!

THE FINAL ISSUE!
BUT, EGG'S REVOLUTION GOING ON!

Egg magazine features Ganguro
on the front cover, 2000

It is rare for Japanese to try to identify themselves with the African American body, since many Japanese admire and aspire to Euro-American white skin. It is also unusual that girls should darken their skin to the point that many people considered unacceptable. Yet however "black" they may have appeared, these girls did not use their style to address any racial issues; rather, they simply wanted to display themselves and to be noticed in urban spaces. Indeed, according to one research study, many of them intended to "retire" from their "black" appearance at the end of high school. There was a belief among them, then, that this look should be limited to their youth.[16]

I shall try to shed light on the production of the Ganguro style from three points of view. First, it was related to the media, especially to teenage street magazines. Since the 1980s, there have been various street magazines in Japan. These magazines are strongly associated with their readers. They often include pictures of young people on the street and often feature stories about their readers in their articles. This close relationship makes it easier for girls in particular to be attracted to a certain style. The more intimacy young readers feel in relation to such magazines, the more they are influenced by them. Thus, once a particular look started to appear in the magazines, readers copied it very quickly.

Second, the fashion and cosmetics industries both played important roles in creating the appearance of the Ganguro. Some fashion brands became popular for girls because their products were obtainable at reasonable prices and the retailers had good marketing skills. An important factor is that the shop assistants were almost as young as their customers. They picked up on customers' needs at once and reported back to the designers of the brands. As the designers were also about the same age as the customers, they immediatey knew what consumers wanted. As a result, girls could get what they wanted very soon. In addition, in order to make cheaper products, the clothing companies used sewing factories in Korea or China, which reduced labor costs. They sent order forms on the internet, and factories produced garments in a few days in order to ship the products back as soon as possible. This is called the "quick response system." The

development of information technology and the post-Fordist system, means that the clothing industry can respond to the demands of its customers instantly.

Third, urban spaces have provided an important location for youth subculture. Youth needs a place to hang about in the city. In Tokyo, some downtown areas such as Shibuya, Harajuku, and Ikebukuro have been developed commercially since the 1970s. Department stores and retail stores emerged in these districts and changed the character of the streets to be more consumer-oriented. Teenagers come to these districts to buy clothing and cosmetics, to eat and drink, and to meet friends, expecting something exciting to happen. The streets have become a theatre for youth. In addition, street-fashion magazines often come to these streets to pick up the latest trends firsthand. Since the 1990s, editors and photographers have regularly gathered on the main streets of the districts and taken pictures of these youngsters. Thus the streets have provided young people with a stage on which they can take pleasure in displaying themselves to others. The Ganguro was formed through this interactive process between the girls and the media, the retailers and the street.

It is also important to note that Ganguro style was an exaggeration of Kogal style, so the Kogal should be considered forerunners of the Ganguro. There are many similarities between the two. In order to differentiate themselves from the earlier style, however, the Ganguro tried to escalate their characteristics to the extreme.

The Ganguro was a "taste culture," whereby the girls felt sympathy with one another's taste in fashion and make-up. It is interesting that these girls ignored any interest men might have in them. Indeed, their appearance was so weird that few boys of the same age were attracted to them, and although the girls often walked around in the streets, boys kept at a distance. In other words, the girls didn't care about outsiders' judgments; rather, it was more important for them to gain respect from other girls with the same tastes. When Sarah Thornton analyzed club culture in the U.K., she referred to "subcultural capital," deriving from Bourdieu's concept of "cultural capital."[17] The Ganguro was a culture based on subcultural capital

in terms of fashion, cosmetics, dance, and so on. The style could be considered as a cultural process by which young people could interpret their relationship with society.

*

In closing this essay, I should like to emphasize two principal points about Japanese street style. The first concerns the cultural process of globalization. Formerly, Japanese youth identified itself with western, mainly American, material life styles. Japanese tribes of the 1950s and 1960s imitated their western counterparts. Because of a lack of sub-cultural capital, however, the style had its own character. Since the 1970s, street style has inevitably developed in unique directions. Japanese young people have combined different cultural sources to forge their own aesthetic. Following the line of argument of the critic Dick Hebdige, Japanese subcultural styles can also be characterized as acts of "bricolage,"[18] in which items of different origin are reassembled.

The second point concerns the relationship between location and style. In many cases, street style has emerged in certain urban spaces and specific locations. The aim of the "stylists" has been to display the body in public, or, in other words, to stand out from the public. By wearing a costume, young people can be visible in urban spaces. It is difficult to find any intention of subversion in these cases, unlike the hippies and the punks. Along with other scholars who studied at the Birmingham Centre for Contemporary Cultural Studies,[19] Hebdige semiotically analyzed various youth cultures and demonstrated a homology of styles and agents. He concluded that their styles were an expressive form of subversion. With Japanese street style, on the other hand, such an intent can barely be found since the 1980s. However deviant they may have made themselves look, the Ganguro did not use their style to address any political agenda: they wanted merely to display themselves and to be looked at in urban spaces. The Birmingham approach does not fit this case.[20]

It has often been said that young people wear certain clothes to express personal identity. As seen with the Ganguro, Japanese tribes

have not fabricated styles to express something inside; rather, they have enjoyed the pleasure of being watched. Street style has been a costume to make them conspicuous on the street. They have flirted with the media, the fashion industry, and with urban spaces in order constantly to reshape their identity. The identity of youth has been neither firm nor coherent, but changing and uncertain. For Japanese youth, street style is a significant way of redefining their identities in urban spaces.

notes

1 O. Hashimoto, *Edo ni France Kakumei wo!* (French Revolution in Edo!), Tokyo: Seidosha, 1990.

2 N. Maruyama, *Edo Modo no Tanjo* (The Birth of Edo Mode), Tokyo: Kadokawa, 2008. See also, R. Mori, *Momoyama Edo no Fashion Leader* (Fashion Leader in Momoyama and Edo), Tokyo: Haniwashobo, 2007.

3 The history of youth tribes is illustrated in the following books: K. Mabuchi, *Zokutachi no Sengoshi* (Tribes in Post-War Japan), Tokyo: Sanseido, 1989; *Across* (ed.), *Street Fashion 1945–1995*, Tokyo: Parco, 1995.

4 *Season of the Sun* was made into a movie in 1956. Because of its great success, there followed other movies featuring hedonistic youths. They were called Taiyozoku cinema. A series of movies had influenced the rise of the tribe.

5 A. McRobbie, "Second-Hand Dresses and the Role of the Ragmarket," in *Post Modernism and Popular Culture*, London and New York: Routledge, 1994.

6 T. Igarashi (ed.) *Yankii Bunkaron-josetsu* (Introduction to Yankee Studies), Tokyo: Kawadeshoboshinsha, 2009. K. Namba, *Yankii Sinkaron* (The Evolution of Yankee), Tokyo: Kobundo, 2009.

7 I. Sato, *Bosozoku no Ethnography* (Ethnography of Bosozoku), Tokyo: Shinyosha, 1984. There are many books on this tribe.

8 Y. Tanaka, *Nantonaku, Kurisutaru* (Somehow Crystal), Tokyo: Kawade-shoboshinsha, 1981. Tanaka added hundreds of footnotes on detailed information about fashion, restaurants, and so on at the end of the novel. He represented the Crystalzoku himself.

9 M. Matsuura, *Sekai to Watashi to Lolita Fashion* (The World and Myself, and Lolita Fashion), Tokyo: Seikyusha, 2007.

10 H. Narumi (ed.), *Cosupure-suru Shakai* (The Cosplay Society), Tokyo: Serica, 2009.

11 Though the word means 'your house,' its connotation is 'you.' As a columnist, Akio Nakamori, observed, the *otaku* often used it in reference to each other in conversation. It is commonly believed they were too concerned with hobbies to take care of their appearance. While male *otaku* predominated at first, there has been an increasing number of female *otaku*. Some female *otaku* have become cosplayers.

12 A. McRobbie, *Feminism and Youth Culture*, Boston: Unwin and Hyman, 1991.

13 There were male counterparts to gal subculture such as Center Guy, or Gal-O (Gal man) early in the twenty-first century. As it is probable that they looked like cheap imitations, they did not receive as much public attention as did the Kogal.

14 A. Miura (ed.), *Ganguro Gal Chosa* (Report on Ganguro Gal), Tokyo: Culture Studies, 2001.

15 *Kesho Bunka*, Tokyo: Pola Research Institute of Beauty & Culture, vol. 40, 2000.

16 This temporary nature is a significant characteristic. Japanese deviant youth are keenly conscious of the time at which they should retire from a group. They call it "graduation."

17 S. Thornton, *Club Cultures*, Cambridge: Polity Press, 1995.

18 D. Hebdige, *Subculture*, London and New York: Routledge, 1979.

19 The so-called British Cultural Studies approach was established in this institution. S. Hall, and T. Jefferson (eds.), *Resistance through Rituals*, London: Routledge, 1976.

20 Hebdige himself revised his opinion on subculture later. See D. Hebdige, *Hiding in the Light*, London and New York: Routledge, 1988.

bibliography

IS JAPAN STILL THE FUTURE?

"Anime Future Fashion," Japanese *Vogue*, May 2007.

Aoki, Shoichi, *Fruits*, London: Phaidon, 2001.

———, *More Fruits,* London: Phaidon, 2005.

Arata, Isozaki, "Of City, Nation, and Style," in *Postmodernism and Japan,* Durham, NC: Duke University Press, 1989.

Barthes, Roland, *Empire of Signs,* New York: Farrar, Straus and Giroux, Inc., 1982.

Bardsley, Jan, and Hiroko Hirakawa, "Branded: Bad Girls Go Shopping," in Laura Miller and Jan Bardsley, eds., *Bad Girls of Japan*, New York: Palgrave Macmillan, 2005.

Brehm, Margreit, ed., *The Japanese Experience Inevitable*, Kraichtal: Ursula Blickle Foundation and Hatje Cantz Verlag, 2002.

Brown, Kendall H., and Sharon Minichiello, *Taisho Chic: Japanese Modernity, Nostalgia and Deco,* Honolulu: Honolulu Academy of Arts, 2002.

Brubach, Holly, "The Truth in Fiction," *The Atlantic*, May 1984.

Calza, Gian Carlo, *Japan Style,* London: Phaidon, 2007.

Clark, John, "What Modern and Contemporary Asian Art Is or Is Not: The View from MOMA and the View from Asia," in *Eye of the Beholder: Reception, Audience, and Practice of Modern Asian Art*, John Clark, Maurizio Peleggi and T. K. Sabapathy, eds., Sydney: Wild Peony, 2009.

Colman, David, "The All-American Back from Japan," *New York Times*, June 17, 2000.

Comme des Garçons, 1975–1982, Tokyo: Comme des Garçons, 1982.

"The Contrast," *Vogue*, July 1983.

"Costume Play!" and "Manga", Japanese *Vogue*, July 2009.

Craig, Timothy J., ed., *Japan Pop! Inside the World of Japanese Popular Culture*, Armonk, New York, and London: M. E. Sharpe, 2000.

Dalby, Liza Crihfield, *Kimono: Fashioning Culture*, New Haven and London: Yale University Press, 1993.

Dale, Peter N., *The Myth of Japanese Uniqueness*, New York: St. Martin's Press, 1986.

Davies, Roger J., and Osamu Ikeno, eds., *The Japanese Mind: Understanding Contemporary Japanese Culture*, Tokyo, Rutland, Vermont, Singapore: Tuttle Publishing, 2002.

English, Bonnie, "Fashion as Art: Postmodernist Japanese Fashion," in Louise Mitchell, ed., *The Cutting Edge: Fashion from Japan*, Sydney: Powerhouse Publishing, 2005.

Finanne, Antonio, *Changing Clothes in China: Fashion, History, Nation,* New York, Chichester, West Sussex: Columbia University Press, 2007.

Fondation Cartier pour l'art contemporain, *Issey Miyake Making Things,* Zurich, Berlin, New York: Scalo, 1998.

Frankel, Susannah, "An Un-bride-led classic," *Independent*, April 2, 2007.

Fukai, Akiko, et al., *Japonisme and Fashion*, Tokyo: National Museum of Western Art and Kyoto Costume Institute, 1996.

Fukai, Akiko, "A New Design Aesthetic," in Louise Mitchell, ed., *The Cutting Edge: Fashion from Japan*, Sydney: Powerhouse Publishing, 2005

Gagné, Isaac, "Urban Princesses: Performance and 'Women's Language' in Japan's Gothic/Lolita Subculture," in *Journal of Linguistic Anthropology*, XVIII:i, pp. 130–50.

Galbraith, Patrick W., *The Otaku Encyclopedia: An Insider's Guide to the Subculture of Cool Japan,* Tokyo: Kodansha International, 2009.

Godoy, Tiffany, *Style Deficit Disorder: Harajuku Street Fashion Tokyo*, San Francisco: Chronicle Books, 2007.

———, et al., *Japanese Goth*, New York: Universe, 2009.

H. Naoto, interview with Valerie Steele, June 2008.

Haga, Koshino, "The Wabi Aesthetic through the Ages," in Nancy G. Hume, ed., *Japanese Aesthetics and Culture*, Albany: State University of New York Press, 1995.

Hata, Kyojiro, *Louis Vuitton Japon: L'Invention du Luxe*, Paris: Assouline, 2004.

Horyn, Cathy, "Gang of Four," *New York Times Style Magazine*, Spring 2008.

Howe, Adam, "The New People: After the Bubble, Japan's New Generation," *The Face*, April 1993.

Hume, Nancy G., ed., *Japanese Aesthetics and Culture: A Reader*, Albany: State University of New York Press, 1995.

"Is Japan Still the Future?" special issue of *Wired*, September 2001.

Iwabuchi, Koichi, *Recentering Globalization: Popular Culture and Japanese Transnationalism*, Durham and London: Duke University Press, 2002.

Iwaya, interview with Dr. Valerie Steele, June 2008.

Jo, Kazuo, *Japanese Fashion*, Tokyo: Seigensha, 2008.

Kawamura, Yuniya, *The Japanese Revolution in Paris Fashion*, Oxford: Berg, 2004.

———, "Japanese Fashion," in Valerie Steele, ed., *Encyclopedia of Clothing and Fashion*, New York: Charles Schribner's Sons, 2005.

———, "Placing Tokyo on the Fashion Map: From Catwalk to Streetstyle," in Christopher Breward and David Gilbert, eds., *Fashion's World Cities*, Oxford: Berg, 2006.

Keet, Philomena, *The Tokyo Look Book*, Tokyo: Kodansha International, 2007.

Kelts, Roland, *Japanamerica: How Japanese Pop Culture has Invaded the U.S.,* New York: Palgrave Macmillan, 2006.

Kerr, Alex, *Lost Japan*, Hawthorne, Australia: Lonely Planet, 1996.

Kerwin, Jessica, "Tao," *W*, May 2005.

Kinsella, Sharon, "Cuties in Japan," in Lisa Skov and Brian Moeran, eds., *Women, Media, and Consumption in Japan*, Honolulu: University of Hawaii Press, 1995.

———, "What's Behind the Fetishism of Japanese School Uniforms?" *Fashion Theory*, VI, no. ii, June 2002.

———, "Black Faces, Witches, and Racism against Girls," in Laura Miller and Jan Bardsley, eds., *Bad Girls of Japan*, London: Palgrove Macmillan, 2005.

Koda, Harold, "Rei Kawakubo and the Aesthetic of Poverty," *Dress: Journal of the Costume Society of America*, no. 11, 1985, pp. 5–10..

Koren, Leonard, *New Fashion Japan*, Tokyo: Kodansha International, 1984.

Kuki, Shuzo, *Reflections on Japanese Taste: The Structure of Iki*, translated by John Clark, Sydney: Power Publications, 1997.

"Kurai Kawaii: interview with Jun Takahashi," *Metropolis*, http://archive.metropolis.co.jp/tokyo/454/fashion.asp.

Kurino, Hirofumi, "Essay on Sacai and TOGA," *High Fashion*, February 2008.

Kusunoki, Shizuyo, *The Tokyo Collection*, Tokyo: Books Nippan, 1986.

Lambourbe, Lionel, *Japonisme: Cultural Crossings between Japan and the West*, London: Phaidon, 2005.

Lau, Vanessa, "Turning Japanese," *W*, March 2010.

Lloyd, Fran, ed., *Consuming Bodies: Sex and Contemporary Japanese Art,* London: Reaktion Books, 2002.

Long, Mary L., "Yohji Yamamoto," *People*, November 1, 1982.

Los Angeles County Museum of Art, *Breaking the Mold: Contemporary Fashion from the Permanent Collection*, Milan: Skira, 2007.

Luna, Ian, et al., *Tokyo Life: Art and Design*, New York: Rizzoli, 2008.

Macias, Patrick, and Izumi Evers, *Japanese Schoolgirl Inferno*: Tokyo Teen Fashion Subculture Handbook, San Francisco: Chronicle, 2007.

"Manga X Mode Special," Japanese *Vogue*, July 2009.

"Manga Takes the Catwalk," Japanese *Vogue*, July 2009.

Martinez, D. P., ed., *The Worlds of Japanese Popular Culture: Gender, Shifting Boundaries and Global Cultures*, Cambridge: Cambridge University Press, 1998.

Marx, David, "Under the Covers," *Nylon Guys*, Fall 2006.

McGray, Douglas, "Japan's Gross National Cool," *Foreign Policy,* May/June 2002.

McVeigh, Brian J., *Wearing Ideology: State, Schooling and Self-Presentation in Japan*, Oxford and New York: Berg, 2000.

Mears, Patricia, "Fraying the Edges: Fashion and Deconstruction," in Brooke Hodge, Patricia Mears, and Susan Sidlauskas, *Skin + Bones: Parallel Practices in Fashion and Architecture*, London: Thames & Hudson, 2006.

Menzies, Jackie, ed., *Modern Boy, Modern Girl: Modernity in Japanese Art, 1910–1935*, Sydney: Art Gallery of New South Wales, 1998.

Menkes, Suzy, "Feminist versus Sexist," *The Times*, March 22, 1983.

——, "Undercover: Strange, 'but beautiful'," *International Herald Tribune*, May 31, 2006.

——, "The Young Apprentice: Japan's Secret Weapon – Style," *International Herald Tribune*, May 31, 2006.

Miller, Laura, "Youth Fashion and Changing Beautification Practices," in *Japan's Changing Generations: Are Young People Creating a New Society?* London and New York: Routledge Curzon, 2004.

——, *Beauty Up: Exploring Contemporary Japanese Body Aesthetics*, Berkeley, Los Angeles, and London: University of California Press, 2006.

——, and Jan Bardsley, eds., *Bad Girls of Japan*, New York: Palgrave Macmillan, 2005.

Mises, Claire, "Pret-à-Porter 1982: Du Sectarisme grace aux formes adoucies," *Libération* October 17-18, 1981.

Mitchell, Louse, ed., *The Cutting Edge: Fashion from Japan*, Sydney: Powerhouse Publishing, 2005.

Misako Aoki, interview with Valerie Steele, February 18, 2010.

Mitsuko Watanabe, interview with Valerie Steele, June 2008.

Miyamoto, Masao, *Straightjacket Society: An Insider's Irreverent View of Bureaucratic Japan*, Tokyo, New York, London: Kodansha International, 1994.

Monroe, Alexandra, *Japanese Art after 1945: Scream Against the Sky*, New York: Abrams, 1994.

Morimoto, Katsuhide, *Grace,* 2008.

Morris, Bernadine, "Designer Does What He Likes – And It's Liked," *New York Times*, July 12, 1972.

Morris, Ivan, *The World of the Shining Prince: Court Life in Ancient Japan*, New York: Knopf, 1964.

Mower, Sarah, "Fight Club," *Vogue*, September 2006.

Museum of Contemporary Art Detroit, *Refusing Fashion: Rei Kawakubo*, Detroit: MOCAD, 2008.

Miyake, Issey, *Making Things*, Zurich: Scalo/Fondation Cartier, 1998.

Nago, Maya, "Tokyo Designers Talking: Daisuke Obana, N.Hoolywood," *High Fashion*, August 2007.

——, "Tokyo Designers' Portfolio: Tao Kurihara: Tao Comme des Garçons," *High Fashion*, August 2008.

Nandan, Jahnvi Dameron, *Tokyo Style File*, Tokyo: Kodansha International, 2007.

Napier, Susan J., *From Impressionism to Anime: Japan as Fantasy and Fan Cult in the Mind of the West*, New York: Palgrave Macmillian, 2007.

Narumi, Hiroshi, *Street Fashion,* 1945–1995, Tokyo: Parco Shuppan, 1995.

Narumi, Hiroshi, *The Cosplay Society: Subculture and Body Culture*, Tokyo: Serika Shobo, 2009.

"The Next Dimension – The New Wave of Fashion from Japan," *Vogue,* April 1983.

Richie, Donald, *The Image Factory: Fads and Fashions in Japan*, London: Reaktion Books, 2003.

Rio and MOA, interview with Valerie Steele, February 18, 2010.

Roach, Mary, "Cute Inc.," *Wired*, December 1999

Roden, Donald, *Schooldays in Imperial Japan: A Study in the Culture of an Elite,* Berkeley: University of California Press, 1980.

Sato, Barbara, *The New Japanese Woman: Modernity, Media, and Women in Interwar Japan*, Durham and London: Duke University Press, 2003.

Sato, Ikuya, *Kamikaze Biker: Parody and Anomy in Affluent Japan*, Chicago and London: The University of Chicago Press, 1991.

Schilling, Marc, *The Encyclopedia of Japanese Pop Culture*, New York: Weatherhill, 1997.

Seidensticker, Edward, *Low City, High City,* London: Allen Lane, 1983.

———, *Tokyo Rising: The City Since the Great Earthquake*, New York: Knopf, 1990.

Shimizu, Sanae and NHK, *Unlimited: Comme des Garçons*, Tokyo: Heibonsha, 2005.

Shoji, Kaori, "Cult of the Living Doll in Tokyo," *New York Times*, February 8, 2010.

Shouno, Yusuke, et al., *Front Line of Fashion*, Tokyo: Kouichi Yabuuchi, 2009.

Silverberg, Miriam, *Erotic Grotesque Nonsense: The Mass Culture of Japanese Modern Times*, Berkeley and Los Angeles: University of California Press, 2006.

Shinichi Kashihara, interview with Valerie Steele, February 2010.

Skov, Lisa, "Fashion, Trends, *Japonisme* and Postmodernism: Or 'What is so Japanese about *Comme des Garçons?*'" *Theory, Culture & Society*, XIII, iii, August 1996, pp. 129–51.

Slade, Toby, "The Japanese Suit and Modernity," in Peter McNeil and Vicki Karaminas, eds., *The Men's Fashion Reader*, Oxford and New York: Berg, 2009.

Slade, Toby, *Japanese Fashion: A Cultural History*, Oxford and New York: Berg, 2009.

Sozzani, Carla and Yohji Yamamoto, eds., *Yohji Yamamoto: Talking to Myself,* Milan and Tokyo, Carla Sozzani Editore and Yohji Yamamoto Inc., 2002.

Sparke, Penny, *Modern Japanese Design*, New York: E. P. Dutton, 1987.

———, *Japanese Design*, New York: The Museum of Modern Art, 2009.

"Story of Two Brands: Sacai + TOGA," *High Fashion*, February 2009.

Sudjic, Deyan, *Rei Kawakubo and Comme des Garçons*, New York: Rizzoli, 1990.

Sugimoto, Yoshio, ed., *The Cambridge Companion to Modern Japanese Culture*, Cambridge: Cambridge University Press, 2009.

Tanizaki, Junichiro, *In Praise of Shadows*, trans. Thomas J. Harper and Edward Seidensticker, New Haven, Conn.: Leete's Island Books, 1977.

———, *Naomi: A Novel,* Oxford and New York: Berg, 2001.

Tao Kurihara, interview with Dr. Valerie Steele, June 2008.

Tarantino, Tarina, *Tokyo Hardcore Collection,* Los Angeles: Tarina Tarantino LLC, 2007.

Teunissen, José, *Made in Japan: The Latest Fashion*, Utrecht: Uitgever and the Centraal Museum, 2001.

Thurman, Judith, "The Misfit," *New Yorker*, July 4, 2005.

Tokyo Metropolitan Museum of Photography, *Samurai: Dandyism in Japan*, Tokyo: Nigensya Publishing Company, 2003.

Tsuzuki, Kyoichi, *Happy Victims,* Tokyo: Seigensha Art Publishing, 2008.

Vinken, Barbara, *Fashion Zeitgeist: Trends and Cycles in the Fashion System,* New York: Berg Publishers, 2005.

Watanabe, Mitsuko, "Junya Watanabe and Tao Kurihara – What is Their Idea of the Spirit of Commes Des Garçons?" Japanese *Vogue,* December 2009.

Wilcox, Claire, ed., *Radical Fashion*, London: V&A Publications, 2001.

Winge, Theresa, "Undressing and Dressing Loli: A Search for the Identity of the Japanese Lolita," in Frenchy Lunning, ed., *Mechademia 3: Limits of the Human*, Minneapolis and London: University of Minnesota Press, 2008.

Women's Wear Daily, March 7, 1994.

Women's Wear Daily, October 10, 1996.

Yamamoto, Yohji, *Talking to Myself*, Milan and Tokyo: Carla Sozzani and Yohji Yamamoto, 2002.

Yano, Charlotte R., "Wink on Pink: Interpreting Japanese Cute as It Grabs the Global Headlines," in *The Journal of Asian Studies*, LXVIII, iii, August 2009, pp. 681–88.

Yoshinaga, Masayuki, *Zoku,* Tokyo, Japan: Little Moore, 2003.

Zielenziger, Michael, *Shutting Out the Sun: How Japan Created Its Own Lost Generation,* New York: Random House, 2006.

Aoki, Junko, "Western Taste as Reflected in Women's Clothing in Japanese Style: The Modernist Background," *Journal of the International Association of Costume* (Japan), no. 22, 2002, pp. 65–82.

Armstrong, Lisa, "Deconstructing Yohji," British *Vogue*, August 1998, pp. 134–37.

Bilzarian, Alan, phone interview with Patricia Mears, Brooklyn, New York, August 8, 1999.

Blume, Mary, *Lartigue's Riviera*, New York and Paris: Flammarion, 1997.

Brubach, Holly, "The Truth in Fiction," *Atlantic Monthly*, May 1984, pp. 94–96.

Carnets de notes sur vêtements et villes, Wim Wenders, director, Road Movies Filmproduktion GmbH, in cooperation with the Centre National d'Art et de Culture Georges Pompidou, 1989.

Carter, Lee, "Connect the Dots: Rei Kawakubo Maps Out Her Universe, One Superstar at a Time," *New York Times*, August 28, 2005, p. 94.

Cook, Roger F., and Gerd Gemunden, eds., *The Cinema of Wim Wenders: Image, Narrative, and the Postmodern Condition*, Detroit: Wayne State University, 1997.

Cressole, Michel, "Yohji Yamamoto: l'après le troisième guerre du feu," *Libération*, March 27–28, 1982, p. 9.

Cunningham, Bill, "Fashion du Siècle," *Details*, March 1990. pp. 177–299.

Daney, Serge. "Enquête sur la look japonais," *Libération*, December 14, 1982, p. 12.

de la Haye, Amy, and Cathie Dingwall, *Surfers Soulies Skinheads and Skaters: Subculture Style from the Forties to the Nineties*, London: Victoria and Albert Museum, 1996.

Derycke, Luc, and Sandra van de Veire, eds., *Belgian Fashion Designers*, Antwerp: Ludion, 1999.

Evans, Caroline, *Fashion at the Edge: Spectacle, Modernity and Deathliness*, New Haven and London: Yale University Press, 2003.

Frankel, Susannah, "Start From Zero: Junya Watanabe," *Dazed and Confused*, March 2003, 116–25.

Fukai, Akiko, "Japonism in Fashion," in *Japonism in Fashion*, Kyoto, Japan, 1994.

Gill, Alison, "Deconstruction Fashion: The Making of Unfinished, Decomposing, and Re-assembled Clothes," *Fashion Theory*, 11, no. 1, pp. 25–50.

Harrison, Charles, and Paul Wood, eds., *Art in Theory 1900–1990: An Anthology of Changing Ideas*, Oxford and Cambridge, Mass.: Blackwell, 2000.

Hildreth, Jean C., *A New Wave in Fashion: Three Japanese Designers*, Phoenix: The Arizona Costume Institute of the Phoenix Art Museum, 1983.

Hirokawa, Taishi, *Sonomama Sonomama: High Fashion in the Japanese Countryside*, San Francisco: Chronicle Books, 1988.

Hollander, Anne, *Sex and Suits*, New York and Tokyo: Kondansa International, 1994.

Kageyama, Koyo, *Showa no onna: Senso to heiwa no shinjunen 1926 nen–1965 nen (Women of the Showa Era: The Forty Years Between War and Peace)*, Tokyo, 1965

Kawakubo, Rei, ed., Comme des Garçons special edition, *Visionaire*, no. 20, March 1997.

Kawamura, Yuniya, *The Japanese Revolution in Paris Fashion*, Oxford and New York: Berg, 2004.

Kirke Betty, *Madeleine Vionnet*, San Francisco: Chronicle Books, 1998.

Koda Harold, "Rei Kawakubo and the Aesthetic of Poverty," *Dress: Journal of the Costume Society of America*, no. 11, 1985, pp. 5–10.

Kolker, Rober Phillip, and Peter Beicken, *The Films of Wim Wenders: Cinema as Vision and Desire*, Cambridge: Cambridge University Press, 1993.

Kondo, Dorinne, *About Face: Performing Race in Fashion and Theater*, New York: Routledge, 1997.

Koren, Leonard, *New Fashion Japan*, Tokyo: Konansha International, 1984.

———, *Wabi Sabi for Artists, Designers, Poets and Philosophers*, Berkeley, Calif.: Stone Bridge Press, 1994.

Long, Mary L., "Yohji Yamamoto," *People*, November 1, 1982, p. 7.

Martin, Richard, "Destitution and Deconstruction: The Riches of Poverty in the Fashions of the 1990s," *Textile & Text*, 1992, xv, no. 2. pp. 3–12.

———, *Three Women: Madeleine Vionnet, Claire McCardell, and Rei Kawakubo*, New York: Fashion Institute of Technology, 1984.

———, and Harold Koda, *Infra-Apparel*, New York: Metropolitan Museum of Art, 1994.

McCarthy, Patrick, and Jane F. Lane, "Paris: The Japanese Show Staying Power," *Women's Wear Daily*, October 15, 1982, p. 5.

Mears, Patricia, "Etre japonais: une question d'indentité," in *xxième Ciel: Mode in Japan*, Milan: Five Continents, and Nice: Musée des arts asiatiques, 2003, pp. 37–45.

———, "Fraying the Edges: Deconstruction in Fashion," in *Skin and Bones: Parallel Practices in Fashion and Architecture*, New York: Thames and Hudson, 2005, pp. 30–37.

———, *Japonism in Fashion*, Brooklyn: Brooklyn Museum of Art, 1998.

———, "Junya Watanabe: maître artisan," in *xxième Ciel: Mode in Japan*, Milan: Five Continents, and Nice: Musée des arts asiatiques, 2003, pp. 101–11.

———, "Révolutionaires: Rei Kawakubo et Yohji Yamamoto," in *xxième Ciel:*

Mode in Japan. Milan: Five Continents, and Nice: Musée des arts asiatiques, 2003,

pp. 65–99.

Mises, Claire, "Pret-à-porter 1982: du sectarisme grâce au forme adoucies," *Libération,* October 17–18, 1981, p. 8.

Mocafico, Guido, "Yohji's Private World," *Harper's Bazaar*, June 1999.

Monro, Tom, "Junya High: The Class of 03. Principal, J. Watanabe," *Homme, Arena*, Spring/Summer 2003.

Morris, Bernardine, "From Japan, New Faces, New Shapes," *New York Times*, December 14, 1982, p. C10.

———, "Loose Translators: The New Wave," *New York Times*, January 30, 1983, pp. 40, 43.

Mower, Sarah, "Talking with Rei," *Vogue Nippon*, September 2001, pp. 156–59.

Oka, Hideyuki, *How to Wrap Five More Eggs: Traditional Japanese Packaging*, New York and Tokyo: Weatherhill, 1989.

Paillié, Élizabeth, "Yohji Yamamoto: brut et sophistication," *Dépêche Mode*, September 1982, p. 56.

Rhodes, Zandra, and Anne Knight, *The Art of Zandra Rhodes*, Boston: Houghton and Mifflin Co., 1985.

Rust, Marina, "Something Japanese," *Vogue*, May 1997, pp. 146, 148.

Sainderichin, Ginette, "Éditorial: le bonze et le kamikaze," *Jardins de Modes*, December 1982, p. 5.

Samet, Janie, "Les Japonais jouent 'Les Misérables,'" *Le Figaro*, March 19, 1983, p. 23.

Shaw, Dan, "To Make His Own Marc," *New York Times*, February 28, 1993, p. VI, 9.

Sidlauskus, Susan, *Intimate Architecture: Contemporary Clothing Design*, Cambridge, Mass.: The MIT Committee on the Visual Arts, 1982.

Sidorsky, Gail, "From East to West: A New Breed of Japanese Designers," *Image NYC*, 1983, 17-20.

Spindler, Amy M., "Coming Apart," *New York Times*, Style Section, July 25, 1993, pp. 1, 9.

———, "Do You Otaku?" *New York Times Magazine*, Spring 2002, part 2, pp. 134, 136.

Steele, Valerie, *Black Dress*, New York: HarperCollins, 2007.

———, *Paris Fashions: A Cultural History*, Oxford: Oxford University Press, 1987.

Stinchecum, Amanda, "The Japanese Aesthetic: A New Way for Women to Dress," *Village Voice*, April 19, 1983: 70–76.

Sudjic, Deyan, *Rei Kawakubo and Comme des Garçons*, New York: Rizzoli, 1990.

Takashina, Shuji, "Japonism: An Aesthetic of Shadow and Fragment," in *Japonism in Fashion*, Kyoto, Japan, 1994.

Talley, André Leon, "Style Fax: Paris P.C.," *Vogue*, December 1999, pp. 62, 64.

Tanizaki, Junichiro, *In Praise of Shadows*, trans. Thomas J. Harper and Edward Seidensticker, New Haven, Conn.: Leete's Island Books, 1977.

Thurman, Judith, "The Misfit," *New Yorker*, July 4, 2005, pp. 60–67.

Vinken, Barbara, "Transvesty-Travesty: Fashion and Gender," *Fashion Theory*, VIII, no. 3, October 2004, pp. 33–50.

Wakefield, Neville, "Facing East," *Travel & Leisure*, October 1999, pp. 236–71.

Washida, Kiyokazu, "The Past, the Feminine, the Vain," in Carla Sozzani and Yohji Yamamoto, eds., *Yohji Yamamoto: Talking to Myself,* Milan and Tokyo, Carla Sozzani Editore and Yohji Yamamoto Inc., 2002, n.p.

Weinstein, Jeff, "The Man in the Gray Flannel Kimono," *Village Voice*, April 19, 1983.

Weir, June, "New Wave Japan," *New York Times*, January 30, 1983, p. 40.

———, "The Rising Prestige of Tokyo," *New York Times*, June 27, 1982, pp. 46, 47, 50.

Weiser, Barbara, phone interview with Patricia Mears, Brooklyn, New York, September 20, 1999.

Wilson, Elizabeth, *Adorned in Dreams: Fashion and Modernity*, Berkeley, Calif.: University of California Press, 1988.

Yoshida, Shin-ichirio, *Riches from Rags: Saki-ori and Other Recycling Traditions in Japanese Rural Clothings*. San Francisco: San Francisco Craft and Folk Art Museum, 1994.

Zahm, Oliver, "Before and After Fashion," *Artforum*, 1995, XXXIII, no. 7, pp. 74–77, 119.

JAPANESE FASHION SUBCULTURES

Akihabara Housemaid-café Costume Collection & Guidebook, Tokyo, Japan: Takeshobo, 2005.

Durkheim, Emile, *Suicide: A Study in Sociology*, trans. John A. Spaulding and George Simpson, New York: The Free Press [1897], 1968.

Goffman, Erving, *The Presentation of Self in Everyday Life*, New York: Anchor Books, 1959.

Greenberg, Arielle, *Yout Subcultures: Exploring Underground America*, Harlow, Essex, UK: Longman, 2006.

Hebdige, Dick, *Subculture: The Meaning of Style*, London: Routledge, 1981.

———, *Hiding in the Light: On Images and Things*, London: Routledge, 1989.

Jenks, Chris, *Subculture: Fragmentation of the Social*, London: Sage Publications, 2004.

Kawamura, Yuniya, "Japanese Teens as Producers of Fashion," in Patrik Aspers and Lise Skov (eds.), *Current Sociology*, London: Sage, LIV, no. 5, 2005, pp. 784–801.

——— ,"Japanese Street Fashion: The Urge to be Seen and to be Heard," in Linda Welters and Abby Lillethun (eds.), *Fashion Reader*, Oxford: Berg, 2007, pp. 343–45.

Matsuura, Momo, *Sekai to Watashi to Lolita Fasshon* (*The World, Myself, and Lolita Fashion*), Tokyo, Japan: Seikyusha, 2007.

Riesman, David, Nathan Glazer and Reuel Denney, *The Lonely Crowd: A Study of the Changing American Character*, New Haven, Conn.: Yale University Press, 1950.

Simmel, Georg, "Fashion," *American Journal of Sociology*, LXII, no. 6, May [1904] 1957, pp. 541–58.

Veblen, Thornstein, *The Theory of Leisure Class*, London: Allen and Unwin [1899], 1957.

JAPANESE SREET STYLE

Hall, Stuart, and Tony Jefferson, eds., *Resistance through Rituals: Youth Subcultures in Post-War Britain*, London: Routledge, 1976.

Hashimoto, O., *Edo ni France Kakumei wo!* (*French Revolution in Edo!*), Tokyo: Seidosha, 1990.

Hebdige, Dick, *Subculture: The Meaning of Style*, London: Routledge, 1979.

———, *Hiding in the Light: On Images and Things, London: Routledge*, 1988.

Igarashi, T., ed., *Yankii Bunkaron-josetsu* (*Introduction to Yankee Studies*), Tokyo: Kawadeshoboshinsha, 2009.

Kesho Bunka, Tokyo: Pola Research Institute of Beauty and Culture, 2000, XL.

Mabuchi, K., *Zokutachi no Sengoshi* (*Tribes in Post-War Japan*), Tokyo: Sanseido, 1989.

Maruyama, N., *Edo Modo no Tanjo* (*The Birth of Edo Mode*), Tokyo: Kadokawa, 2008.

Matsuura, Momo, *Sekai to Watashi to Lolita Fasshon* (*The World, Myself, and Lolita Fashion*), Tokyo: Seikyusha, 2007.

McRobbie, Angela, *Feminism and Youth Culture*, Boston: Unwin and Hyman, 1991.

———, "Second-Hand Dresses and the Role of the Ragmarket," in *Post Modernism and Popular Culture*, London: Routledge, 1994.

Miura, A., ed., *Ganguro Gal Chosa* (*Report on Ganguro Gal*), Tokyo: Culture Studies, 2001.

Mori, R., *Momoyama Edo no Fashion Leader* (*Fashion Leader in Momoyama and Edo*), Tokyo: Haniwashobo, 2007.

Namba, K., *Yankii Sinkaron* (*The Evolution of Yankee*), Tokyo: Kobundo, 2009.

Narumi, Hiroshi, ed., *Street Fashion 1945–1995*, special edition of *Across*, Tokyo: Parco, 1995.

———, ed., *Cosupure-suru Shakai* (*The Cosplay Society*), Tokyo: Serica, 2009.

Sato, I., *Bosozoku no Ethnography* (*Ethnography of Bôsôzoku*), Tokyo: Shinyosha, 1984.

Tanaka, Y., *Nantonaku, Kurisutaru* (*Somehow Crystal*), Tokyo: Kawadeshoboshinsha, 1981.

Thornton, Sarah, *Club Cultures: Music, Media and Subcultural Capital*, Cambridge: Polity Press, 1995.

acknowledgments

Many people helped make possible this book and the related exhibition. Our sincere thanks to Mr. Yuzo Yagi, Chairman, President and CEO of Yagi Tsusho Limited, the exhibition's Platinum Sponsor. Thanks also to Machiko Hilton, Scott Sakino, Satoshi Sumiyoshi, Bob M. Tanaguchi, and Yozo Yagi. As always, we are grateful to Dr. Joyce F. Brown, President of the Fashion Institute of Technology, for her support for The Museum at FIT. We are also grateful to the Consul General of Japan in New York. Thanks also to Mr. Yo Shitara, President of Beams and Hiroshi Kubo, Creative Director, who shared their insight about Japanese fashion. I am grateful to Teruyo Mori of Spur magazine, who was one of the first people who helped me make contacts in Japan. Mariko Nishitani of *High Fashion* magazine kindly introduced me to many young designers in Tokyo in 2008. Akiko Shinoda of the Japan Fashion Week Association was very helpful on my second research trip to Japan in 2010. Katsu Oiwake and Nichi Kashihara produced the Tokyo Fashion Festa at FIT, and then Katsu arranged for Rio Takeshi Kubo and Ayaka Shigeno of Indivisual to introduce me to many important figures in Tokyo's fashion and music scenes. Tiffany Godoy was my guide to all aspects of the Tokyo fashion scene.

Special thanks to all of the designers whom I interviewed and to the individuals and companies who permitted their work to be included in the book and exhibition, including, Chitose Abe of Sacai, Junichi Abe of Kolor, Yosuke Aizawa of White Mountaineering, Asüka and Maki, and Hiroko Honda of Angelic Pretty, Fumiyo and Akinore Isobe of Baby, the Stars Shine Bright, Comme des Garçons, Yasuko Furuta of TOGA, Han Ahn Soon, Tamae Hirokawa of SOMARTA, Yoshiki Hishinuma, Hiroyuki Horihata and Makiko Sekiguchi of Matohu, Issey Miyake, Toshikazu Iwaya of DRESS33, Tao Kurihara of Tao Comme des Garçons, Mastermind JAPAN, Yasuhira Mihara of Miharayasuhiro, Takahiro Miyashita of Number (N)ine, Mug of G.V.G.V., Hiroki Nakamura of visvim, Hirooka Naoto of h.NAOTO, Daisuke Obana of N.HOOLYWOOD, Takeshi Osumi of Phenomenon, Jun Takahashi of Undercover, Arashi Yanagawa of John Lawrence Sullivan, Yohji Yamamoto, Atsushi Yasui of Freewheelers and Company, and Hidenobu Yasui.

We would also like to thank the photographers, artists, and illustrators who permitted their work to be featured in this book, including, Moyoco Anno, Shoichi Aoki, Chiho Aoshima, Martha Camarillo, John S. Couch, Frédérique Dumoulin, Kjeld Dutis, Hans Feurer, T. Hayashida, Kiyohide Hori, Tsukasa Isono, Kazuma Iwano, Ulfert Janssen, Shoichi Kajino, Takashi Kamei, Hiroyuki Kamo, Asaki Katsuhide, Yoya Kawamura, Leslie Kee, Kushida, Peter Lindbergh, Momo Matsuura, Mr. Mamoru Miyazawa, Mariko Mori, Katsuhide Morimoto, Hideaki Motegi, Mr., Takashi Murakami, Junichi Nakayama of Bamboo Memory, Minako Nishiyama, Keiichi Nitta, Takashi Osaki, Peach-Pit, Eiichiro Sakata, Keita Sinya, Sorata, STUDIO4°C/Hideki Futamura, Maureo Suemasa, T.O.L (trees of Life)/Saito and Kuno, Yuriko Takagi, Aya Takano, Kozo Takayama, Robert Tecchi, Yutaka Toyama, Tetsuya Toyoda, Chisami Tsuchiya, Kyoichi Tsuzuki, Maria Chandoha Valentino, Masayuki Yoshinaga, Yasuaki Yoshinaga, and Petronella J. Ytsma. Special thanks to William Palmer for his photography done especially for this book.

Thanks also to all the individuals and institutions who provided invaluable assistance, especially, Al Abayan at Number (N)ine, Takao Ambe at Kodansha Ltd., Misako Aoki, Yasuaki Arai at Kolor, Mr. Asaba at Factotum, The Asahi Shinbun, Hiroshi Ashida, Kiya Babzani of Selvedge, Mary Baskett, Michael Bruno at Supreme Model Management, Fabrice Buon at Up-Front Music Inc., Yoshiko Byers, Yasuyuki Cho of Wacoal Corp., Linda Ciampoli at Mariko Mori

Studio, David Colman,Christine Cornetti of Michele Filomeno, Cedric Diradourian at *Vogue Nippon*/GQ *Japan*, *Egg Magazine*, Akiko Fukai at the Kyoto Costume Institute, Takeshi Fukui at SOMARTA, Michelle Harper, Eunice Haugen at the Goldstein Museum of Design, Chieri Hazu at Undercover, Miki Higasa, Hiroko Hirayoshi, Kiyoshi Igai at Black Peace Now, Tomoko Igori at The News Inc., Akiko Iida at N.HOOLYWOOD, Seriko Ikeda at Ikeda Production, Satomi Imai at Black Peace Now, Reiko Ishiguro at 21st Century Museum of Contemporary Art, Kanazawa, Ryo Ito at the Tamala Project, Cassel Kelner at Volks Inc., Jun Kanai at Miyake Design Studio, Tsuji Kaori at DS Factory, Arisa Kasai of SAKATA, Nichi Kashihara at Madame Killer Inc., Maki Kato at Sacai, Maiko Kawada at White Mountaineering, Tayu Kishimoto at *Vogue Nippon*/GQ Japan, Eiko Kosaka at visvim, Gene Krell of *Vogue Nippon*, Ikuko Kumagai at Yohji Yamamoto, Kunitomo at S-inc. Music, Lubo Lakic for Mastermind JAPAN, Masako Lida at Kaikai Kiki, Nathan Liu, Patrick Macias of JaPress, The Mainichi Shinbun, Saori Masuda at *Vogue Nippon*, Haruka Matsunuma at TOGA, Peter McNeil, Daijiro Mizuno, Izumi Miyachi at The Yomiuri Shimbun, Shintaro Miura at Phenomenon,Yumi Miura at Peach PR, Moa, Toru Momu at the Kobe Fashion Museum, Leigh Montville of Condé Nast, Takashi Mori at Soma Design, Miki Nagai at PROI, Hirohisa Nagaya of Muratado, Rena Nakagawa of *Vogue Nippon*, Jin Nakamura, Emi Nakano at TOGA, Lin Nelson-Mayson of the Goldstein Museum of Design, Rei Nii at The Kyoto Costume Institute, Hitomi Nomura of Grimoire, Yaz Noya at h.NAOTO, Azusa Nozaki and Noe Okamoto at SOSU International Co.,Ltd., Linda Ogawa, Yoko O'Hara, Mr. Oishi at S-inc. Music, Tao Okamoto, Masako Omori at the Issey Foundation, Nozomi Oshima at Kaikai Kiki, Hiroko Ozeki, Parco Co. Ltd., Parkett Publishing, Megumi Saito of Tokyo Enterprise Company Ltd., The Shiseido Corporate Museum, Nori Sato, Ayaka Shigeno, Yoshinori Shime at Up-Front Music Inc., Hiromi Shimizu at Han Ahn Soon, Margot Siegel, Linda Spierings, Corinna Springer at Nouveau-PR, Mr. Suzuki at h.NAOTO, Lee Talbot at The Textile Museum, Chigako Takeda at Comme des Garçons, Sharon Takeda at The Los Angeles County Museum of Art, Rin Tanaka, Naoaki Tobe at Grimoire, Kaori Tsubaki, Kyo Tsujimoto at Phenomenon, Kaori Tuji at DRESS33, Kimiko Uehara at Baby, the Stars Shine Bright, Tsuenemasa Uema, Mako Wakasa, Andre Werther of WIB Paris, Nina Westervelt at MCV Photo, Kensuke Yamamoto, Naomi and Yuka Yamamoto, Yukako Yamazaki at Up-Front Agency, Atsushi Yasui of Freewheelers and Company. Please forgive us if we have forgotten anyone!

Special thanks to my fellow authors: Patricia Mears, Dr. Yuniya Kawamura, and Professor Hiroshi Narumi. Yuni, in particular, provided valuable assistance and good companionship in Tokyo. As always thanks to our editor, Gillian Malpass, and Paul Sloman at Yale University Press. Within the Museum at FIT, thanks are owed to Julian Clark, Ann Coppinger, Eileen Costa, Fred Dennis, Charles B. Froom, Colleen Hill, Tanya Melendez, Ken Nintzel, Gladys Rathod, Vanessa Vasquez, and many others, but especially Varounny Chanthasiri, who did amazing internet research, Harumi Hotta, who translated articles and e-mails, and Melissa Marra, who did almost all of the picture research. As always, thanks to John S. Major for editing and moral support.

Valerie Steele